Pushing Pixels

Secret weapons for the modern animator

Pushing Pixels

Secret weapons for the modern animator

Chris Georgenes

Focal Press
Taylor & Francis Group

NEW YORK AND LONDON

First published 2013
by Focal Press
70 Blanchard Road, Suite 402, Burlington, MA 01803

Simultaneously published in the UK
by Focal Press
2 Park Square, Milton Park, Abingdon, Oxon OX14 4RN

Focal Press is an imprint of the Taylor & Francis Group, an informa business

Library of Congress Cataloging-in-Publication Data
Georgenes, Chris.
Pushing pixels : secret weapons for the modern Flash animator / Chris Georgenes.
pages cm
Includes index.
1. Computer animation. 2. Flash (Computer file) I. Title.
TR897.7.G4625 2013
777'.7--dc23
 2012024996

ISBN: 978-0-240-81843-6 (pbk)
ISBN: 978-0-240-81844-3 (ebk)

Contents

social

Please download the example files from
www.pushingpixelsbook.com

The files have been organised based on Project number and include the Flash source files (FLA) as well as the compiled Flash Player files (SWF). All I ask is for you to use them for educational purposes only.

If you have a question, comment or in the extremely rare case a complaint, please don't hesitate to contact me. I love hearing feedback.

 @keyframer

 facebook.com/chris.georgenes
facebook.com/pushingpixelsbook

 gplus.to/chrisgeorgenes

introduction

It's not every day that a publisher like Focal Press asks you to author a brand new title and is completely open to any and all ideas. This book represents a rare opportunity in any artist's career: complete artistic autonomy. Well, perhaps not 'complete' but close enough.

Since I have written extensively about animation software, specifically Flash, I wanted to make sure I wasn't repeating myself by writing about the same design and animation techniques. This title had to be unique enough to earn the desk space next to your computer and, more importantly, next to other books.

This book shares my most useful tips and tricks while at the same time illustrating my approach with various animation projects from conception to deployment across the web and mobile devices.

Foreword

'Whatever you can do, or dream you can do, begin it. Boldness has genius, power, and magic in it. Begin it now.'

- Johann Wolfgang von Goethe

It was 1997 and I was reading an article in **Animation Magazine** about this new software called Flash. I was currently working at an animation studio in Arlington, Texas, called LSG Animation. I remember getting very excited and telling the partners of the studio, T.G. Weems and Roman Flute, that Flash was going to change everything for animation on the internet. Then I saw the Gabocorp Flash website and it changed my life. I dived head-first into learning Flash and have been animating ever since.

I first met Chris Georgenes at a Flash Forward conference held in Austin, Texas in 2006. It was my first Flash Forward conference and I didn't know quite what to expect. The way the conference was set up, people had a choice about which talk to attend during the various time slots. Chris was one of the speakers in a talk called Flash Animation: Characters, Motion Graphics and Production Techniques. How could I not attend the lecture from the guy who called his website mudbubble.com?

The room was packed. Chris got up on stage and showed us a few of his characters. One was a boy wearing a baseball cap and the other was a goofy-looking yellow dog. It wasn't the art or even the animation techniques that left an impression on me, it was Chris's passion. Chris went over some tips and tricks on animating in Flash, but he also explained how just a few years earlier he was one of us, sitting in the audience. He encouraged us to continue to experiment, practice and that the sky was the limit as to what was possible if we put our minds to it. He basically told us that if he could do it, so could we. At the end of the talk, I stood in line with the rest of the attendees, shook his hand, told him he did an amazing job, gave him my business card and went away inspired to do better work.

I decided to attend the Flash Forward conference the next year in Boston. One of the reasons I decided to go was because I knew Chris was going to be a speaker again at the event. This time Chris's talk was called Animation Tips and Tricks. He started off the talk with an animation of a character based on his daughter riding a tricycle. He had animated his daughter using Flash and the tricycle using a software package called Swift 3D. He explained how the first thing he did was come up with a vision or concept for the animation. Then he went into detail on the various challenges he encountered to bring his vision for the animation to life. After his talk, I stood in line again to say hi.

I sought Chris out a few times during the show that year and listened to a few other talks he gave as he did some software demonstrations on the show floor. I left Boston knowing a few things about Chris. First, he was a super-nice guy who loved his family. Second, he was totally passionate about Flash and animation. Third, he wasn't tied to only using Flash. Chris was about exploring new techniques and

finding ways to bring his concepts to creation even if it involved other software packages.

After Boston, Chris and I exchanged e-mails back and forth a few times. Then when I got on Facebook we connected there as well. When his book **How to Cheat in Flash CS3** came out, I bought it right away. I am proud to say I have bought every single edition of **How to Cheat in Flash** he has written. I can also say that in a large part due to Chris's books I have had the opportunity to work with clients like American Airlines, Comedy Central, JC Penney, Mary Kay Inc. and RadioShack.

Creation is a messy business. Giving birth to ideas and art is a lot like the process of having a child. The beginning stages are a lot of fun. The first step is normally overcoming the fear of not knowing exactly what to do, then finding a comfortable spot after fumbling in the dark for a bit. The next step involves developing a rhythm and eventually producing what could be the beginning of something wonderful. Then, if the idea sticks, the real work begins.

If you are in a partnership, one partner normally does most of the heavy lifting as the idea grows and begins to develop. Developing ideas need to be fed with time, effort and care. As the idea expands and begins to take shape, tests are recommended to make sure everything is going as planned. The gestation process can include fear, discomfort, bloating, pain and even false alarms. When the idea is finally ready to be pushed out into the world, the release can include cursing, blood, sweat, tears and other bodily fluids. Then the idea is cleaned up and presented to the world.

I can think of no better birthing coach for animation than Chris Georgenes. He has tried every single software package he could get his hands on. Whether you are using Flash, After Effects or Toon Boom, Chris has been there and he has done that. In addition to being one of the nicest and hardest-working human beings I have ever had the privilege of knowing, he is amazingly passionate about sharing his knowledge with the rest of the world.

I am deeply honored that Chris asked me to write the forward to this book. I hope you will use this book to help to bring your ideas to life. I also hope that some of you, like me, will one day have an opportunity to meet Chris in person and thank him for his contributions to the animation community.

J. Schuh
Animator/Designer/Motion Graphics Artist
www.toonsndesign.com
www.texasanimator.com

How to Use This Book

Open, read and close is normally all you need to know. Instructions for changing a light bulb could only be simpler. But this book is a little different since there are added details to discover along the way that will help you.

QR Codes - QR Codes are two-dimensional matrix barcodes capable of storing large amounts of information. You will find **QR Codes** throughout this book on pages that contain a url or contact information. To read **QR Codes** you will need a **QR Code reader** which comes preinstalled with **Android** devices or as a downloadable app if you have an **iPhone** or **iPad**. Using **QR Codes** will make it easier for you to access the websites referenced in the information.

This penguin icon highlights a notable tip or trick that is important in my workflow. If I talk about that golden nugget of information, chances are this icon will indicate where it is for easy access.

Be social. Visit **facebook.com/pushingpixelsbook** to ask questions, get answers or post your own works of art and animation.

Follow me on Twitter @keyframer. I'm pretty consistent when it comes to tweeting about trends and technologies as well as cool new gadgets. You can also find out where and when my next speaking engagement will be.

This book will guide you through my entire animation production process.

Why This Book?

Because you asked for it. Well, maybe not you in particular but I have received several requests from aspiring Flash animators all over the world asking the same question: 'How do I put it all together?' This made me think about how the entire process of creating an animation could be explained. You may as well ask a carpenter how to build a house. It's a loaded question that can be answered countless ways. How exactly are all these techniques, tips and tricks combined to produce an original animation?

Designer enemy number one: the blank stage. It is a daunting sight, cold, stark and intimidating. Literally uninviting. It dares you to deface it, practically screaming at you: 'Go ahead, desecrate me! Just try to mark my surface and come away with anything anyone would consider worthwhile to gaze upon!' I have confronted this enemy head-on countless times and in most cases I've ended up on the successful side of the creative process. It may never be perfect or completely finished, but I've managed to overcome the dreaded blank stage and the ensuing artist's block.

An original design or animation is not always an easy task. Add to that a firm deadline from your boss or client and the stress can quickly cloud the creative process. My goal for writing this book is to help provide a window into my technical workflow as well as the cerebral side of my creative process. Sometimes ideas come easily while other times it feels like it would be easier to solve a Rubik's cube blindfolded and with only one hand. For years I've experienced the pressures of meeting tough deadlines while trying to exceed the client's expectations and I can tell you with great certainty, it's not easy. I don't have a simple explanation as to how you can guarantee your creations will be fully realized with relative perfection. It's not possible to provide that answer in a brief and concise paragraph or two. What I can do is deconstruct, step by step, my entire process from start to finish with the hope that I'll provide that golden nugget of information somewhere along the way that can be added to your own workflow. This book leaps the synaptic gap between the creative idea and its analog/digital execution. Good results come from good planning. The first step in a good plan is finding a good story. So where does a good story come from?

inspiration

30 Shorts in 30 Days

A great method of finding inspiration is to set a challenge for yourself. Take **Adam Phillips**, best known for his wonderfully animated **Brackenwood** series, who forced upon himself the task of animating an original short every day for 30 days. A daunting assignment but a great exercise that forces the creative process. Animation of this nature has to be fast and efficient. To be successful requires keeping everything simple.

Many of us are familiar with Adam's career and agree that his animation skills are nothing short of extraordinary. Regardless of how your skill level compares to Adam's, we can all learn from his self-imposed animation deadlines. If nobody is pushing you to create something, then you need to find a way to push yourself. Check out Adam's '**30 Shorts in 30 Days**' at **bitey.com/30**.

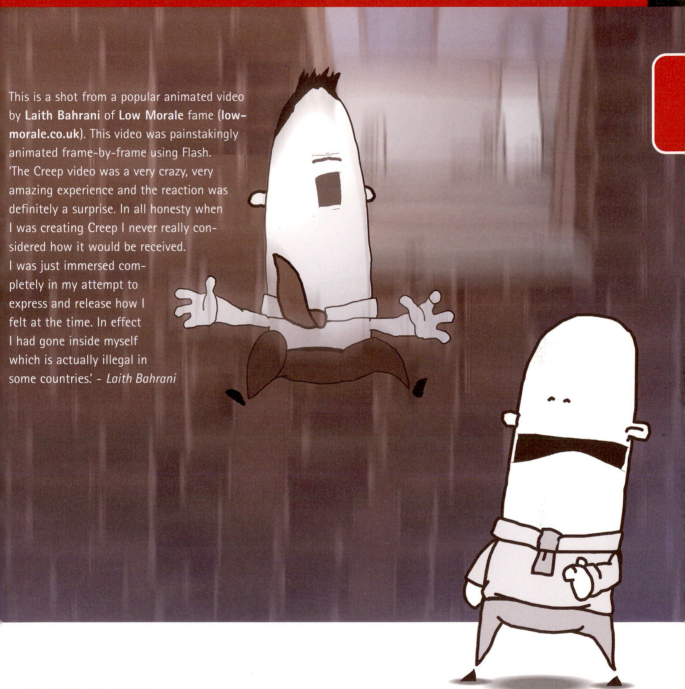

This is a shot from a popular animated video by **Laith Bahrani** of **Low Morale** fame (**low-morale.co.uk**). This video was painstakingly animated frame-by-frame using Flash. 'The Creep video was a very crazy, very amazing experience and the reaction was definitely a surprise. In all honesty when I was creating Creep I never really considered how it would be received. I was just immersed completely in my attempt to express and release how I felt at the time. In effect I had gone inside myself which is actually illegal in some countries.' - *Laith Bahrani*

music videos

Have a favorite song? Then perhaps you will be inspired to create an animation to go along with it. **Laith Bahrini**, a brilliant animator from the UK, became internationally recognized for his animated **Creep** video. Music is a great form of inspiration and most of us are music lovers of one kind or another. Pick a favorite song and imagine an animation that would compliment it. Most songs tell a story and can provide you with a jump start to an animated short.

JCB Song Video

'I'm Luke, I'm five, and my dad's Bruce Lee. Drives me around in his JCB...'
If you haven't yet seen this gem of an animation, put this book down now and go to **jcbsong.co.uk**. You can thank me later. The animation is based on a popular song by the two-member band **Nizlopi** from the UK. Once again **Laith Bahrani** creates another masterful work of animated sweetness. He had a little help from his friend **David Crawford** who animated the little *Moo Cows* that are sprinkled throughout the animation. Coincidentally I got to work with David and his partner-in-crime **James Woodward** (both from the UK), for a game developer in Los Angeles.

my Pet Cat Simon

A good story can come from anywhere and everywhere, you just have to allow yourself to recognize a story that might otherwise go unnoticed. Great examples of this are stories that come from everyday life. Often mundane, typical home scenarios can often provide the inspiration for an original short and even a series. **Simon Tofield** is an English animator who has garnered worldwide adoration for his YouTube series **Simon's Cat**. His YouTube channel features several animated shorts based upon the daily relationship between a precocious cat and his credulous owner.

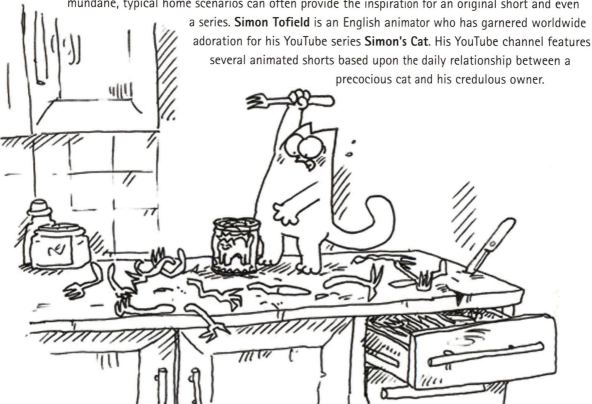

What's most interesting is that the **Simon's Cat** series started out as an exercise for the sole purpose of learn how to use Flash. Tofield's YouTube channel contains several episodes and boasts 274,171,222 views collectively as of this writing. Not bad for your first Flash animation series. Watch the entire series at **youtube.com/user/simonscat** and check out the official website at **simonscat.com**.

Hardware

intuos.5

I'll admit it, I've had a long love affair with **Wacom**. I don't remember exactly when it started but I got my first **Wacom** tablet in the late 1990s. It was during my first paying job as an animator in a small animation studio and it was love at first stroke. Using a stylus to draw on a computer was a completely new experience for me and it made the transition from my fine art background to using graphics and animation software almost seamless. To even attempt to draw on a computer without a graphics tablet is practically criminal. Drawing with a mouse is about as ergonomic as drawing with a brick. For your mental and physical well being, please consider a quality graphics tablet if you do not have one already.

Based on my long and intimate history with **Wacom** products, I feel confident that the latest **Intuos 5** is the best graphics tablet **Wacom** has developed. I prefer the **medium** size **Intuos** for two reasons: it has a nice 1:1 size ratio to my **MacBook** 15 inch display and the tablet fits perfectly in my backpack. One of the key new features for **Intuos 5** is the multitouch gesture support allowing you to interact with your computer using only your fingers.

Only about five percent of **Intuos** users take advantage of the **ExpressKeys**™ and **Touch Ring** features. That said, only a very small percentage of these specific users take advantage of everything these features have to offer. These users fall into the category of 'power user' and thrive on a level of efficiency most **Intuos** users never bother to explore. I am a power user when it comes to the **Intuos**. I love the **ExpressKeys** and **Touch Ring** and they speed up my workflow considerably. These features are a huge part of the **Intuos** line and after all, I paid for them, why not use them? I realize I'm also the minority when it comes to tech-nology and just about everything else in the modern world. I'm the guy that actually reads the manual that came with the car.

The most used feature in my workflow is the **Touch Ring**, especially when I'm working in **Adobe Photoshop** and **Flash**. The **Touch Ring** is four tools in one. Press the center of the **Touch Ring** to cycle through each tool and then swipe along the perimeter of the **Touch Ring** to control the functionality of the selected tool.

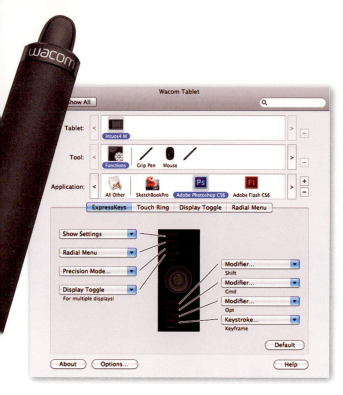

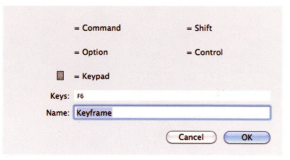

The **Intuos** tablet is completely customizable from within the **Wacom Tablet** settings panel in your system's settings. If you don't see your application listed in the **Applications** section, click the '**+**' symbol to add it. Tablet customization is specific to the currently selected application. Click the **ExpressKeys** tab to view and customize the assigned shortcuts.

As an animator one of my most useful **ExpressKey** shortcuts takes advantage of the **F6** keyboard shortcut for inserting keyframes. Having an **ExpressKey** for keyframing puts the shortcut closer to where my left hand naturally is when drawing with the Inutos tablet.

The **Touch Ring** settings are customizable by clicking the **Touch Ring** tab and assigning a new command using the **Function** drop-down menus. My favorite and most used **Touch Ring** functions for **Photoshop** are **Brush Size** and **Rotate Canvas**. I customized the **Touch Ring** to control the frame indicator on the timeline when animating in **Flash**. Swiping the **Touch Ring** dial clockwise moves the frame indicator to the right and swiping counter-clockwise moves it to the left. Having the ability to swipe the **Touch Ring** to scrub the timeline as well as an **ExpressKey** to insert keyframes are huge time savers in my workflow.

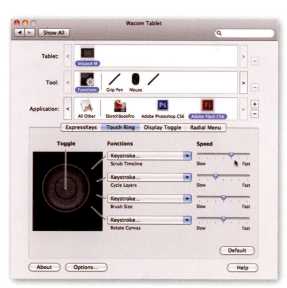

Recording Hardware

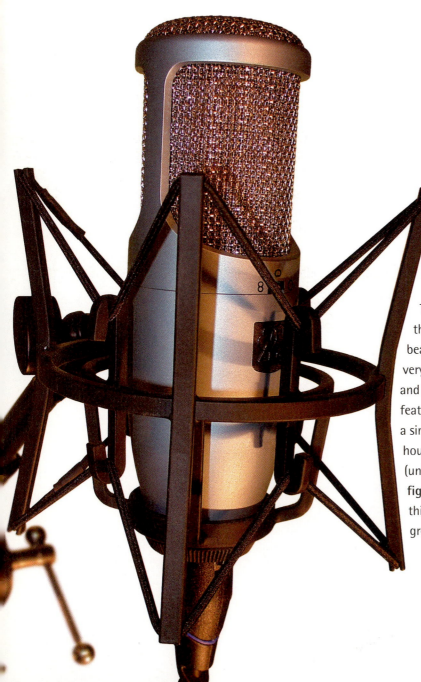

This is my microphone of choice, the **AKG Perception 400** and it's listed as discontinued by AKG. Similar microphones, such as the 420, retail between $200 - $250 US as of this writing. There are certainly better microphones on the market but for its price point you can't beat the AKG Perception series. I can record very clean vocals as well as sound effects and musical instruments. One of its nicest features is the multi-pattern recording. Using a simple switch on the side of the microphone housing you can choose between **cardiod** (uni-directional), **omni** (360 degree) or **figure-8** recording patterns. I've been using this microphone for the past few years with great success.

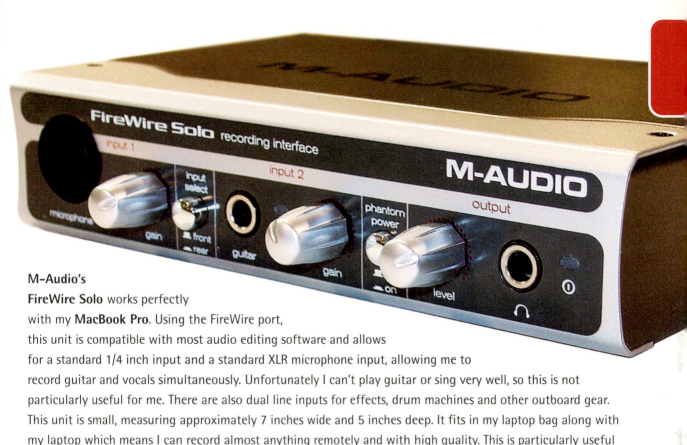

M-Audio's

FireWire Solo works perfectly
with my **MacBook Pro**. Using the FireWire port,
this unit is compatible with most audio editing software and allows
for a standard 1/4 inch input and a standard XLR microphone input, allowing me to
record guitar and vocals simultaneously. Unfortunately I can't play guitar or sing very well, so this is not
particularly useful for me. There are also dual line inputs for effects, drum machines and other outboard gear.
This unit is small, measuring approximately 7 inches wide and 5 inches deep. It fits in my laptop bag along with
my laptop which means I can record almost anything remotely and with high quality. This is particularly useful
when my subject is unable to come to me. If I need ambient sounds I can simply travel to where the sounds are,
open my laptop, connect the FireWire Solo and microphone and start recording.

When recording vocals, it always helps to
have some form of noise protection. A **pop
filter** prevents sudden bursts of sound from
distorting your recording. There's nothing worse
than getting that perfect vocal performance
only to find on playback some consonants caused
noticeable distortion. A basic pop filter can be
purchased for $10 - $20 US and is well worth it if you want
to avoid the dreaded popping noise commonly associated with words
that start with the letter 'p'.

It's a safe bet your recording hardware may not be exactly the same as mine. For this reason I am not going to go into too much detail about connecting the microphone to the **M-Audio FireWire Solo** to the computer. There are too many variables across too many products to cover everything. The microphone is connected by a standard **XLR** cable connector. The biggest decision is how long the cable should be. Typically they come in 5, 10, 20, 30 and 50 ft lengths. Obviously the 5 ft cable is too short for most recording needs and the 50 ft cable is too long. The 10 ft cable will suffice for most recording situations if you are doing voiceover work. You can always connect multiple XLR cables together if the need arises. I was in a recording situation where I needed much longer cable so I purchased a 20 ft cable and connected the two together to give me a total of 30 ft to work with.

The XLR cable has two different connections: male on one end, female on the other. The **M-Audio FireWire Solo**'s microphone input accepts the male end. Naturally the female end plugs into the microphone itself.

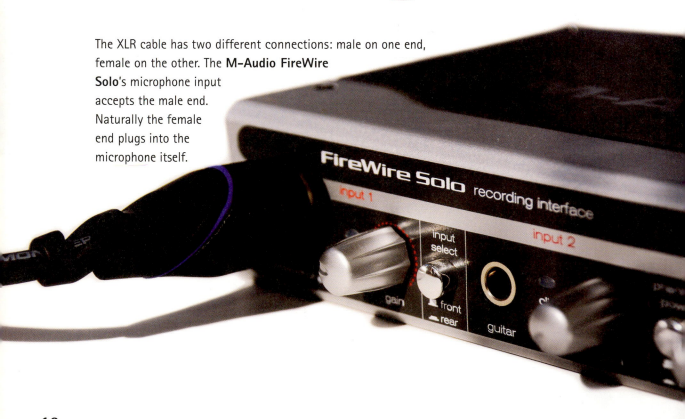

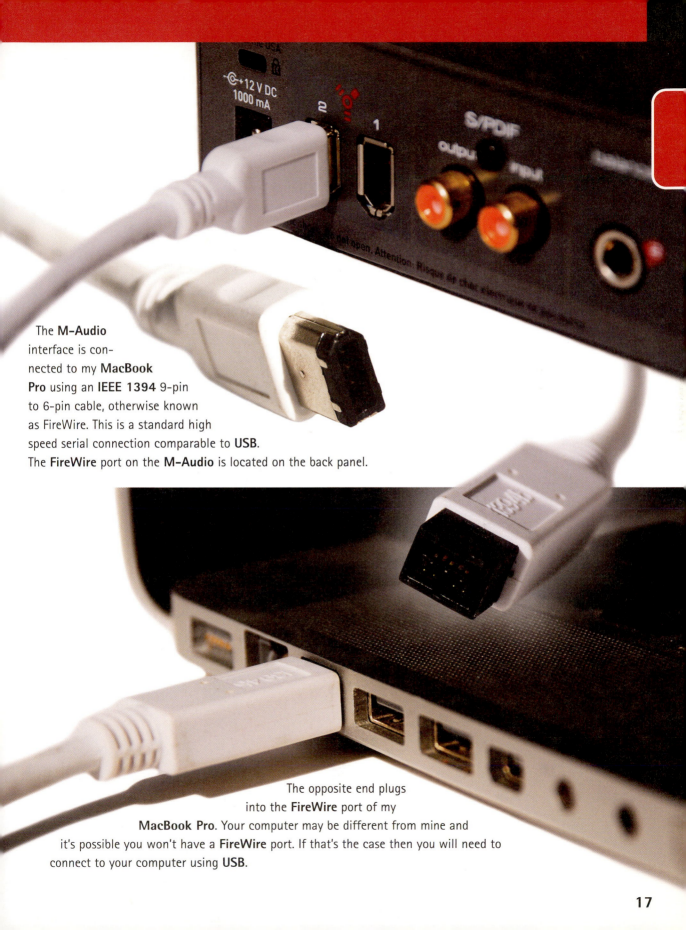

The **M–Audio** interface is connected to my **MacBook Pro** using an **IEEE 1394** 9-pin to 6-pin cable, otherwise known as FireWire. This is a standard high speed serial connection comparable to **USB**. The **FireWire** port on the **M–Audio** is located on the back panel.

The opposite end plugs into the **FireWire** port of my **MacBook Pro**. Your computer may be different from mine and it's possible you won't have a **FireWire** port. If that's the case then you will need to connect to your computer using **USB**.

SAMSON®

Condenser microphone technology is becoming increasingly sophisticated. There are a number of quality microphones that connect to your computer using **USB** only. There's no need to purchase additional hardware and cables and in most cases, the microphone is extremely portable due to its small size.

The best bang for your buck may be the **Samson Go Mic**. The **Go Mic** is a portable USB condenser microphone that literally fits in the palm of your hand. The microphone chassis alone is only two and a half inches in height and just over an inch wide. The microphone is attached to a weighted base using a ball joint allowing it to be angled in almost any direction. The base can sit on any flat surface or mounted to the top of your laptop screen using the integrated clip. The base has four integrated rubber feet to help limit external vibrations and a hole provides the option to mount it to a microphone stand.

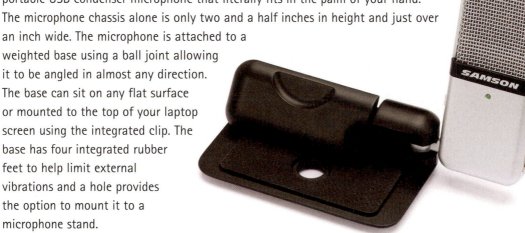

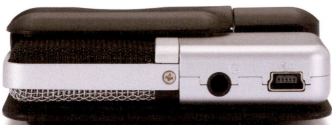

The **Go Mic** provides a ⅛ inch output so you can connect your headphones. The **Mini–B** size **USB** connector is also located on the same side of the microphone.

What good is portability if it doesn't come with some form of protection for when it's bouncing around the bottom of your laptop bag? **Samson** includes a zipper case with the **Go Mic** to eliminate the fear of the microphone getting dirty or damaged in transit.

The **Go Mic** comes bundled with **Cakewalk Music Creator** software but I opted to stick with **Adobe Audition** because of my familiarity with it. The Go Mic is designed to work with a variety of editing software such as **Apple Logic**, **Garage Band**, **Sony Sound Forge**, **Cubase** and more. Out of the box, I connected the Go Mic to my **MacBook Pro** and it was instantly recognized by **OS X** and **Adobe Audition**. No need to download drivers, the Go Mic just works. I was recording within seconds and my initial spoken-word tests were surprisingly crisp and balanced.

You can also tailor the Go Mic to your recording environment by switching between **cardoid** and **omni-directional** polar patterns. The cardoid setting records sound in one direction while **omni-directional** captures sound in all directions. Use the cardoid setting for recording vocals in front of the microphone. Sounds from the sides and behind the Go Mic will be rejected. **Omni-directional** is great for situations where you are recording the environment - perfect for ambient sounds or live music situations. Good news for those of you on a limited budget: as of this writing, the **Go Mic** can be found on amazon.com for under $50 US. The **Samson Go Mic** is an outstanding product for recording high quality sounds with portability. With a **Go Mic** and a laptop, the world is your stage.

Other quality products from Samson are the **Meteor Mic** and **G-Track** microphones. Both are **USB** condenser microphones with additional features that go beyond their Go Mic counterpart. The **Meteor Mic** (pictured left) has a large 25mm condensor diaphram (the **Go Mic** diaphram is 10mm). The **G-Track** (picured right) boasts a built-in audio interface and mixer and a 19mm diaphram. The power of the **G-Track** is its ability to record vocals and an instrument at the same time, making it ideal for studio musicians. Any one of these microphones is an affordable way for the casual or professional animator to capture high quality sounds for their animations. Learn more at **samsontech.com**.

Most of my work is created using a **MacBook Pro**. In fact, this entire book was written on my **Mac**. To make sure I don't sound platform-biased, I do have a **Windows** machine running **XP** that I use from time to time. It's a custom built CPU that I have my **Wacom Cintiq** connected to. It's a great machine but it's a huge desktop CPU that is far from portable. For this reason it has been delegated to an animation and video workstation and stays put in my home office.

For a while I was working for a game developer on the west coast. Living in the Boston area meant I had to make the occasional cross-country commute to work on-site. Opening my laptop in-flight while seated in the coach section was simply not an option for a couple of reasons: the seats were too close together for me to angle the screen enough for me to see it comfortably. I was also in constant fear of someone's drink spilling directly into the keyboard.

My solution? The **Apple iPad**.

The trip from Boston to Los Angeles is about six hours and the **iPad** allowed me to be productive during each flight. With apps like **Photoshop Touch**, **Autodesk SketchBook Pro**, **DoInk** and **Pages**, it was easy for me to design, animate and write all from the comfort of my seat 30,000 ft in the air.

I love finding well designed apps that allow me to be creative. So I got really excited when I got a first-hand look at the **Adobe Touch Apps** on the **Samsung Galaxy Tab** at **Adobe MAX** in September 2011. Thanks to **Paul Trani**, Adobe product evangelist, I had the unique opportunity to try the apps in a closed testing room with other designers in front of the **Samsung** and **Photoshop Touch** teams. It was a thrill to not only learn about the **Photoshop Touch App** but to provide the teams with my gut reactions in real time. Constructive feedback from a room full of designers while each representative from

each team frantically took notes based on our reactions to the app. It was a very cool experience.

In parallel with the launch of their **Touch Apps**, Adobe launched the **Creative Cloud**: a cloud-based service to share your files between multiple devices. Now designers can start the creative process using the **Adobe Touch Apps**, upload them to the **Creative Cloud** and continue working on them using the **Adobe Creative Suite** on a different computer. Between the **Touch Apps** and the **Creative Cloud**, you can create designs almost anywhere. A few weeks after the **Touch Apps** were released, **Adobe** sent me a **Galaxy Tab** for testing, teaching and feedback. This was great because I could spend some quality time with each application, especially **Photoshop Touch**. It didn't take long before I was able to incorporate my ideas using these apps and the **Adobe Creative Cloud**. Having a portable version of **Photoshop** can be an invaluable tool if you are constantly on the go or just stuck in a long meeting.

During the production of this book, **Adobe** released their suite of **Touch Apps** for **iOS**. Around the same time **Apple** released the new **iPad**.

Acknowledgments

First and foremost, I acknowledge my wife **Becky**. Between her active work schedule and community efforts, my full-time job, ongoing music career and our busy children, finding the time to write this book was a daily challenge. In the moments between our collective chaos, I managed to disappear with my laptop to write, leaving Becky to fill the parental void I left behind. If it weren't for her you wouldn't be reading this.

My success as an author is in part due to **Katy Spencer**, my editor throughout most of the How to Cheat series and the early stages of **Pushing Pixels**. Thank you for having so much faith and trust in me these past few years. I'll miss working with you.

Melissa Sandford of **Focal Press** for grabbing the reins from Katy and keeping me on track.

Dee Sadler for being such a talented force of nature, for her eye for detail and for always reminding me that Adobe Illustrator is truly the bomb.

Myra Ferguson for her friendship, amazing generosity and the best Adobe MAX ever. Myra unselfishly put herself on the front line with this book and provided invaluable constructive criticism throughout. I can't thank her enough. Go Tigers!

Special thanks to Adobe Systems, Karina Boussou (Toon Boom), Stephen Brooks (Rubber Onion Animation), Richard Galvan, Evan Hays (Samson), Karen Miller (DoInk), iStockphoto, Morris Les, Sally McEachen, AJ Peterson and Justin Putney (Ajar Productions), Jay Schuh (toonsndesign.com), David Skinner (Ten One Design), Joseph Sliger (Wacom), Ayala Stadnikov, and Pam Stalker.

About the Author

School was always easy for me: give me some facts to memorize or a complex situation to analyze and I was one happy student. It wasn't that way for Chris. As a tall, non-basketball-playing artist and drummer at an all-boys Catholic school that focused on sports (not the arts), he didn't really fit in. Never felt totally comfortable. But senior year of high school, Chris's parents hired someone to help him put together an art portfolio. And it was then, during his college interview at University of **Hartford Art School**, that Chris felt truly smart, for the first time.

Chris graduated from '*Hahtfod Aht School*' (he is from Boston, you know) in 1989 with a degree in print making and illustration. For the next several years, he worked as a manager in his family's Boston diner, as a mechanic at a Jeep dealership, as a drummer in a popular funk band, and as a freelance illustrator (his early pieces graced the covers of trade magazines for the funeral industry). Finally in 1995, the timing was right when he carried his portfolio, unannounced, into **Tom Snyder Productions** – the creators of **Comedy Central's Dr. Katz Professional Therapist**. A week later, he was hired to work on their new pilot for **Steven Spielberg**. While that show was never picked up, he did bring to life animated characters in later shows such as **Science Court (ABC)** and **Home Movies (Cartoon Network)**.

After six years, Chris started **Mudbubble Animation**. Supporting his growing family while working at home from the basement, Chris used Flash to create motion graphics and cartoons (or as our kids described it, 'coloring') for clients such as **PBS**, **L'il Romeo**, **Microsoft**, **Digitas** and **Yahoo** to name just a few. Currently Chris works as an art director for the **Game Show Network Digital** where he helps design the highly successful **GSN Casino** app as well as provide the overall look and feel for the digital side of **GSN**. Between work, writing books, being the go-to-guy for people who need design and animation, having fun with his three kids and playing golf, Chris is the drummer in two bands – **One Moe Time** and **Morris Les & the Stray Tones**. He lives with his family in Massachusetts – not too far from where he grew up in Jamaica Plain.

- Becky Georgenes

23

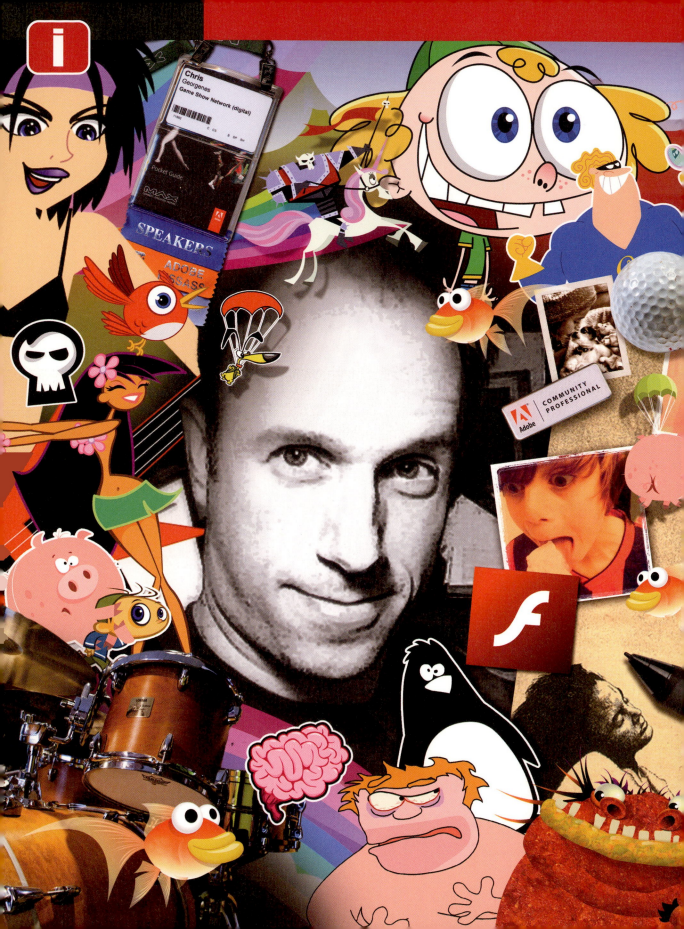

Project 1

Frog Day Afternoon

Typically, an animation starts with a fully realized concept, a storyboard, character design and background art. If this was a client project, I would have spent a good deal of time designing assets for the client to approve before animating a single keyframe. The Frog Day Afternoon project was more about exercising my animation brain. It began with a simple doodle and a few frames later, blossomed into a simple story. In the gruelling world of client deadlines, sometimes it's a fun departure to forget the rules and improvise a little.

For this first project we're going to look at an example of one of my stream of consciousness animations. These are more like exercises where I mindlessly draw something and see where it takes me. This particular animation uses a frame-by-frame method (also referred to as 'full animation') and was purposely kept simple.

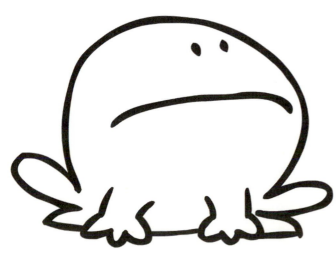

Toon Boom Animate Pro

Frog Day Afternoon is an exercise in animation that was never intended to go beyond my hard drive, yet I've decided to feature it in this book. Here is why: I had recently installed **Toon Boom's Animate Pro** software in an effort to learn how to use it. My preferred method of learning is to see how far I can get playing with the tools and interface before surrendering to the help documents and tutorials. If the basic functions of a software program aren't intuitive through exploration, then it's safe to say the entire learning curve will be an uphill battle and that will determine if the software will win its place in my arsenal of animation weaponry. The first thing I do after the program's maiden launch is to locate the toolbox, grab the brush tool and start drawing directly on the stage. A good graphics program should have a solid drawing engine, one that is responsive and provides instant feedback to the user. I can usually tell within the first couple of strokes whether or not I'm going to love or hate a drawing engine and with **Toon Boom Animate**, not only did I like it, I literally said out loud; 'WHOA MOMMA!' **Toon Boom Animate Pro**'s drawing engine is, in a word, *sexy*. It is vector-based yet the line quality has that raster-based look and feel. **Toon Boom Animate Pro** uses **Open GL** technology to anti-alias each brush stroke, thereby eliminating the super-crisp shapes typical of other vector-based graphics programs.

A shape created using the **Brush** tool in **Adobe Flash**.

A shape created using the **Brush** tool in **Toon Boom Animate Pro**.

Here's what I drew in **Animate Pro** in frame 1:

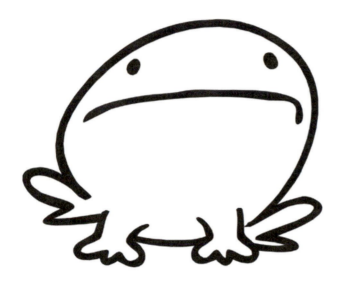

In all honesty I had no preconceived notion to draw a frog. It just so happened my doodle turned out looking like one. So I decided to see how it would look if I turned on the **Onion Skin** tool and drew him a few more times;

All of the drawings may look exactly the same but they are not, thanks to the imperfect nature of the human hand. I played back my animation as a loop and the frog came to life due to the subtle variations in the line work across each frame. The resulting oscillating effect is typical of hand-drawn **frame-by-frame animation**.

Project Settings

Before I get too far into the animation, lets take a quick step back and talk about some basic document settings. Almost all my animated projects are set up for high definition resolution at a **16:9 aspect ratio**, unless the client specifies otherwise. The reason for this is simple: almost every modern day flat screen television is designed for this aspect ratio as well as most mobile devices. If you want to support the **HD playback** option on **YouTube** and **Vimeo**, then you'll want to author your content using this setting. To make it simple, set the width of your document to **1920** pixels and the height to **1080** pixels.

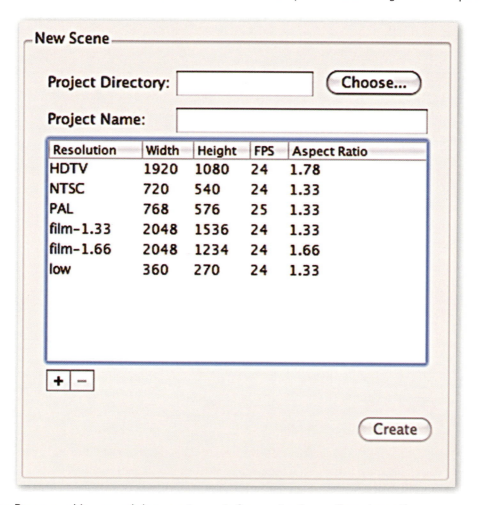

New Scene

Project Directory: _____ (Choose...)

Project Name: _____

Resolution	Width	Height	FPS	Aspect Ratio
HDTV	1920	1080	24	1.78
NTSC	720	540	24	1.33
PAL	768	576	25	1.33
film–1.33	2048	1536	24	1.33
film–1.66	2048	1234	24	1.66
low	360	270	24	1.33

[+] [−]

(Create)

Toon Boom provides several document presets for you to choose from depending on your project needs and output. Just choose a directory, type in a project name, select the preferred resolution and click the **Create** button.

New Resolution

Resolution name:	Untitled
Width:	500
Height:	400
Frame Rate:	30

Cancel Create

Alternatively, If you click the '**+**' symbol a **New Resolution** menu pops up allowing you to enter your own custom width, height and frame rate.

As you work your way through each project in this book, you'll notice each one is authored with a **1920 x 1080** resolution and animated at **24 frames per second**. This is typical of how I like to work based on the intended viewing platform and the frame speed at which I like to animate.

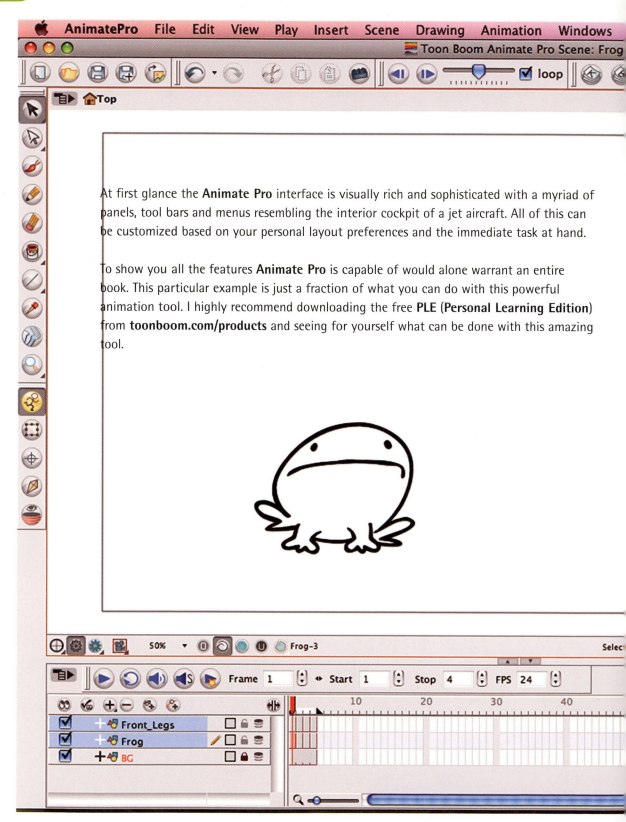

At first glance the **Animate Pro** interface is visually rich and sophisticated with a myriad of panels, tool bars and menus resembling the interior cockpit of a jet aircraft. All of this can be customized based on your personal layout preferences and the immediate task at hand.

To show you all the features **Animate Pro** is capable of would alone warrant an entire book. This particular example is just a fraction of what you can do with this powerful animation tool. I highly recommend downloading the free **PLE** (**Personal Learning Edition**) from **toonboom.com/products** and seeing for yourself what can be done with this amazing tool.

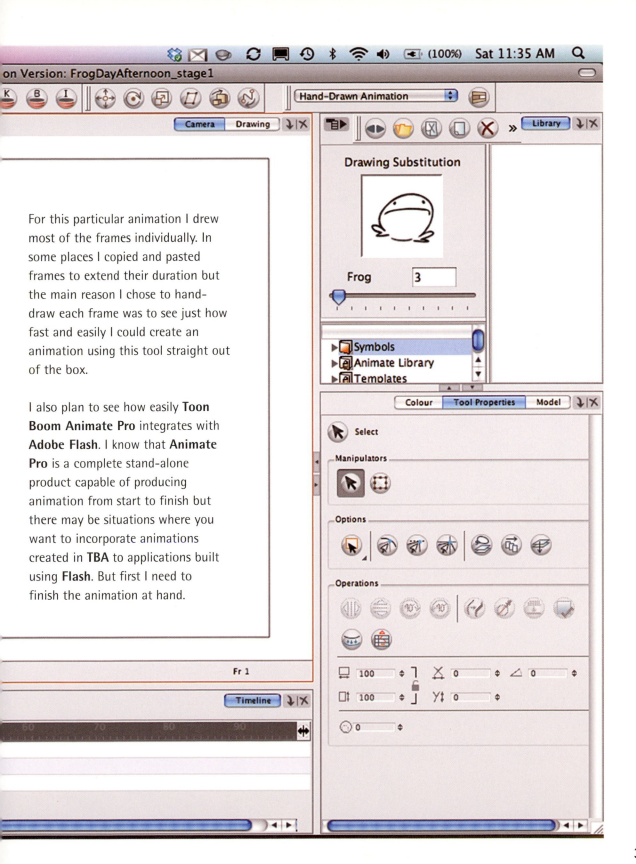

Hand-Drawn Animation

Camera Drawing

Library

Drawing Substitution

Frog 3

▶ Symbols
▶ Animate Library
▶ Templates

Colour **Tool Properties** Model

Select

Manipulators

Options

Operations

100 X 0 ◁ 0
100 Y↕ 0
0

For this particular animation I drew most of the frames individually. In some places I copied and pasted frames to extend their duration but the main reason I chose to hand-draw each frame was to see just how fast and easily I could create an animation using this tool straight out of the box.

I also plan to see how easily **Toon Boom Animate Pro** integrates with **Adobe Flash**. I know that **Animate Pro** is a complete stand-alone product capable of producing animation from start to finish but there may be situations where you want to incorporate animations created in **TBA** to applications built using **Flash**. But first I need to finish the animation at hand.

Fr 1

Timeline

60 70 80 90

Onion Skin

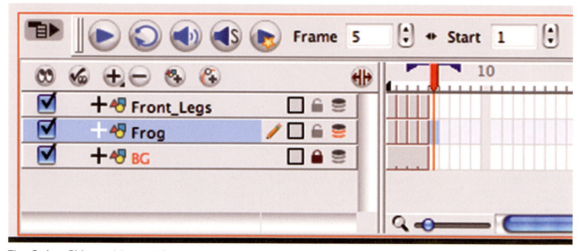

The **Onion Skin** tool is specific to each layer. You can turn it on or off for each individual layer or across multiple layers depending on how much **onion skinning** you need. Just click the **Onion Skin** icon in the layer to turn it on.

I drew the main body of the frog on a single layer initially. If I just want to add this artwork to the **Onion Skin**, then I need to turn it on for this layer.

The front legs were drawn on a separate layer above the frog body. Pictured here are both layers added to **Onion Skin**.

Naturally, for an animated short to have some appeal, something actually has to happen. The fun part is figuring out what that might be. In an effort to avoid spending several long hours on this particular animation, I quickly decided that the frog would encounter a fly that would perhaps become a nuisance in some fashion. The best part was that the fly could be represented by a simple dot and would require almost no design time. Animating the flight path of the fly would also be a fun exercise. Time to add a new layer and start animating a fly.

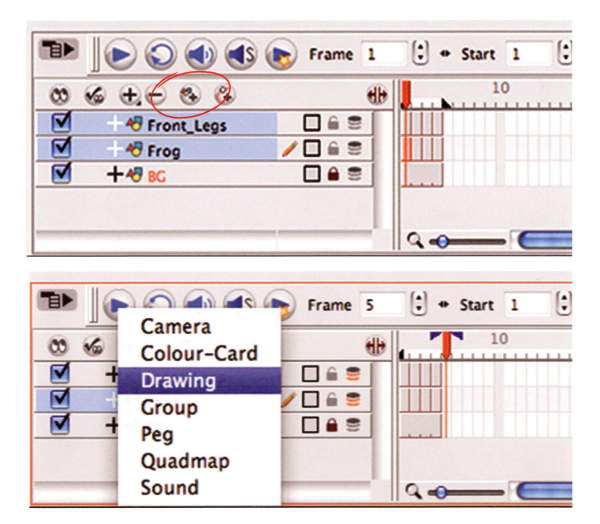

To add a layer, click the '+' sign and select the appropriate layer style. Since I am going to add an animation, I select a **Drawing** layer.

Starting from just outside the viewable stage, the 'fly' enters the scene represented by simple dot drawn with the **Brush** tool. The black dot indicates the current frame and the trailing red dots represent previous frames when **Onion Skin** is turned on. For the fly animation it was critical to add several frames to the **Onion Skin** in order to get a sense of timing and the path of the fly.

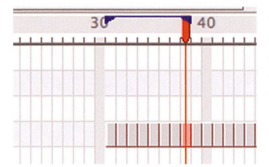

You can adjust the number of frames that get added to the **Onion Skin** by sliding the blue marker to the left of the frame indicator in the **Timeline** panel. This will add the frames before the frame indicator to the **Onion Skin**. The artwork on the stage is represented in the color red.

The frames after the current frame can also be added to **Onion Skin** by adjusting the blue slider on the right side of the frame indicator. The artwork in these frames are displayed in green to help differentiate them from the frame(s) preceding the current frame.

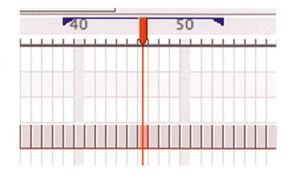

The fun part is animating the path of the fly. As an animator, I try to take notice of how things around me move in everyday life. Even by observing something as mundane as a fly and its flight patterns, much can be learned. They are quick and random, hardly ever maintaining a constant rate of speed or direction. I tried to mimic this in my animation.

In places where I wanted the fly to slow down and travel in different directions, the distance between each drawing was reduced.

In places where I want the fly to speed up, the distance between each frame was slightly deformed to provide the illusion of very high speed.

The storyline for **Frog Day Afternoon** came about organically. As I animated the fly, I was considering several options as to what would happen next and ultimately decided that the frog would eat the fly. Eating the fly is what you would expect to happen, which makes this animation dangerously predictable. I needed something else to happen, something unexpected to pique the viewer's interest and make this animation more entertaining.

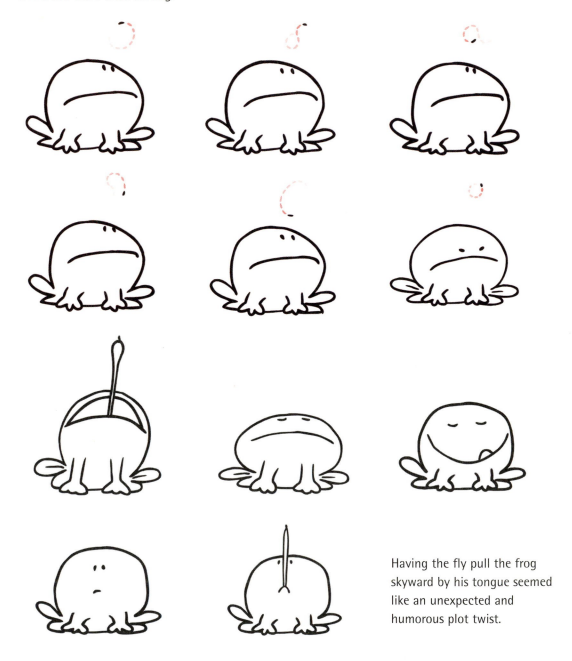

Having the fly pull the frog skyward by his tongue seemed like an unexpected and humorous plot twist.

The best part about this animation is that it is not completely resolved. The story ends just after the fly and frog exit the scene, but that does not mean it has to be over. I have the option of continuing this animation and picking up where I left off. Imagine just how far this story could go if I continue with the frog being pulled into the sky. I can imagine an unlimited range of possibilities as the frog is now the unlikely victim and helplessly being lifted high into the air. For now, I'll leave it as a cliffhanger and someday continue what I started by adding more animation.

Now that I have my animation in **Animate Pro**, it's worth seeing if it can be integrated into Adobe **Flash**, if at all. Can animations created in Animate be imported into **Flash** while maintaining layers and other features? The reason this workflow may be of interest to some designers and developers is if you wanted to take advantage of Animate's animation features in combination with Flash's powerful programming language. Since **Animate Pro** and **Flash** are developed by two completely different companies, there's very little incentive for either Toon Boom or Adobe to develop a workflow designed to bridge these two programs together. It is up to the user to find a work-around for getting **Animate Pro** content into the **Flash** authoring tool.

Adobe Flash integration

In order to integrate **Toon Boom Animate Pro** with Adobe **Flash**, let's first take a look at **Animate Pro's** export options. Go to the **File** menu and select **Export**. Since **Toon Boom Animate Pro** doesn't export to the native **Flash** format (**Fla**), the next best option is to export the animation as a **SWF**. The **SWF** format is widely used across the web as a browser plugin to display vector-based graphics, animations, video and interactivity using ActionScript.

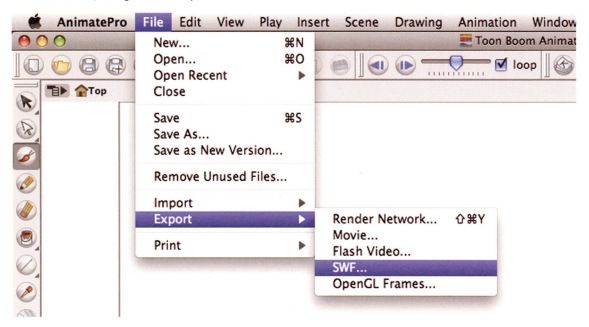

It's important to know that the SWF format doesn't support layers. All the layers used in your **Animate Pro** timeline will be flattened on export to the SWF format.

When you choose the SWF format, **Animate Pro** provides additional settings to choose. Here you can select all frames or a range of frames to export, change the frame rate and if you have imported bitmaps in your timeline, select the amount of **JPEG** compression. You can also protect your SWF from being imported back into **Flash** (which is an option we do not want selected) and compress your movie. I recommend leaving this option unchecked also. Click **OK** to export your animation to the SWF format.

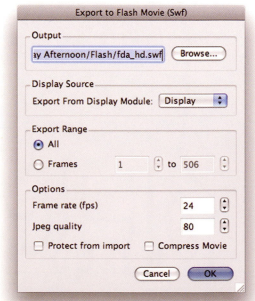

Launch **Adobe Flash** and create a new document.

Go to **Modify > Document** and enter the same dimensions used in **Animate Pro**, in this case it was **1920 x 1080**. The frame rate should also be the same in both projects, in this case it was **24fps**. You can click **Make Default** if you want every new document to adopt these exact settings. New to **Flash CS5.5** is the **Auto-Save** feature that can be turned on or off at any time. When selected you can customize the interval (in minutes) as to how often **Flash** will auto-save your document. It's a secure feeling to know that **Flash** has your back when it comes to making sure any unsaved changes are saved. **Auto-Save** is one of my favorite new features in **CS5.5**.

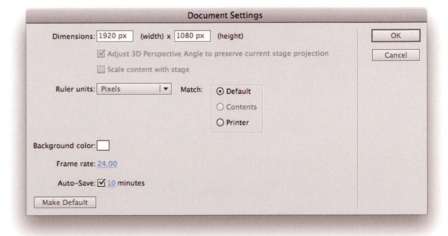

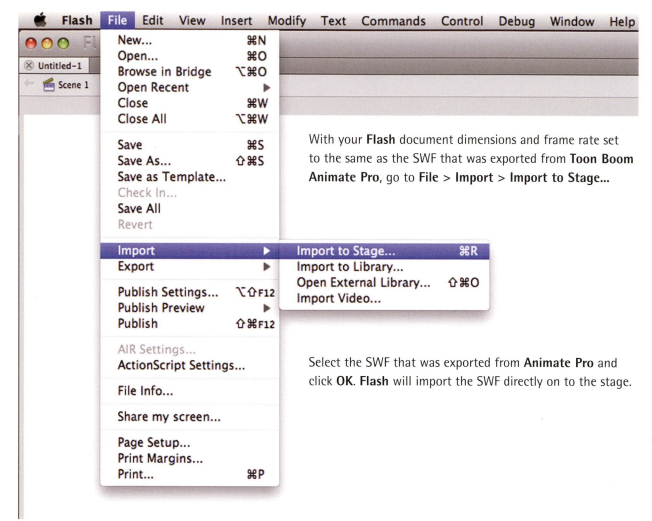

With your **Flash** document dimensions and frame rate set to the same as the SWF that was exported from **Toon Boom Animate Pro**, go to **File > Import > Import to Stage...**

Select the SWF that was exported from **Animate Pro** and click **OK**. **Flash** will import the SWF directly on to the stage.

You will notice that the layer in the timeline is now populated by keyframes in every frame. These keyframes are a result of **Flash** interpreting the imported SWF which is a compressed format. The process of exporting the SWF from **Animate Pro** flattened all the layers into a single layer.

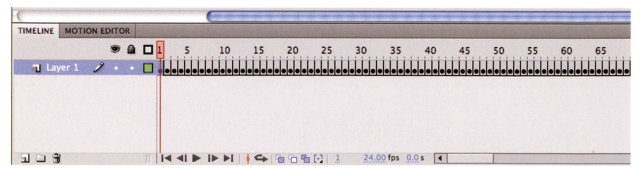

Animate Pro Brush Tool

The next noticeable difference is that the brush strokes that were previously anti-aliased in **Animate Pro** are no longer anti-aliased in **Flash**. This change in the type of display happens because **Flash** does not support Open GL anti-aliasing like **Toon Boom Animate** does. The line quality is crisp and sharp and has become synonymous with that '**Flash** look', the look of vector art. This may be a completely acceptable and intended design detail for your project, in which case you may prefer to continue working within the **Flash** authoring tool.

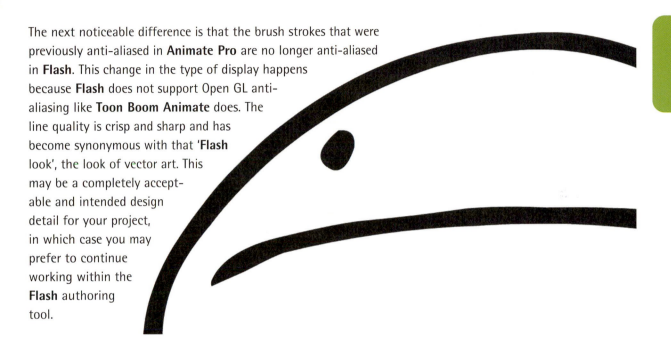

Here's what the original frog looks like in **Animate Pro** when enlarged. The brush strokes are clearly anti-aliased and have much softer edges. The line quality looks as if it had been created in a raster-based program, yet it is 100 percent vector.

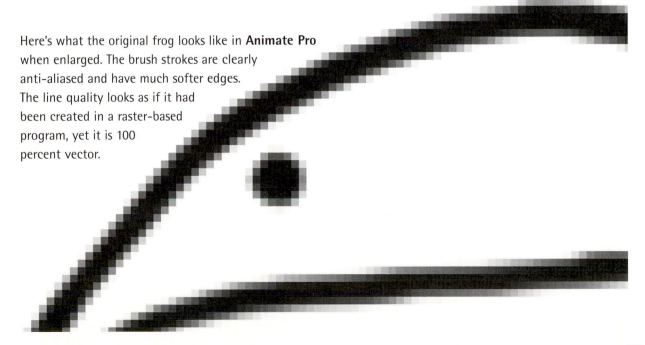

You can adjust the amount of anti-aliasing by going to **Animate Pro**'s **Preferences** panel and clicking on the **OpenGL** tab. In the **Real–Time Antialising** section, make sure the **Enable** box is checked and set the numerical value to a low number for more anti-aliasing and a higher number for less.

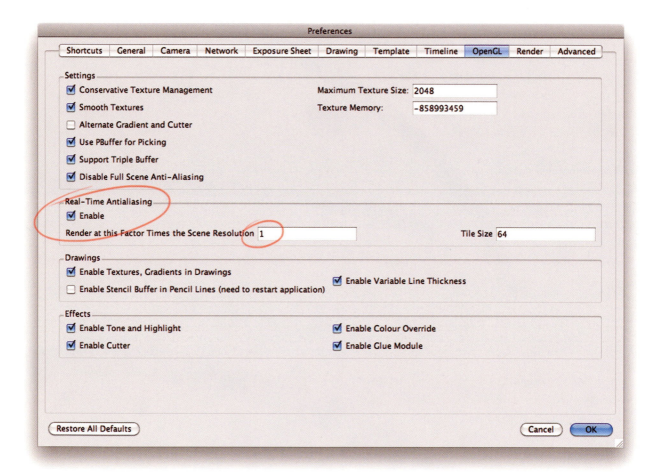

Animate Pro offers many great features and one of the best is its drawing engine. I'm a huge fan of the **Brush** tool because of the visually satisfying look and feel of each stroke while drawing in real time using a pressure-sensitive graphics tablet. **Animate Pro** also allows you to fine-tune your brush with several options in the **Tool Properties** panel.

The **Brush Tool Properties** panel includes a number of presets you can choose from by clicking on the **Brush** icon in the **Options** window.

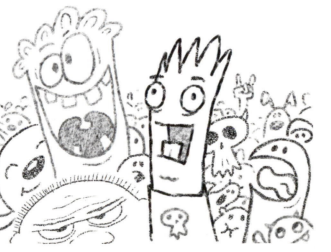

Select the brush of your choice from the drop-down menu. Beyond the normal brush sizes, **Animate Pro** offers several texture brushes.

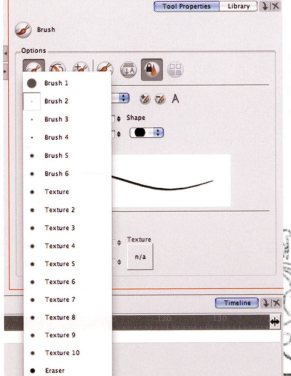

All of the characters below were drawn using the various texture brushes. **Animate Pro** conveniently combines vector brushes with the look and feel of real media commonly associated with a raster-based drawing program.

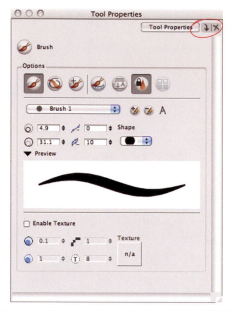

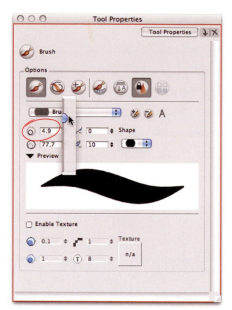

The **Tool Properties** panel can be opened by clicking the downward facing arrow in the upper right corner of a panel that's already open.

The **Brush** has two size settings: **taper** and **width**. Use the top slider to adjust how much taper you want your brush strokes to have.

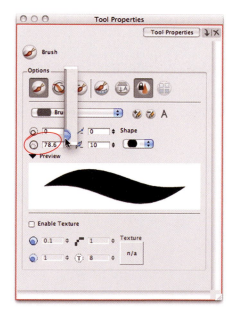

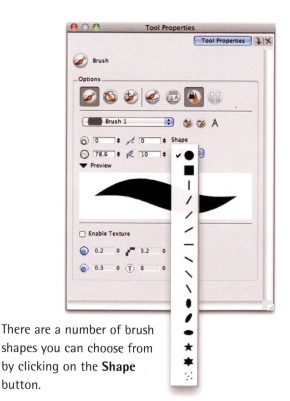

Use the lower slider to adjust how thick your brush strokes will be. These settings are applied when using **Animate Pro** with a pressure sensitive graphics tablet.

There are a number of brush shapes you can choose from by clicking on the **Shape** button.

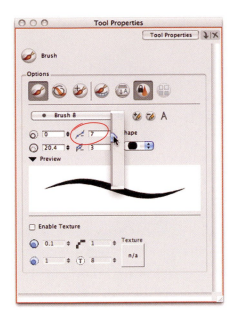

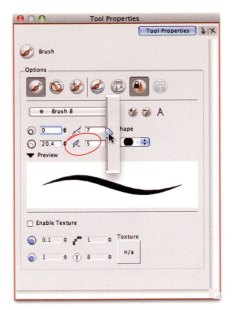

You can control the amount of smoothing applied to each brush stroke using the **Smoothness** setting.

Contour Optimization controls the number of vector points along the perimeter of the drawn shape.

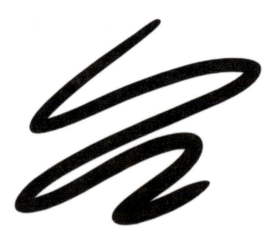

The brush **Tool Properties** panel includes a number of brush presets you can choose from by clicking on the **Brush** icon in the **Options** window.

The **Repaint** brush limits each stroke within the confines of another drawn shape. Many interesting effects can be achieved easily with this brush.

iStockphoto Audio

The choice to add sound is not often an easy one. Depending on your needs, creating sound effects or a musical soundtrack for your animation can be complicated and expensive. Depending on your intended production value, creating your own custom sounds requires a quality condenser microphone, a hardware interface to bridge the microphone to your computer's sound card and audio editing software. In some of my past writings I've documented the hardware and software needs to turn your animation studio into a sound booth, but let's face facts: not everyone has hundreds of dollars to spend on the tools necessary to record and edit their own soundtracks. Even if you did, composing, recording, editing and mixing sounds can take a long time - often longer than the animation itself. Consider adding **iStockphoto** to your arsenal of tools. You may already be familiar with **iStockphoto**'s vast image library and since 2008 they have been a useful source of royalty-free audio of all kinds, sound effects, musical styles, ambience, holiday, cartoon and user uploaded content. It is hard to say just how many audio files are available but my guess is it is in the tens of thousands, if not hundreds of thousands. You can find pretty much any kind of sound effect and background music for your animation needs. For this project I created a list of sounds needed: an ambient swamp sound to set the scene, a buzzing sound for the fly, a swooshing sound for the frog's tongue and a smacking sound for when the tongue hits the frog. Once you know what audio you want, go to **istockphoto.com**, create an account or sign in if you already have one, select the **Audio** category and type in some keywords. For the ambient sound I searched for *swamp* and received 63 audio samples to choose from.

A search for *fly* sent back 55 samples, *swoosh* had 199 samples and *smack* returned 243 samples. You can preview each sample before deciding which sound is the most appropriate for your animation. Download each zipped sound file, save them to a folder and unpackage them. The file format for most **iStockphoto** audio files is **44.1 kHz stereo WAV** format. The **WAV** file format is typically uncompressed and is suitable for editing if you have an audio editing program.

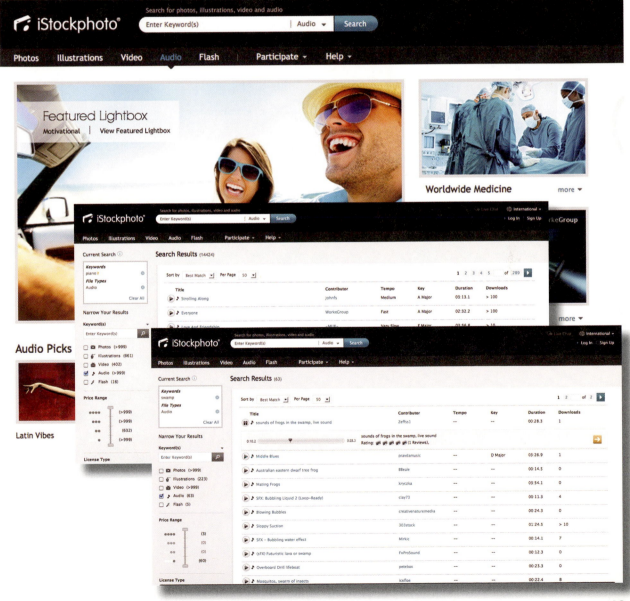

Audio from **iStockphoto** is not free, but depending on your needs, it is an affordable alternative for adding music and sound effects to your projects. The **iStockphoto** economy uses a credit system. To purchase images or audio you need to buy **iStockphoto** credits. The value of the image or audio file depends on its complexity, size and the collection it belongs to. The transaction is made when you download the file of your choice.

iStockPhoto offers three types of plans to choose from;

	Pay-as-you-go	Subscriptions	Corporate Accounts
What do you want?	Buy credits the way you always have. **Buy credits**	Buy yourself credits in bulk and save. **Subscribe**	Buy your team bulk credits and save. **Apply**
Credits as low as	95¢ USD/credit	24¢ USD/credit	29¢ USD/credit
Credits last	One year	Choose a daily credit limit (credits expire daily at midnight MST)	Choose a daily credit limit (credits expire daily at midnight MST)
How do you use credits?	On an as-needed basis	Daily or regularly for ongoing projects	Your team needs a daily supply of credits
Perks of the plan	Low cost, flexibility and freedom to use credits whenever you want	Fixed costs, daily credit supply and discounts on bulk purchases	Save on bulk credits and give your team Sub-Accounts

Personally, I find the 'pay-as-I-go' pricing model fine for most of my needs. You may also unless you have a relatively large project with a budget for several sound effects or music.

Many of us are not capable of scoring complex soundtracks and don't have the budget to hire the necessary talent to compose and record it for us. When you compare the cost of purchasing **iStockphoto** credits and purchasing all the hardware and software necessary to set up your own personal sound studio, the difference can be significant. Of course there's no denying the flexibility that comes with the ability to record and edit your own sounds, but most of us are simply not trained in the art of creating effects from scratch. If your project requires images or audio, **iStockphoto** or an alternative royalty-free library can provide an invaluable resource to animators.

For my frog animation I wanted a background ambient soundtrack and decided a swamp environment would work best. Using **iStockphoto**'s search engine and the keyword *swamp* I was quickly able to find a large variety of swamp sounds to preview.

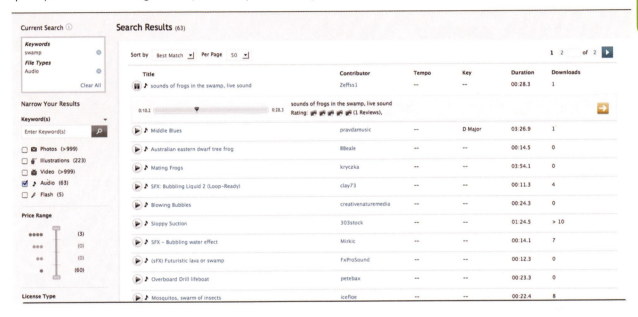

To preview a sound just click the play button next to each audio title. To see a detailed view of the audio track, click on the name of the file. Each file has its own page containing information based on sample rate, file size, channels, credit amount, contributor, length, number of downloads and more. Audio files are also rated and reviewed by the **iStockphoto** community.

Once your **iStockphoto** sound files have completely downloaded, copy or move them from your computer's download folder to a folder within your project directory.

Working with Sound

After downloading and unpackaging my sound from **iStockphoto.com**, I imported it into **Animate Pro** by navigating to **File > Import > Sound**. **Animate Pro** will automatically create a new sound layer and place each sound on this layer as part of the import process.

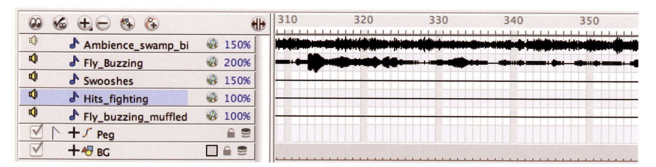

Here's what the timeline looks like after I imported all of my sound files. As you can see, the new sound layers are indicated by a musical note icon to the left of the layer name which has conveniently adopted the sound file name during the import process.

There are a few sound options conveniently built in to the sound layer itself. Toggle the sound of any layer on or off by clicking the yellow speaker icon.

🔇	♪ Ambience_swamp_bi	🌐	100%
🔈	♪ Fly_Buzzing	🌐	100%
🔊	♪ Swooshes	🌐	100%
🔉	♪ Hits_fighting	🌐	100%
🔉	♪ Fly_buzzing_muffled	🌐	100%

Control the size of the waveform using the slider button. Simply click and drag horizontally to adjust the size of the waveform using incremental values.

🔊	♪ Ambience_swamp_bi	↔	150%
🔉	♪ Fly_Buzzing	🌐	100%
🔉	♪ Swooshes	🌐	100%
🔉	♪ Hits_fighting	🌐	100%
🔉	♪ Fly_buzzing_muffled	🌐	100%

If you want more control over the size of your waveform, type in a custom value using the input field. Just click on the default value of **100%** and type your desired percentage value.

🔉	♪ Ambience_swamp_bi	🌐	300
🔉	♪ Fly_Buzzing	🌐	100%
🔉	♪ Swooshes	🌐	100%
🔉	♪ Hits_fighting	🌐	100%
🔉	♪ Fly_buzzing_muffled	🌐	100%

The **Playback** toolbar not only provides the tools necessary to play back your animation but it also controls how you work with the sound in your timeline.

To hear sound on playback, depress the **Sound** icon.

To hear sound while scrubbing the timeline (manually moving the play head back and forth), depress the **Scrubbing** icon.

While **Animate Pro** doesn't specialize in audio editing, it does offer a tools for editing audio directly within the application. To edit sound in **Animate** you need to launch the **Sound Element Editor**. Double-click on a sound layer or...

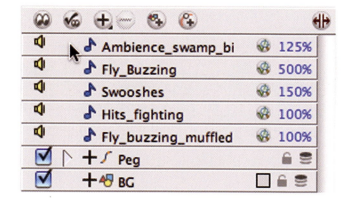

...click on the **Sound Editor** button in the **Layer Properties** panel.

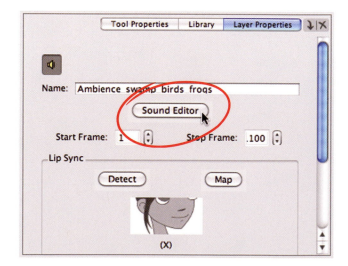

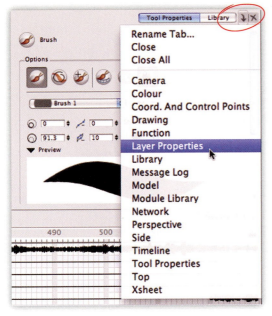

If the **Layer Properties** panel is not visible within your current work space, click on the little downward-pointing arrow in the upper right corner of any panel and select **Layer Properties**.

The **Sound Element** window displays the waveform of the actual sound file. Click inside this window to display the current sound file in the **Current Sound** window.

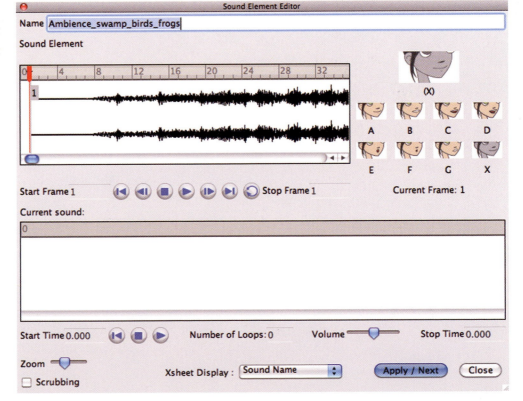

This is the Current Sound window and is where most of the audio editing is done and what the waveform in the timeline references.

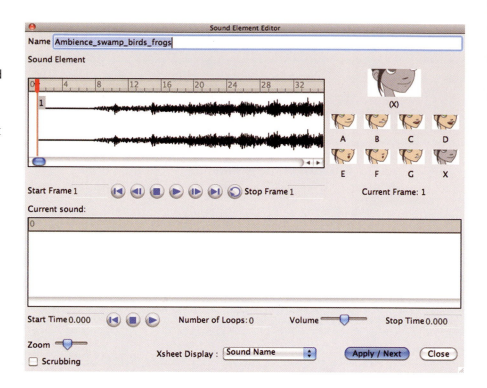

In this screenshot I have selected the waveform in the Sound Element window. I can now see and edit the same waveform in the Current Sound window. Note the small green flags (circled) with the number '1' on them. These flags work like markers and can be dragged to the frame you want the sound to start on. There are flag markers at the end of the waveform that are used to determine on which frame you want the sound to stop playing.

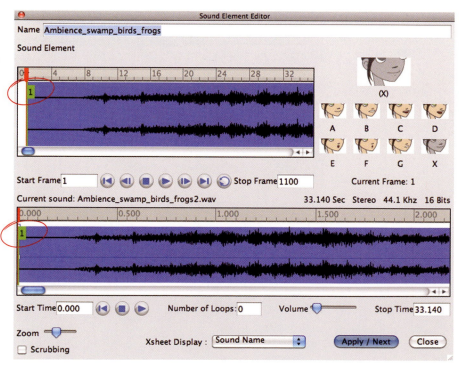

Here I have dragged the flag marker so that the sound starts a few frames into the waveform. I lowered the volume of the entire audio file using the **Volume** slider because this sound is the ambient swamp sound and it should be just barely noticeable to set the mood for the scene.

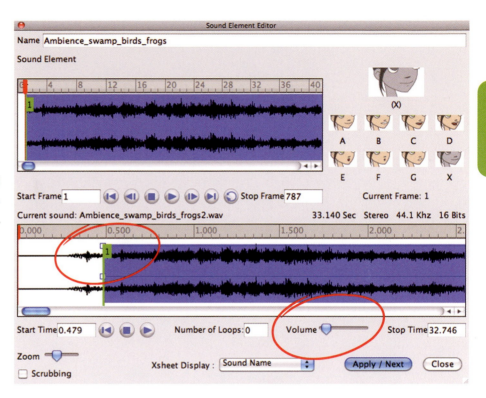

I faded in the sound by clicking in the waveform window to add the white boxes circled below. These white boxes act like keyframes for the audio file. There are two sets of white boxes because the sound file is in stereo. I dragged the first set of boxes as far down as they could go which creates a fade-in effect on playback.

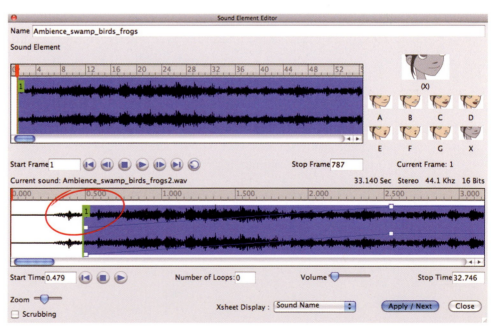

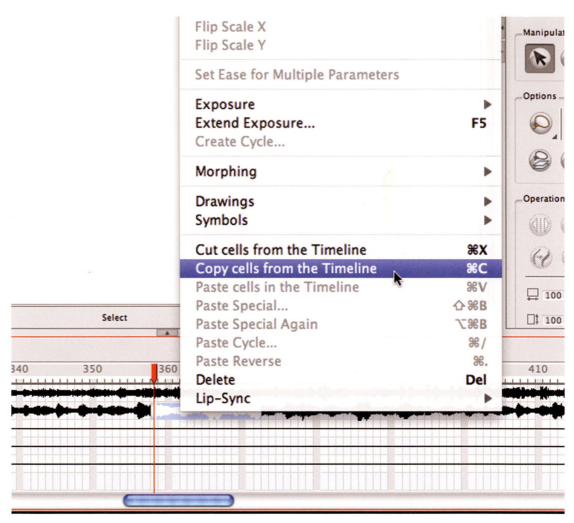

One of my favorite features is the ability to copy and paste a range of cells in a sound layer. Some areas of the fly buzzing sound file didn't match the animated flight of the fly as well as I would have liked. I could have gone back to the source and used an audio editor such as Adobe Audition to make my edits, but I found it easier and faster to make the edits in the **Animate Pro** timeline. By scrubbing the timeline I could determine where I wanted to make my edits. By clicking and dragging across a span of cells, I was able to copy them by right-clicking over the selected range of cells and selecting **Copy cells from the Timeline** from the contextual menu.

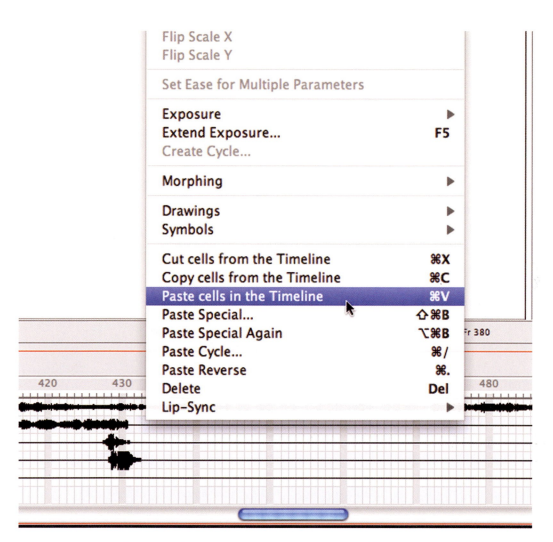

Flip Scale X
Flip Scale Y

Set Ease for Multiple Parameters

Exposure ▶
Extend Exposure... F5
Create Cycle...

Morphing ▶

Drawings ▶
Symbols ▶

Cut cells from the Timeline ⌘X
Copy cells from the Timeline ⌘C
Paste cells in the Timeline ⌘V
Paste Special... ⇧⌘B
Paste Special Again ⌥⌘B
Paste Cycle... ⌘/
Paste Reverse ⌘.
Delete Del
Lip-Sync ▶

Select a different cell or range of cells, right-click over them and select
Paste cells in the Timeline from the contextual menu. The pasted cells
overwrite the existing cells and the audio data they contain. Copying and
pasting cells does not edit the original source file, only the instance of the
audio in the **Animate Pro** timeline.

Once all my sounds are added and the animation finished, it's time to
export the animation for the world to see.

Exporting

One of the shifts in the industry is how we are getting our animation to the world. For over a decade I relied on the **Flash** authoring tool

and **Flash Player** plugin to author my content, publish it and play it within a browser. The **Flash Player** plugin is the most downloaded browser plugin in internet history with a penetration rate of around 98 percent worldwide. The published SWF files are small and can be quickly streamed to any desktop computer across all browsers. As an animator, getting my work to my audience was easy.

On January 9, 2007, Steve Jobs announced the iPhone. That was the day things started to change. The iPhone and iPad do not support the **Flash Player**. At first it wasn't a big deal, but the iPhone gained popularity at a rapid pace. As of this writing we are in the fifth generation of the iPhone and the third generation of the iPad. Both are arguably the most popular and widely used mobile devices on the planet and suddenly I find myself realizing my SWFs are reaching a diminishing audience. It is time to adapt. Most of my work is now exported to video and uploaded to **YouTube** and **Vimeo**. This delivery insures audiences on all platforms and devices can watch my animation. Exporting and uploading is a pretty straightforward process but there are some details not to be overlooked. **Compression** settings, frame rates, data rates, key frames, frame reordering, encoding settings, these are most of the options you will need to address when exporting to video format.

The export settings recommended by You Tube

Video

Compression type: **H.264**

Frame rate: **30 is preferred. 23.98, 24, 25, 29.97 are also acceptable.**

Datarate: **Automatic**

Key frames: **Automatic**

Frame reordering: **Unchecked**

Audio

Codec: **ACC**

Data rate: **Up to 320 kbps**

Sample rate: **44.1kHz is the highest supported sample rate.**

The export settings recommended by *vimeo*

Video

Compression Type: **H.264**

Frame rate: **30, 24 or 25**

Data rate: **2000 kbps (Standard Definition), 5000 kbps (High Definition)**

Resolution: **640 x 480 (4:3 SD), 640 x 360 (16:9 SD), 1280 x 720 (HD) or 1920 x 1080 (HD)**

Frame reordering: **Unchecked**

Audio

Codec: **ACC**

Data rate: **320 kbps**

Sample rate: **44.1kHz is the highest supported sample rate.**

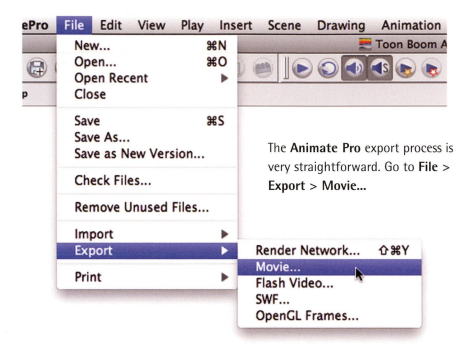

The **Animate Pro** export process is very straightforward. Go to **File** > **Export** > **Movie...**

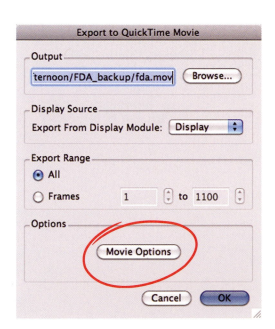

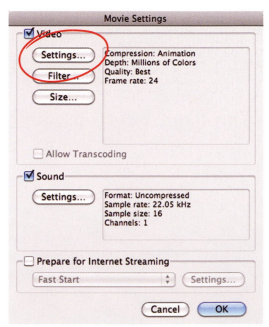

In the **Export to QuickTime Movie** panel, click on the **Movie Options** button to change the movie compression settings.

In the **Movie Settings** panel click the **Settings** button to change the compression type.

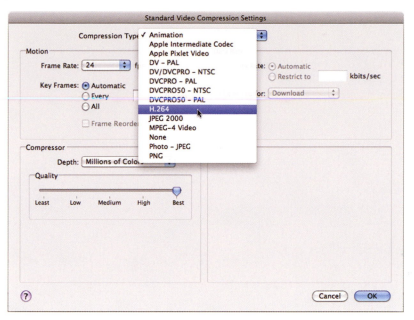

Select **H.264** from the **Compression Type** drop-down menu. **H.264** is a standard compression type and widely used for streaming video on the Internet, such as via **YouTube** and **Vimeo**.

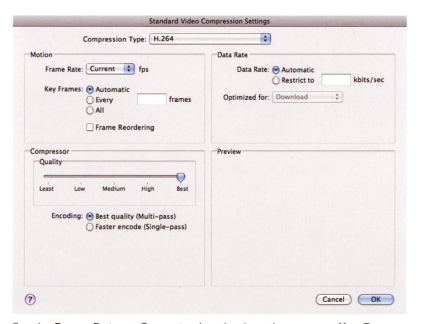

Set the **Frame Rate** to **Current** using the drop-down menu. **Key Frames** should be set to **Automatic** and compression quality to your preference: I like **Best** with multi-pass encoding. **Data Rate** can be set to **Automatic** unless a specific kbit/sec rate is required. Click **OK**.

My movie settings look like this:

Video

Compression: **H.264**
Quality: **Best**
Encoding mode: **Multi-pass**
Filter: **None**
Size: **Current**

Sound

Format: **Uncompressed**
Sample rate: **22.05 kHz** *
Sample size: **16**
Channels: **1**

I find these settings produce the best results at reasonable file sizes. Click **OK**.

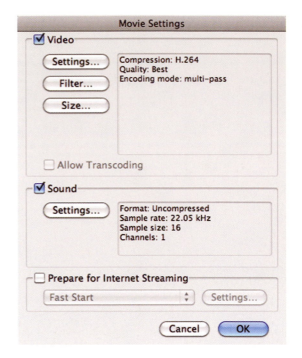

Animate Pro provides a status dialog during the export process. At any time you can stop or pause the export if necessary.

A few minutes later my video is complete and I have a conveniently packaged **MOV** file ready for upload. If you don't already have a **YouTube** or **Vimeo** account, it's free and easy to sign up for one. Once you've signed in, just click the upload button and navigate to the MOV file you just exported. Both **YouTube** and **Vimeo** have wizard-like interfaces for uploading video files allowing very little room for error.

*The audio sample rate should match the sample rate of the source file, typically 22.05 or 44.1 kHz.

Once your video has been processed and is ready for viewing, it can be shared easily across a wide variety of platforms, devices and social networks. **YouTube** and **Vimeo** offer the embed code for quick and easy embedding of the video in your website, blog or social network.

uploading to the internet

When you go to the **YouTube** page containing your video, click the **Embed** button. A drop-down will appear containing the code necessary to embed your video in your website. You can customize what happens after your video has finished playing as well as choose the size of the video display from the four presets or enter your own custom width and height.

Embed this video

NEW! This is our new embed code which supports iPad, iPhone, Flash and beyond. Don't like change? Use the old embed code instead.

Get the embed code

```
<iframe src="http://player.vimeo.com/video/28387539?
title=0&byline=0&portrait=0" width="530" height="398"
frameborder="0" webkitAllowFullScreen mozallowfullscreen
allowFullScreen></iframe>
```

Preview the embedded video

When you go to the **Vimeo** page containing your video, click the **Embed** button. A pop-up window will appear containing the code necessary to embed your video in your website. **Vimeo** provides a convenient preview image of your video and options to further customize your embed code. You can edit the width and height, the color scheme and how much intro information is included. Other options include how the video behaves when someone visits the page.

This preview has been restricted to 400 pixels wide; when you embed this video, it will be 530 pixels wide.
Did you know you can customize the embed settings for this video?

▸ **Customize embed options**

▾ **Hide options**

Size: 530 × 398 pixels

Color: Select... ▾ Or 00adef

Intro: ☐ Portrait ☐ Title ☐ Byline

Other: ☐ Autoplay this video.
☐ Loop this video.
☐ Show text link below video.
☐ Show video description below video.

Restore default options?

On **Facebook**, click **Update Status** and simply paste the embed code in the input field. **Facebook** will update the post with a thumbnail image of the video and the description used from **YouTube** or **Vimeo**. I find **Facebook** to be a great platform to get my work seen and commented on. If your animation has the potential to go viral, it will likely obtain its popularity on a social network such as **Facebook** or **Google+**.

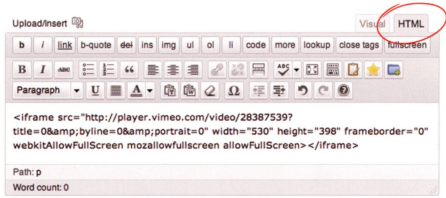

If you are a blogger and use **Wordpress**, embedding your **YouTube** or **Vimeo** hosted video is just as easy. Login to your **Wordpress** dashboard and click on the '**Add New Post**' link. Make sure to select the **HTML** tab to switch from **Visual to HTML**. The code you are pasting takes care of all the instructions needed to properly display your video. This is all you need to do to embed video in your blog. You can add your own text before or after the embed code based on whether you want your comments to be above or below the video.

Stream

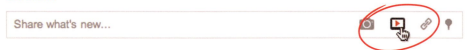

Google**+** is another great platform for sharing your content. The process of embedding video here is different from other social networks and requires a couple of extra steps. To begin, click the **Add Video** button in the share field.

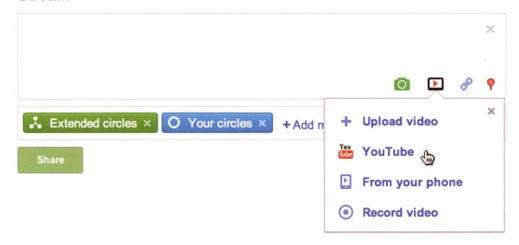

From the drop-down menu, select the **YouTube** option if your video is already uploaded to your **YouTube** channel. In the next screen (below), click the **Your YouTube videos** link from the menu on the left.

Google+ will display a list of all the videos in your **YouTube** channel. The list will include thumbnails as well as the title, description (if any), rating and upload date.

Rocker Chick
Animation test for a game called Rock FREE by Acclaim Games. RockFREE was a browser-based game running on the Flash platform. The game engine was eventually passed on to Slide who developed/published it under the name "Rock Riot". The game lasted a few months on Facebook but was ultimately killed off by Acclaim due to lack of return on investment.
★★★★★ 40 sec - Dec 26, 2011

Frog Day Afternoon
Animation test for an upcoming book title.
★★★★★ 22 sec - Oct 2, 2011

Happy Holidays 2010
Once again, down to the wire, but it is done: the 2010 Georgenes holiday animation starring Andrea, Billy and Bobby YouTube version. Happy holidays everyone!
★★★★★ 3 min - Feb 4, 2012

Luci Takes her Medicine
Big Pink developed the 'Hold my Hand' campaign including a website where carers can 'Connect with others' to support parents and carers through treatment. For patients we created a character called 'Modi-giraffe' who interacts with 'Lucy' to make the materials appealing to young children and show how taking your medicine will make you 'grow up big and strong' just like Modi-giraffe. If you are familiar with my work (www.mudbubble.com) you may recognize my "Andrea" character from my holiday animations. Big Pink requested this same character to be used for this campaign and I was excited to oblige :) This was a very rewarding project for me because it sends a heartfelt message to children who have

Cancel Add video

Rocker Chick
Animation test for a game called Rock FREE by Acclaim Games. RockFREE was a browser-based game running on the Flash platform. The game engine was eventually passed on to Slide who developed/published it under the name "Rock Riot". The game lasted a few months on Facebook but was ultimately killed off by Acclaim due to lack of return on investment.
★★★★★ 40 sec - Dec 26, 2011

Select the video of your choice and click the **Add video** button in the lower right corner.

Happy Holidays 2010
Once again, down to the wire, but it is done: the 2010 Georgenes holiday animation starring Andrea, Billy and Bobby YouTube version. Happy holidays everyone!
★★★★★ 3 min - Feb 4, 2012

Cancel Add video

Your video is now shared thanks to **Google+**. You can choose to share your masterpiece with all of your extended circles or a select few.

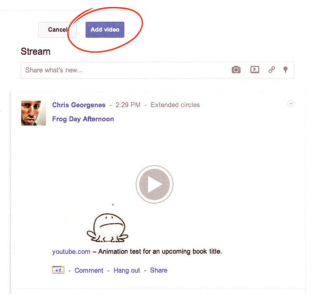

Project 2

The Annual Holiday Animations

I can never predict what the family holiday animation will be about. It's never really planned in detail. There is never a script written or even a storyboard drawn. The process is organic, spontaneous, and at times completely unexpected. But this is precisely what these animations are all about: capturing that special moment that only kids can create because they are kids. They haven't been trained to think a certain way or write with any formulated structure. Their job as children is to act silly and my job is to capture that silliness and bring it to life in animated form.

Apple OS X Functions

There are frequently used keyboard shortcuts in **Flash**, Photoshop and other programs that won't work because **OS X** reserves them for system functions. The keys that are reserved happen to be the most used shortcuts in my **Flash** workflow, the **F5**, **F6** and **F7** keys. Thankfully there's a way to reclaim these function keys to work within **Flash** and other programs.

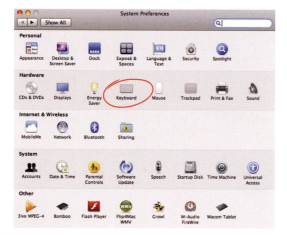

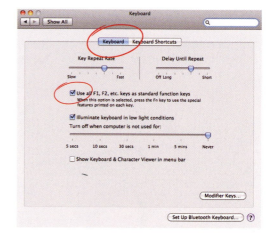

Open your **System Preferences** and locate the **Keyboard** icon in the **Hardware** category.

Make sure the **Keyboard** tab is selected and check the box that allows the use of **F1**, **F2**, etc. keys as standard function keys.

Now those **F1**, **F2**, etc. keys will work as intended inside **Flash** and Photoshop and other programs that have them reserved for specific functions. You will still be able to use these specialty keys across **OS X** by holding down the Fn (function) key. This requires using two hands to hold down two different keys but at least you have the choice of how your function keys operate.

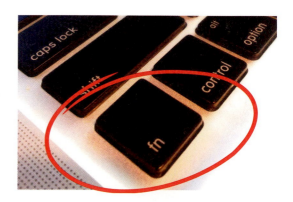

Flash Extensions

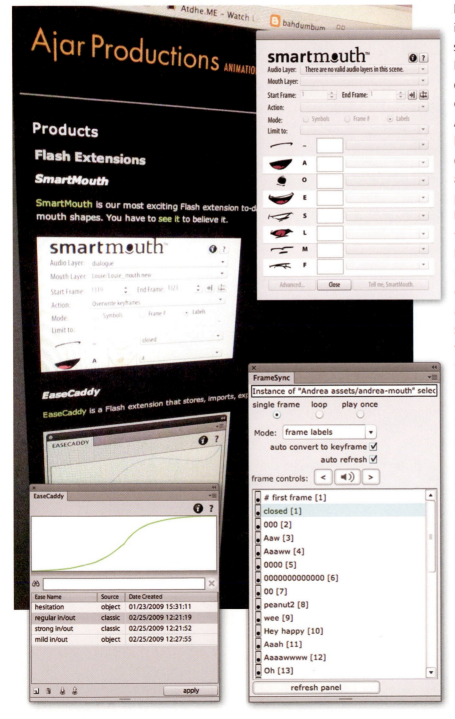

In recent years I have become increasingly dependent on several great **Flash extensions**. My favorites have all been developed by the same company, **Ajar Productions**. Ajar is the brain-child of Justin Putney and AJ Peterson. What do you get when you combine an animator and a programmer into one single brain? You get cool **extensions** for **Flash**. Justin can exercise both sides of his brain giving him the advantage of knowing exactly what animators need and where **Flash** sometimes falls short. Throughout this project you'll see demonstrations of how these extensions work and how I apply them to my workflow. If you are interested in down-loading them for yourself, visit **ajarproductions.com** and then click on Products. For a full list of **Flash** extensions go to **ajarproductions.com/blog/flash-extensions** (Justin has over 30 of them!).

73

inspiration

If you are lucky, inspiration can drop right in your lap. For me this could not have been more literal. My daughter Andrea had just turned two years old. She was quite precocious at an early age, with a confident command of the English language and a newfound singing voice. On one particular day she wandered into my home office to show off a new song that she had learned: **Twinkle Twinkle Little Star**, a popular English nursery rhyme from the early 19th century. Andrea asked to sit up on my lap and as usual I obliged. Being at my desk with my computer in front of us and my little plastic **USB** microphone at the ready, I discreetly clicked record and began capturing her entire performance in digital format.

Andrea was unaware she was being recorded. Her performance was completely natural and not without the human imperfections of a two-year old trying to perform to a level beyond her years. The recording captured all of her hits as well as misses. It was evident that she had not learned all the words to the song as she fumbled her way through the performance but that is precisely what made this recording special: it was real on a human level.

I saved the audio file to my hard drive and went about the rest of my day. It wasn't until seven months later that I would resurrect this audio file for the purpose of using it as the soundtrack to an animation. Since it was the holidays, we tried to take a family photo to send to family and friends as our holiday card. Our efforts were thwarted by our five-year old who was expressing his disdain for being photographed in an emotionally unstable manner. Combined with the dog not posing 'correctly' and various other photographic mishaps, we were unable to get that perfect family shot. Two weeks before Christmas and we had nothing to send to anyone.

I'm an optimist at heart and knowing every problem has a solution, I turned to software for help. I thought maybe I could use Photoshop to edit the best of each of us from all the photos and combine them into one single, perfect family picture. Then I thought of importing the photo into **Flash** and adding some animation, possibly some snow falling and maybe even some Christmas music. Then it hit me! The audio of Andrea singing Twinkle Twinkle Little Star would be perfect to use as a soundtrack to a holiday card. I should also mention that Andrea and I would spend time together drawing and each time I would ask her what she would like me to draw. Her response was always the same: 'Draw me, Daddy!' Using crayons, colored pencils, felt pens and various markers, I had drawn a large number of Andrea characters. Eventually I perfected my daughter as a cartoon character.

At this point I realized:
- I have a recording of Andrea singing.
- I have Andrea designed as a cartoon character.
- I know how to animate in Adobe **Flash**.

I had all the ingredients to make an animated holiday card. All I needed now was a concept. Having done enough work for clients in the world of advertising, I knew that the most successful creative campaigns were the ones with the best concepts. I listened again to the recording of Andrea singing and noticed that she made several mistakes during her performance. The idea of pretending she was performing in an audition on a stage was an easy one to come up with. The rest just fell into place. This was one of those animations that miraculously created itself. It was inspired.

Once I finished the animation and uploaded it to my website, I sent the URL to family, friends and clients as our holiday 'card'. The response was overwhelmingly positive. About a year later I received an email from someone in Australia with the link to my animation. '*I love this and I hope that you will like this to*.' was the body of the message. This was the first time I had created something viral. A complete stranger sending me my own work. It's something I'll never forget.

The annual Georgenes holiday animation was born.

Recording

Somehow with each year I have managed to strike gold of some kind or another during the recording process. One or more of the kids has always invented something completely unexpected and remarkably funny all on their own. In the beginning, when I click the record button for the first time, they become too self-aware and almost everything sounds forced. This is completely normal and necessary to get the first few attempts over and done with so they can get the awkwardness out of their systems. Once they have become desensitized to the idea of the microphone recording everything, they almost forget it is there and act like themselves, in the moment and without inhibitions.

My only job, aside from the technical and spiritual support, is to keep them focused. I play the role of Director and walk the fragile line between their father, mentor and referee. I spend most of my energy listening and guiding them towards something that will hopefully provide for an entertaining animated short.

Once again the kids came through this year but not without a slow and uninspired start during the recording. I started them off by asking what Christmas meant to them. Their responses were, for the most part, predictable and lacking anything too memorable.

Spontaneously Bobby placed both hands over his mouth and began creating rhythmic beats using his voice - a common technique referred to as 'beatboxing'. Billy quickly reacted by rapping a phrase off the top of his head; "Yo my name is Santa and I'm wrappin' them presents...". For something so spontaneous and improvised, it sounded surprisingly good - as if they had rehearsed it. It was a moment where something between them clicked and the essence of this year's holiday animation was born.

It's an interesting exercise to record children. Every time I prepare a written script and explain to them how I want them to act the part, the end result always comes across as sounding forced. If I've learned one thing, it's to turn the microphone on, gently nudge them in a creative direction and then let them improvise they way only children know how. It's certainly a risky process for me but so far I've managed to come away with something memorable and worthy of animating.

Every year I say the same thing: 'I'm not going to wait until three weeks before Christmas to start this year's holiday animation.' But every year, for various reasons I can never remember, I find myself starting with three weeks or less to finish the entire project.

Adobe Audition

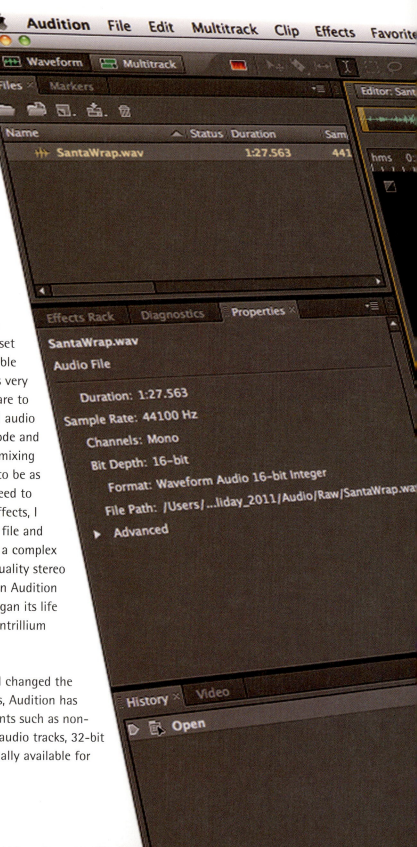

I'm a huge fan of **Adobe Audition**. But I must admit, I don't know much about audio from a technical standpoint. I probably use about 30 percent of what Audition is capable of when it comes to audio editing. What little I do know goes a long way thanks to Audition's rich feature set and intuitive interface. Audition is compatible with the **FireWire Solo** unit and it requires very little effort to get the hardware and software to play nicely together. I can record individual audio files and then switch over to Multitrack mode and turn my **MacBook Pro** into a feature-rich mixing studio. Just like **Flash**, Audition allows me to be as simple or as complex as I want to be. If I need to record a couple of quick and dirty sound effects, I just connect the microphone, create a new file and press the record button. If I want to create a complex multitrack sequence to be used as a high quality stereo soundtrack for a big animation project, then Audition can handle that as well. Adobe Audition began its life as Cool Edit Pro, developed originally by Syntrillium Software.

Adobe purchased Cool Edit Pro in 2003 and changed the name to Adobe Audition. Through the years, Audition has seen several enhancements and improvements such as non-destructive effects, support for 128 digital audio tracks, 32-bit resolution and as of version 4 (**CS5.5**) is finally available for the Mac platform as well as Windows.

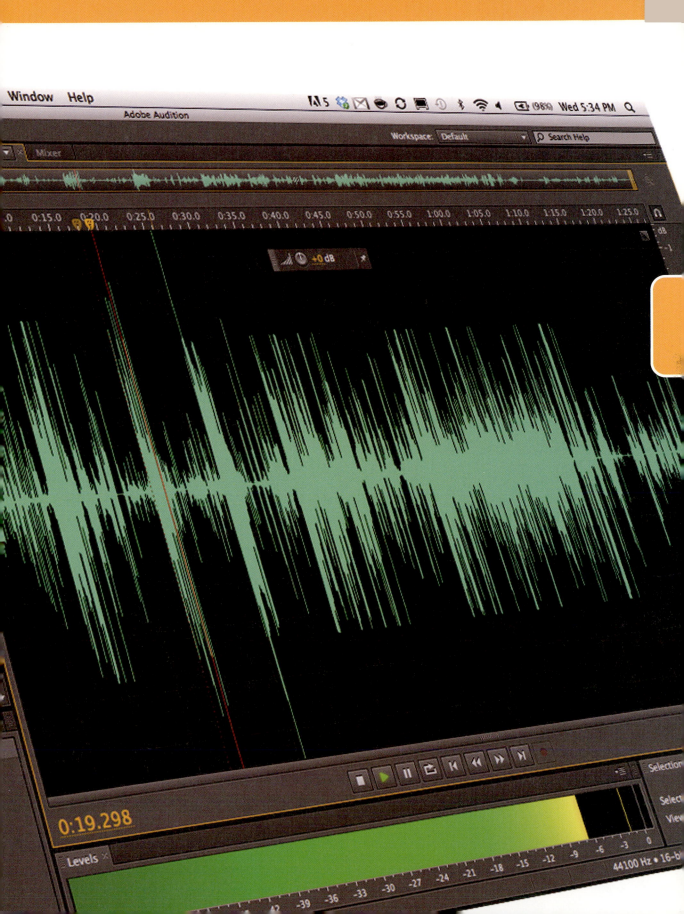

There's nothing worse than recording that special moment, only to find the input levels were too high and the end result is ruined by distortion, clipping and popping. It's critical to test your input levels until you eliminate any and all distortion. Using Adobe Audition I can monitor the input levels in real time and make adjustments on the fly. With my **M-Audio FireWire Solo** interface, I can adjust the input level using the Gain knob on the front panel of the unit.

This is what you want to avoid - the input level is clearly too high. This is commonly referred to as the signal being too 'hot' or as 'clipping'. When this happens, your recording will be ruined.

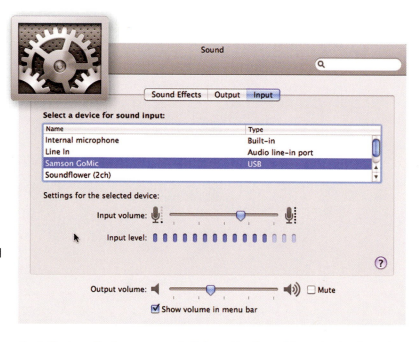

When using the **M-Audio FireWire Solo**, the input level is controlled using the gain knob. If you are using a USB microphone, the input level is controlled by the operating system. **OS X** users need to open their **System Preferences** and click on the **Sound** icon. In the **Sound** panel click on **Input** and then select your recording device. Adjust your input volume using the slider. Windows users can find the input volume controls from the **Windows Control Panel**.

Now this is more like it. During testing, base your level on the loudest possible sound you will be recording to help prevent any distortion. I'd rather have an overall volume level that is too low than too high because the volume can always be increased later using software.

Audio Editing

I now have several long audio files of my kids' performances. I already know most of it will end up not being used. The portion I will use I'll edit down to about one minute in duration. I always try to limit my annual holiday animations to one minute for a few reasons:

1 Due to procrastination during the year, I end up starting the animation too close to the holiday season, thereby giving myself an almost impossibly short time to create it. The longer the audio, the longer the animation, the more lip-syncing and ultimately the less sleep I get.

2 The attention span of anyone watching it tends to peak around the one minute marker. Anything longer than that will likely become too much of a chore to watch unless it's something really amazing.

3 It can take a while to edit audio. The longer the audio soundtrack, the more editing. I try to focus on the high points of the performance and edit out what is redundant or simply not entertaining enough.

Short and sweet is the mantra here. With approximately two weeks to go before Christmas, I am not going to shoot myself in the foot by editing together a two to three minute audio soundtrack and then attempting to animate something to it. It's too much work in too little time. Let's not forget I have a full-time day job that forces me to animate at night, usually after the kids have gone to bed and the house is quiet. I also prefer to present the animation to the world before companies close their businesses and send their employees home. One year I didn't finish the animation until late Christmas eve. Most of my friends didn't see it until well after the new year in January when they went back to work and checked their email. By then the animation had lost some of its charm.

Now that I have my raw audio, it's time to enter editing mode and create the final soundtrack that will become the foundation for this year's holiday animation.

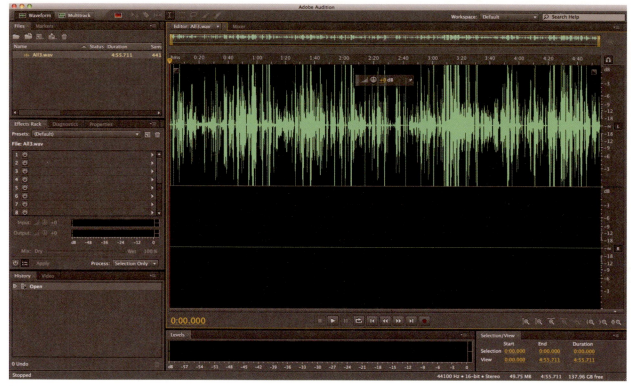

The duration of the unedited audio file is just under five minutes. This is too long for my needs and I know most of it can be edited out. Before I make my first edit though, I need to become familiar with where in the audio the key moments are that I want to keep. This requires listening to the audio from start to finish a few times over.

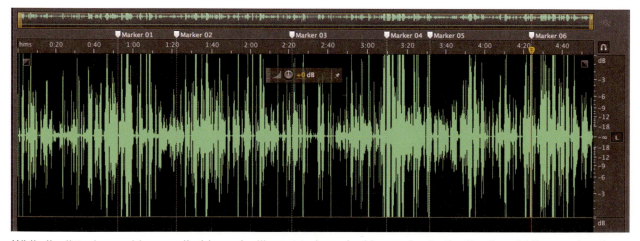

While I'm listening, as I hear audio I know I will want to keep, I add a marker to the timeline. Adding markers is as simple as pressing the 'M' key. A marker is added wherever the play head is at the time the key is pressed. As you can see, markers are indicated by marker flags above the wave form and are named sequentially by default.

The Markers panel auto-populates your markers in a list format. This panel has several features but my favorite is the ability to double-click a marker symbol (circled) to quickly snap the play head to that exact marker in the waveform.

Another useful feature of the Markers panel is the option to rename each marker. To rename a marker, double-click on the marker name to select it. Once selected, type in a new descriptive name that reflects the nature of the audio at this location in the waveform. You

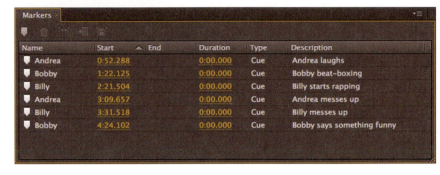

can further define this section of audio by adding a more detailed description in the Description column on the far right side of the panel. Click inside a row in the Description column to highlight it. Once highlighted, type your description.

Use the drop-down menu to select Markers Display and customize the Markers Display panel to suit your needs.

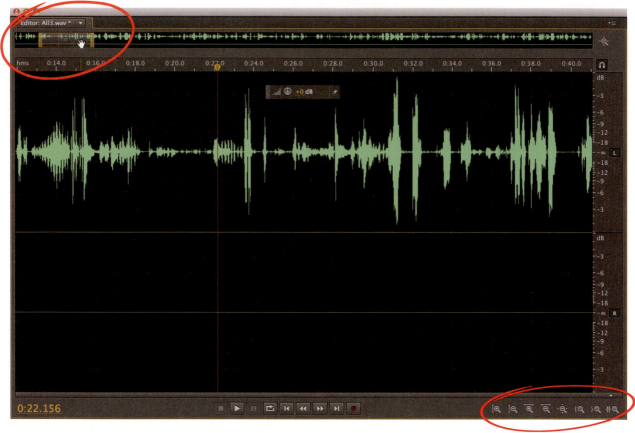

Editing audio is easier when you are zoomed in to the waveform. There a couple
of ways to do this in Audition. My favorite way to navigate the waveform is by using what is called the **zoom navigator** (circled in upper left corner). The navigator is a multifunctional tool that provides a quick and easy way to control the waveform display in the Editor panel. Click and drag either side of the navigator to scale the waveform. Click and drag the navigator to select the desired waveform range. The alternate method of controlling the size of the waveform in the Editor panel is to use the Zoom tools represented by the magnify lens icons in the lower right corner.

It's always good practice to save two versions of your audio file. Both files can be saved in **WAV** or AIF format. One version is kept as the unedited version or what I refer to as the 'raw' file. This will serve as our backup file. Save it again but with a new name to create a copy of the file. I like to append 'edit' to the name as this will be the file I edit.

holiday_2011_raw.wav

holiday_2011_edit.wav

Once I've determined the areas of the audio I want to keep using markers, it's time to remove what I do not want in my final audio. This is a relatively straightforward process of listening to the audio and finding the areas to delete. To delete audio in Adobe Audition, click and drag the section of audio in the Editor panel to highlight it, right-click within the highlighted area and select Delete. It's even easier to press the Delete key on your keyboard.

At this stage my goal is to edit the audio down to about 60 seconds. With my file being nearly five minutes in length, I need to be very liberal with the Delete key. Having much more audio than needed is always good because it's always better to have a hard time deciding what to keep than not having enough good material in the first place. During a ten-day trip to Ecuador and the Galapagos Islands in 2011, I shot over 5,000 photos. I selected the 913 best ones and posted them online to my Flickr account. The most frequent comment from friends was how amazing all my photos were. Once I explained to them that they saw only one-fifth of what I shot, they realized that this was more a case of over-compensating than photographic perfection. I approach recording audio the same way. The more audio captured, the higher the percentage of quality material I'll have to work with.

Unwanted background noises are inevitable with home recordings. There are too many external forces trying to become a part of your audio project. Between the dog barking, three kids, the doorbell, and various noise-emitting household appliances, recording an uninterrupted vocal track can be a test in patience. I have a few tips that I have learned the hard way:

▶ Close all applications that might trigger a sound. Email, instant messaging, various chat applications and anything that sends an audible notification alert should be closed.

▶ Turn off or silence your cell phone. Nothing is worse than the sound of your ringtone during a recording session. You can also bet it will ring right at that perfect moment in the recording performance too.

▶ If possible, record sounds in the evening. You are less likely to be interrupted when everyone else in your house is asleep - including the dogs.

▶ If you can, turn down your thermostats to avoid the furnace from kicking on and shut off air conditioning units.

▶ If possible, turn off any external hard drives and anything that spins, hums or has a fan.

While cardoid microphones are great for blocking out unwanted sounds, it's still difficult to eliminate all interference unless you have the luxury of a professionally soundproofed recording studio. The above waveform shows what ambient room noise looks like. This noise represents the vibrations from an external hard drive located on the same desk surface as the microphone. It's extremely subtle and hard to hear, but it's present in the audio. Good news is, there is a way to reduce this noise if not completely eliminate it using a noise reduction filter.

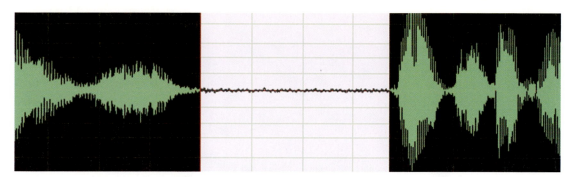

The first step in the noise reduction process is to select a range of audio containing the unwanted noise. It will help to zoom into the wave-form before making your selection.

With the selection made, go to **Effects > Noise Reduction / Restoration > Capture Noise Print** or press **Shift + P**. Capturing a sample of the unwanted noise tells Audition what frequency range you want removed from the file.

Go to **Effects > Noise Reduction / Restoration > Noise Reduction (process)** to open the Noise Reduction panel.

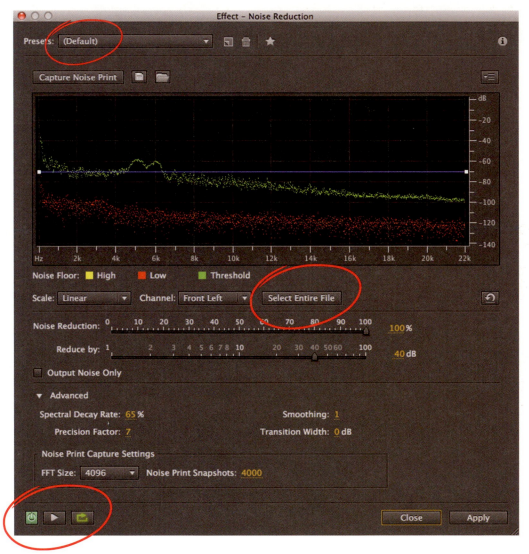

The Noise Reduction panel boasts several features to customize the amount of noise reduction you may want. The default settings do a very good job in general and they're what I use most often. To apply the noise reduction to the entire file, click the **Select Entire File** button. You can adjust the amount of reduction using the sliders or leave them in their default position. To preview the results before applying the filter, click the Play button in the lower left corner of the panel. Once you are satisfied with the amount of noise reduction, click Apply in the lower right corner.

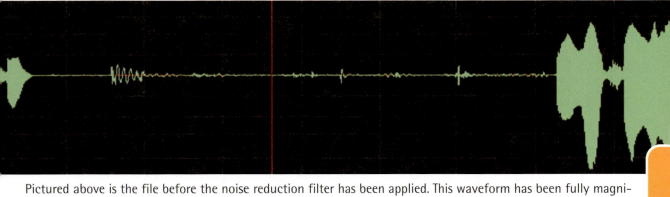

Pictured above is the file before the noise reduction filter has been applied. This waveform has been fully magnified and the noise you see here is barely noticeable unless you listen closely using headphones or high quality speakers. But the noise is discernible enough to warrant its extraction.

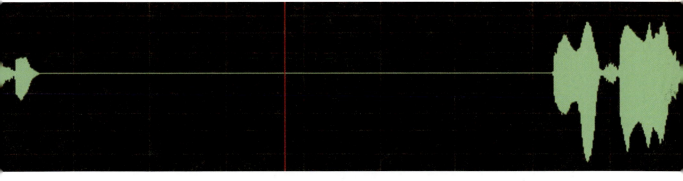

This is the same audio file with the data from the noise profile removed. The unwanted noise is completely gone while the rest of the audio remains untouched by the filter's algorithm. The biggest difference is noticeable during playback of the file. When there is no sound to be played, it is dead silent. This gives the audio a more professional quality.

With the noise removed and a relatively clean-sounding audio file, the next step is to normalize the levels. **Normalize** sets the peak levels to a maximum amplitude. The maximum level is 0 dBFS or decibels relative to full scale. Ideally, normalizing to 0 dBFS is preferred but if you plan on adding effects or any other form of mastering, you'll want to normalize between -3 and -6. Normalizing below 0 dBFS will provide a little head room for added effects later on.

The normalize panel is accessed by going to **Effects > Amplitude and Compression > Normalize (process)**.

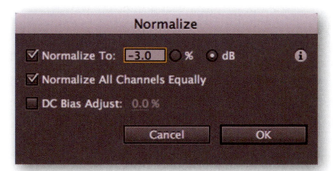

In the **Normalize** panel you can enter the value to normalize using the hot text slider or by typing in an exact value manually. You can also specify normalizing based on a percentage or decibel level.

After the normalization process is complete, play your audio and watch the level meter to verify the maximum signal reaches its target decibel level. As you can see my maximum level is at -3 dBFS leaving me enough room for the next step: mastering.

Open the **Mastering** panel by going to **Effects > Special > Mastering**.

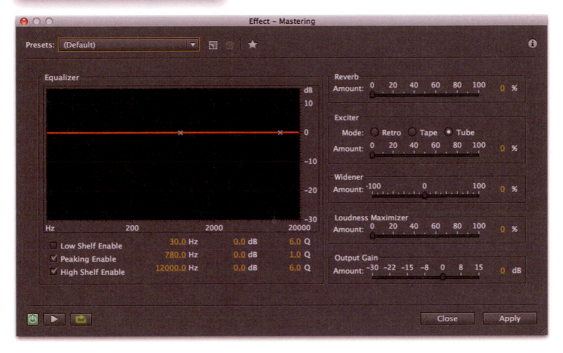

The **Mastering** panel provides adjustment for various settings as well as various presets.

▶ **Reverb** adds ambience to your sound. The more reverb the 'wetter' your sound is, meaning it has a certain amount of decay or echo. A 'dry' sound is without reverb and has a very short or no decay at all.

▶ **Exciter** adds clarity to the higher frequencies. You can apply three different modes as well: Retro adds slight distortion, Tape adds a brighter tone and Tube adds more response.a

▶ **Widener** adjusts the stereo image for stereo files (two channels).

▶ **Loudness Maximizer** has a similar effect to Normalize by limiting the dynamic range of the audio.

▶ **Output Gain** controls the overall volume levels of the audio.

Whether you are new to **Adobe Audition** or a seasoned user, the default presets are not a bad place to start. I personally start with adding **Subtle Clarity** using the presets drop-down menu and then play back the audio to decide if I like what I hear or feel the need to make some adjustments.

You can use the preset as a starting point by customizing the effects further using the sliders. Here I added a little more **Reverb**, **Exciter**, **Widener** and **Loudness Maximizer**.

The **Exciter** setting provides three **Modes**: **Retro**, **Tape** and **Tube**. These settings emulate the analog amplifier sounds. Each mode has its own characteristics and I recommend experimenting until you find the effect with the right characteristics for your needs.

You can save your custom settings as a preset to be applied to other audio files. Click the **New Preset** icon and in the **Save Effect Preset** panel, provide a descriptive name for your preset effect and then click **OK**.

To apply your custom preset, access it from the **Presets** drop-down menu.

(Default)
Bright Hype
Club Master
Dream Sequence
Drum Spreader
Make Room For Vocals
Mid Enhancer
My Master Preset
Reducer
Stereo to Mono
Subtle Clarity
Warm Concert Hall

multitrack Editing

The **Multitrack Editor** allows for multiple audio files to be mixed together using separate tracks. If you have additional sound effects or music to add to your audio, it's best to use the **Multitrack Editor** to control each sound individually and when finished, export a mixdown of the entire project to a single audio file. For this animation I only need to add a *beep* sound effect to the audio of the kids I have already edited. My plan is to animate this with its imperfections intact and use the *beep* effect where I want the animation to look like a filmic edit. I'll get to that effect later in this chapter.

To create a multitrack session go to **File > New > Multitrack Session**. Provide a session name, folder location, sample rate, bit depth and whether you prefer stereo, mono or 5.1 surround sound. Typical settings are **44100 Hz** as the sample rate, **Bit Depth 16** and **Stereo** as the master setting. Click **OK**.

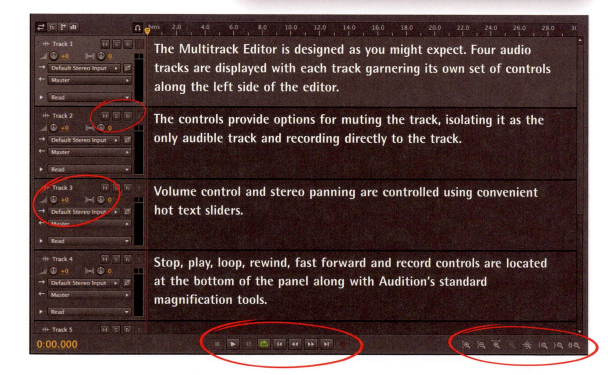

The Multitrack Editor is designed as you might expect. Four audio tracks are displayed with each track garnering its own set of controls along the left side of the editor.

The controls provide options for muting the track, isolating it as the only audible track and recording directly to the track.

Volume control and stereo panning are controlled using convenient hot text sliders.

Stop, play, loop, rewind, fast forward and record controls are located at the bottom of the panel along with Audition's standard magnification tools.

Choose **File** > **Import** > **File...** and locate the file you want to import into the **Multitrack Editor**.

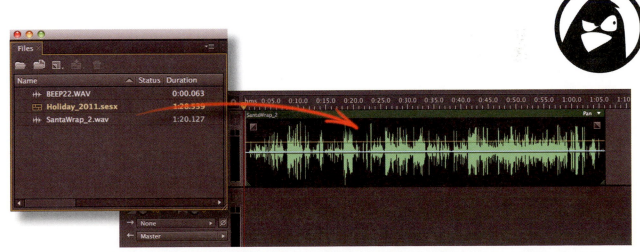

Once all of the files are imported, click and drag each one from the **Files** panel to an empty track in the **Editor** window. The waveform will be automatically generated. One of my homegrown tricks is to drag the file of my main voiceover audio of the kids to two different tracks. The reason for this is the audio file is a mono file, as you can see by the single waveform above. It's mono because I recorded with a single microphone. This being a multitrack editor, if I drag the same file to a second track it will allow me to treat it as a second channel or like a stereo file.

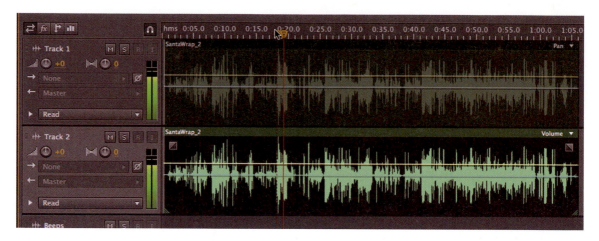

So now that I've got my sound file exported, I can import it into **Flash** as the foundation for my animation. But first I need to create a **Flash** document with the appropriate settings for a successful export for my intended platform.

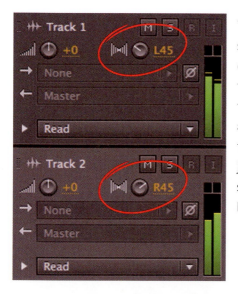

With the same audio residing on two separate tracks, I can control the panning of each track individually. Using the hot text slider, I adjust the panning of one track a small amount to the left channel and the other track the same amount to the right channel. This separates the tracks just enough to make the resulting audio sound *wider* when played back through headphones or stereo speakers.

The **Levels** panel provides real-time visual feedback as to the overall volume level of your audio. I'm constantly watching the peak levels of my audio as I work to avoid distortion.

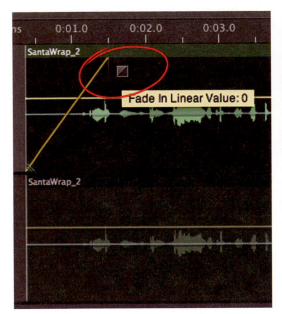

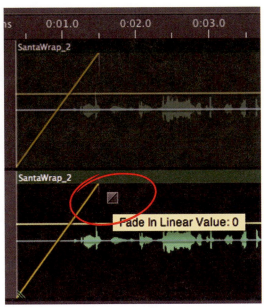

Fading audio is controlled with a visual curve. Drag the **Fade** icon inward toward the audio waveform to set the amount of fade.

With stereo audio files repeat the previous procedure in **Track 2** to match the fade in **Track 1**.

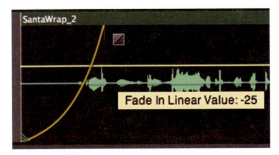

Dragging vertically will produce **symmetrical** or **asymmetrical** fades relative to the drag direction.

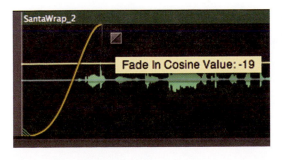

Holding down the **Command** key (**Mac OS**) or **Ctrl** key (**Windows**) while dragging will convert the curve from **linear** to **cosine**. A cosine curve will fade the audio in slowly at first, and gradually increase the volume before ending slowly at the current volume level.

In a multitrack project the yellow horizontal line represents the **volume envelope** for that particular track. Click and drag the line vertically to increase or decrease the overall volume level of the audio.

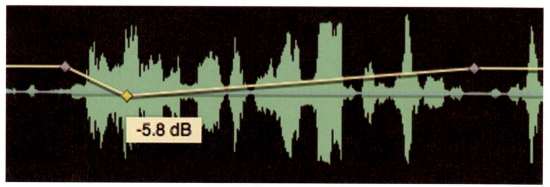

You can add keyframes to the volume envelope by hovering over it until a '**+**' symbol appears next to your cursor and then click on the envelope where you want to add the keyframe. Drag individual keyframes to adjust the volume of the audio over time.

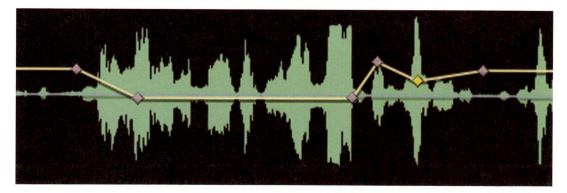

You can use keyframes to amplify quieter sections of audio while reducing the volume of other areas. Each keyframe can be moved or deleted after being added.

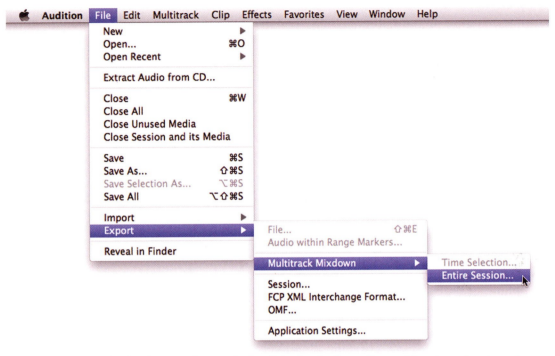

With all edits complete and after listening to the entire multitrack session to make sure everything sounds good, choose **File > Export > Multitrack Mixdown > Entire Session...**

In the **Export Multitrack Mixdown** window provide a file name, location to save file and select the format of choice using the **Format** drop-down menu. Choose either **AIFF** or **WAV** formats because they are both uncompressed. **WAV** format is recognized by **Microsoft Windows** while the **Mac OS** can recognize both **WAV** and **AIFF**.

Character Rigging

Around this time I had been experimenting with a 2D animation technique that created the illusion of 3D. It's a relatively simple technique with fairly sophisticated results. I decided this would be the best animation style to use for this holiday card based on the simplicity of Andrea's character design and the fact that it was two weeks before Christmas and I needed to produce something quickly! Once the character is set up correctly in terms of layers, symbols and nesting, the animation process can be done relatively quickly. I'm going to break down just how Andrea's character was originally built, which is essentially the same technique I use today.

My goal with the design of this character was to keep the linework relatively loose and with a hand-drawn feel. The biggest challenge was her hair. I could have drawn her hair as one image and converted it to a symbol, but I wanted the ability to animate some of the curls independently - especially the one big curl directly between her eyes. This was the biggest characteristic of Andrea in real life and I wanted to capitalize on it with her character.

Another challenge with her hair was how to deal with the **2.5D** technique I planned on using. If the hair was a single object, then it might look too flat when animating the head-turning illusion. In order for the **2.5D** technique to look convincing, each curl needed to be a separate object. That sounds like a daunting task but if I kept it simple then it wouldn't be too bad.

The body is comprised of five simple objects: the dress, two arms and two legs. I used the **Brush** tool with pressure sensitivity to draw each asset using a **Wacom Intuos** tablet. As you can see, the arms are simple lines as are the hands, legs and feet. The main reason for this simplicity is to keep the look and feel as if a child had drawn it. The secondary reason was because it was now less than two weeks to Christmas and I had to start and finish this animation in a very short amount of time.

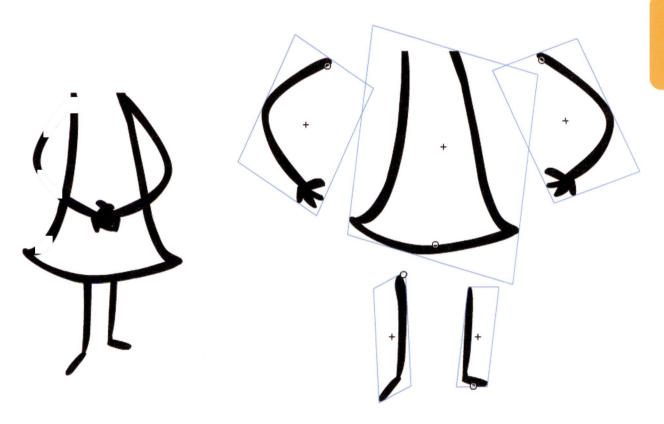

When creating a character for animation, it is standard practice to separate the hands and feet so they can be animated independently. As you can see above, the hands and feet are left connected to the arms and legs. This was a premeditated act to cut corners with production in order to expedite the animation process. I had no plans to animate the character walking, so there was no need to break the legs down into three different sections (upper leg, lower leg and foot). The character was to stand still in the same location for the entire animation, so I only needed to draw her legs and feet as single objects. I treated the arms and hands the same way, as single objects. The only difference was how I *nested* additional arms so the character could have various gestures.

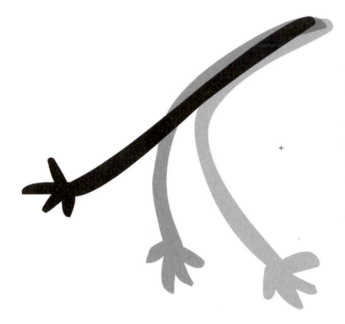

Once the arm was drawn, like all other body parts, I converted it to a **Graphic** symbol. There's a reason for choosing **Graphic** over Movie Clip symbol behaviour which I will get to later. I then double-clicked the symbol to enter Edit mode. Inside this symbol is where I create additional **blank keyframe**s, turn on the **Onion Skin** tool and draw additional arm poses. Having the **Onion Skin** tool on helps provide a reference for how the original arm is positioned relative to where it meets the body.

As you can see I ended up drawing over 30 different arm poses for this character. It may seem like a lot but I knew I needed as many as I could draw so i could animate the character in as many expressive ways possible based on the fact that she would be singing and performing. It didn't take long to draw all of these arms based on their simple design.

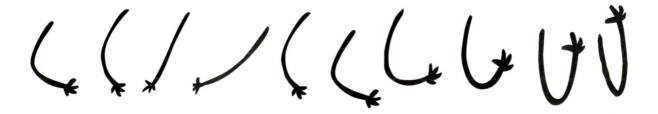

The second arm was simply a copy of the first arm. This literally cut the work in half since all I needed to do was copy and paste the arm symbol to a new layer and flip it horizontally. When I started animating I would be able to control both symbols independently. This included what nested frame was displayed at any time on the parent timeline. I'll go into more detail about that later in this chapter.

Most of the animation throughout is contained within the head. The head itself is made up of several objects including the eyes, nose, mouth and the individual curls of her hair. All of these objects are nested together inside a 'head' symbol and in some cases there are animations within some of these nested assets as well. As simple as I tried to keep this character, there are areas that can be considered sophisticated in terms of setup. The power of **Flash** is in the nesting of drawings and animations. The **2.5D** effect of Andrea's head appearing to turn in 3D space is provided mostly by the technique of layering animations across different symbols and their respective timelines. Layering animations is probably my most successful go-to weapon using **Flash**.

The eyes are usually the most expressive part of any animated character and it's why I pay special attention to their design. Andrea's eyes were no exception. I wanted Andrea's character to have very large eyes but equally as important, I wanted her to have a very realistic blink. The blink was especially critical because throughout the entire animation, she would blink over 30 times. The blink animation was worth spending some extra time animating to make sure it was perfect. Of course, everyone's definition of *perfect* varies. My version of *perfect* is animating the blink so that the eye looks three dimensional as the eyelash folds down over the eyeball. This can't be done using a mask or tweening. In fact, there really isn't an easy shortcut for making a realistic blink like this. The best way is to use *Full Animation* or what is otherwise known as *frame-by-frame* animation.

Before animating the blink, the eye must be converted to a **Graphic** symbol. Once converted, double-click the symbol to enter Edit mode. Within the eye symbol is where the blink animation would be created. The advantage of nesting the blink would come when I started animating. For this entire animation I used symbols with **Graphic** behavior. I did not use Movie Clip behavior because only **Graphic** symbols can be controlled on the timeline while remaining in sync with parent timeline. I'll go into more detail on this later but it's important to nest all animations that you'll want to reuse and have full control over when they start and stop.

Create Motion Tween
Create Shape Tween

Cut
Copy
Paste

Copy Motion
Copy Motion as ActionScript 3.0...
Paste Motion
Paste Motion Special...
Save as Motion Preset...

Select All
Deselect All

Free Transform
Distort
Envelope

Distribute to Layers

Motion Path

Convert to Symbol...
Convert to Bitmap

In Edit mode in the eye symbol, the original eye art on frame 1 by default. I selected frame 2 and converted it to a **blank keyframe (F7)**. **Onion Skin** was turned on to help me reference the original drawing on the previous frame. Here's where I began the blink sequence by drawing the next frame. The key here was trying to feel like the eye was a sphere and the three long lashes were coming down over the front of the eyeball.

Once I was happy with frame 2, I created the next **blank keyframe** in frame 3 and began drawing the next frame. Making sure the **Onion Skin** bracket spanned frames 1 and 2, I tried to make the distance between the eyelashes a little greater compared to the distance between frames 1 and 2. My goal was to manually animate a sense of easing in as the eye began the blink sequence.

The eyelashes in frame 4 made the biggest move across the eye. I purposely avoided drawing the lashes directly along the equator of the eye so that they would animate at the fastest rate across the surface of the eye. This was also the mid-point of the animation as the eyelashes were halfway to the closed position.

Just as I animated the eyelashes *easing in* back in frame 2, here in frame 5 I started slowing down the movement by drawing their position closer to the previous frame. This would slow down the speed and create a sense of *easing out* as the eyelashes closed around the eye.

The final frame showed the eye fully closed. The lashes were positioned as they would be if three-dimensional. I could not have achieved this using a mask or basic tweens. Sometimes you just have to roll up your sleeves and rely on your drawing ability.

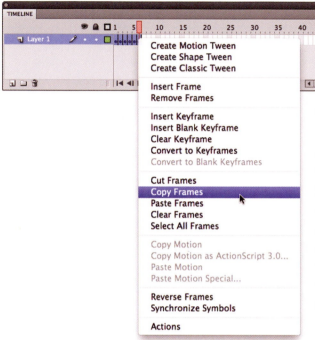

The blinking animation was six keyframes in duration. But it wasn't finished as I had only animated the eye closing. It still had to animate to the open position again. Since the first half of the animation was done, there was no need to manually animate the second half. Taking advantage of the power of software, I selected all of the keyframes and control+clicked over the selected area. In the **Context** menu I selected **Copy Frames**.

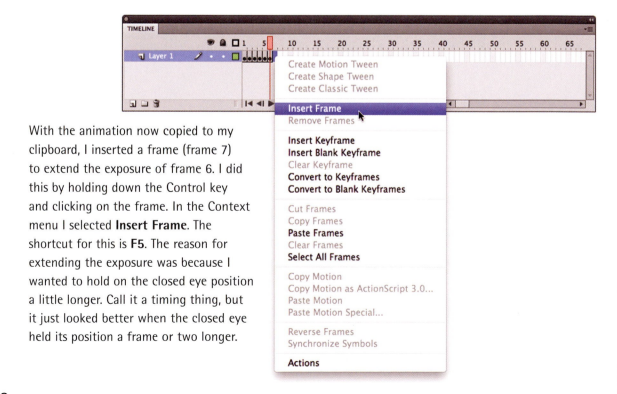

With the animation now copied to my clipboard, I inserted a frame (frame 7) to extend the exposure of frame 6. I did this by holding down the Control key and clicking on the frame. In the Context menu I selected **Insert Frame**. The shortcut for this is **F5**. The reason for extending the exposure was because I wanted to hold on the closed eye position a little longer. Call it a timing thing, but it just looked better when the closed eye held its position a frame or two longer.

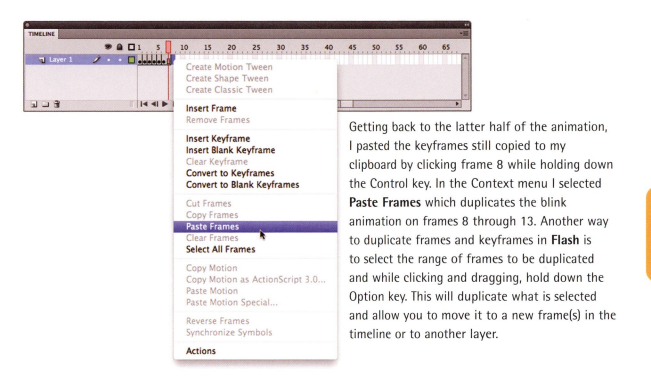

Getting back to the latter half of the animation, I pasted the keyframes still copied to my clipboard by clicking frame 8 while holding down the Control key. In the Context menu I selected **Paste Frames** which duplicates the blink animation on frames 8 through 13. Another way to duplicate frames and keyframes in **Flash** is to select the range of frames to be duplicated and while clicking and dragging, hold down the Option key. This will duplicate what is selected and allow you to move it to a new frame(s) in the timeline or to another layer.

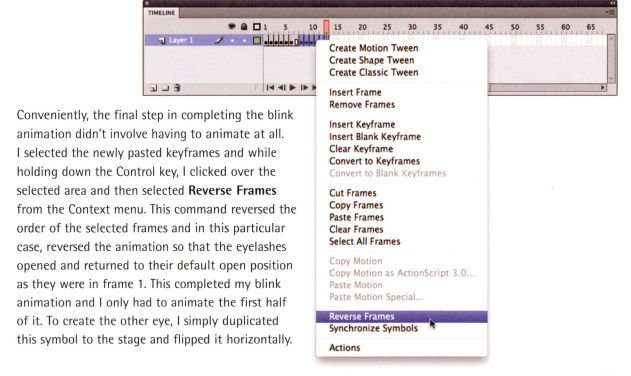

Conveniently, the final step in completing the blink animation didn't involve having to animate at all. I selected the newly pasted keyframes and while holding down the Control key, I clicked over the selected area and then selected **Reverse Frames** from the Context menu. This command reversed the order of the selected frames and in this particular case, reversed the animation so that the eyelashes opened and returned to their default open position as they were in frame 1. This completed my blink animation and I only had to animate the first half of it. To create the other eye, I simply duplicated this symbol to the stage and flipped it horizontally.

There's nothing sophisticated about the design of Andrea's mouth. It's simply a swipe of the **Brush** tool and nothing more. Just as I nested arm poses and the eye blinking, the mouth is treated the same way. Once converted to a **Graphic** symbol, additional mouths were drawn on subsequent keyframes.

All of these mouths represent just about every possible sound needed for lip-syncing. Creating each mouth was not unlike how I animated the blinking sequence for the eye. I created a **blank keyframe** in frame 2, turned on **Onion Skin** and drew the next mouth shape using the mouth on the previous frame as my guide. The most important thing to remember is to create all of these additional assets on their own frame inside a **Graphic** symbol. Think of **Graphic** symbols not as single objects but as extra timelines. **Graphic** symbols can have any number of frames and layers nested inside them and are always in sync with their parent timeline and any other **Graphic** symbol timeline.

Here is the exploded view of all the symbols for Andrea's head. As you can see, most of them are the curls of her hair. Why I chose to create so many individual symbols of her hair is because of the **2.5D** animation technique that I will explain later in this project. Both eyes are instances of the same symbol that contains the blink animation created earlier. The duplicate symbol was flipped horizontally.

Here is the entire head with all symbols in position. The key here is making sure the character still looks like a single drawing even though it has been separated into individual symbols.

With all of the symbols in place, I selected them all and right-clicked over them. I converted them all to a single **Graphic** symbol using the popup menu. I wanted the head as a single symbol so I could rotate it where it connected to the body as a complete object. All of the detailed animation (eyes, blinking, lip-syncing and **2.5D** technique) would be done inside this symbol later on.

Here's the character set up and ready for animation. The entire head is a **Graphic** symbol containing all of the individual symbols nested inside it. The body, arms and legs are all individual **Graphic** symbols on this same level. There was just one thing left to do: convert the entire character to a **Graphic** symbol once again. I wanted the entire character to be nested to allow me the flexibility of controlling her as a single object on the main timeline.

I'm not done converting objects to symbols just yet. I prefer to have the entire character inside a **Graphic** symbol and then do all of my character animation inside this symbol. There are many advantages to nesting the entire character in this fashion. With everything selected, hold down the Control key and click anywhere over the selected area and choose **Convert to Symbol** from the popup menu. Once again, choose **Graphic** behavior to maintain sync with other symbols and the main timeline.

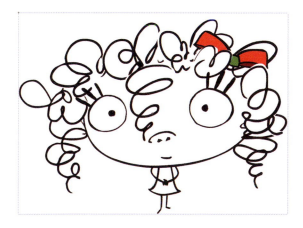

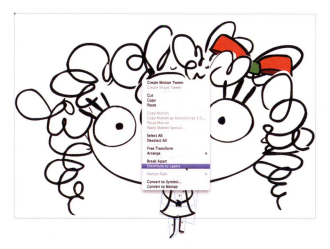

With the entire character nested inside a **Graphic** symbol, it's time to finalize a few details before animation can begin. Double-click this symbol to enter Edit mode.

All of the symbols reside on a single layer. Before I could animate I needed to select them all, control-click over the selected area and choose **Distribute to Layers** from the Context menu.

Distribute to Layers is a great feature because in one single command it creates new layers for every symbol that is selected, places each symbol in its own layer and adopts the symbol name for the layer name as well. The residual Layer 1 in the screenshot above is the default layer in which the symbols were located before the Distribute to Layers command was executed. It can be deleted.

The character was ever so close to being animation-ready. The final step in rigging the character was to properly hinge each symbol so they rotated appropriately. This was done using the **Free Transform** tool. With the **Free Transform** tool selected, I clicked on the head symbol and moved the center point (represented by a small white dot) to where the bottom of the head overlapped the body. Now when I rotated the head symbol, it hinged where it should: at the neck area.

I repeated this procedure for each and every symbol. Here I decided it would be best if the dress hinged at the bottom near the waist.

The legs can be hinged where the feet meet the floor. I had no plans of animating her walking. The character remains standing in this same spot for the entire animation. If anything, I would be animating her leaning back and forth so it made sense to hinge her feet and legs at the floor.

Naturally the arms were hinged where they meet the body: at the shoulder.

The process of hinging symbols continues within the head symbol. I selected each symbol and moved their respective center points to their most obvious positions. Here the curl between her eyes gets hinged where it connects to her head.

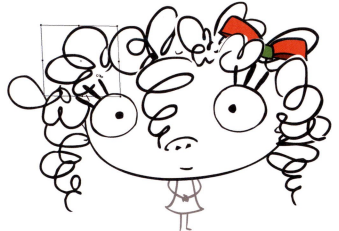

I edited the center point of each curl so that it was located roughly where it met the head. This is a small but important detail when setting up a character for animation. When rotating or skewing a symbol based on its default center point position (center), it won't look realistic because the symbol won't look properly 'connected' to the character.

Here's the difference between the center point in the default position and when repositioned appropriately. The first image shows the default position and what happens when the symbol is rotated. The second image shows a more realistic rotation because the center point is placed at the top where the curl would naturally connect with the head.

Rigging characters in **Flash** using this nesting technique is one of my most successful animation production techniques. For the purpose of explaining the nesting hierarchy, let's take another look at how each symbol is nested, starting with the main timeline. On the main timeline (sometimes referred to as the stage) resides the main **Graphic** symbol that contains the entire character. This symbol is named **andrea_full_rig**.

 Scene 1 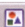 **andrea_full_rig**

Double-clicking the main symbol brings you to the nested timeline within the main symbol. Here reside the head, body, arm and leg symbols. Notice the convenient breadcrumb trail automatically created in the **Edit bar** directly above the stage. As you navigate through symbols the **Edit bar** will update to reflect where you are relative to the main timeline. The **Edit Bar** can be used to navigate through symbols by clicking the Back button or any of the symbols' names.

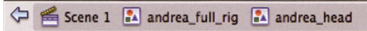

Enter Edit mode for the head symbol and here's where all the head symbols reside. This is the time-line where I animate the character talking, blinking, looking in different directions and the **2.5D** technique where I create the illusion of her head turning.

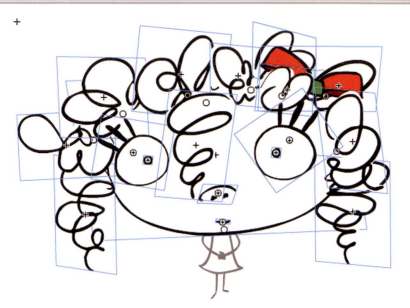

Double-click one of the eye symbols to get to the blink animation I illustrated earlier in this project. Go back to the **andrea_head** symbol and double-clicking the mouth will bring you to the time-line where all the different mouth drawings reside.

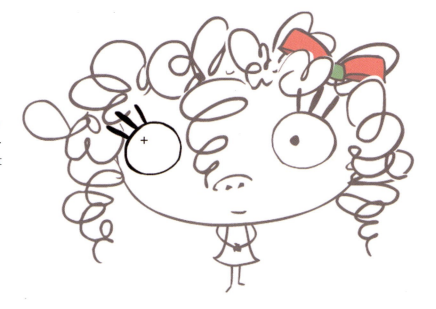

To help illustrate the symbol hierarchy of a character set up for animation in **Flash**, I thought that a flow-chart view might prove useful. This flowchart is not based on any specific character but rather the general structure of a generic character. Your character will likely be different in terms of the number of nested symbols and overall complexity. My goal here is to provide you with a visual structure of how I organize and nest a basic character.

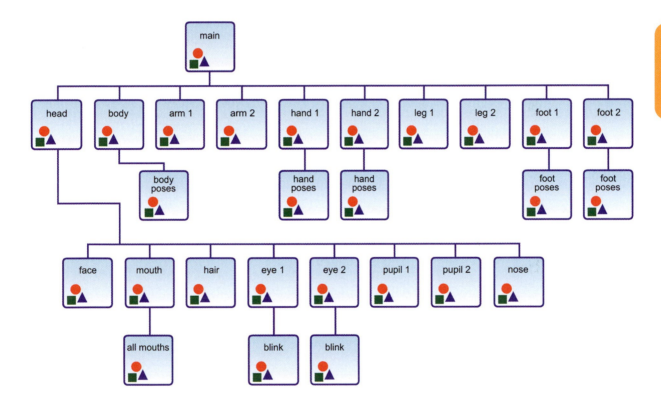

As previously mentioned, your character hierarchy in terms of symbols may end up being different solely based on the way you may have designed it. The more features your character has, the more symbols and potentially more levels of nesting. My most important advice to you is, design with motion in mind. Always be thinking about how your character will move as you design it. Form follows function and there should be a reason behind every detail of your character.

Of course no family holiday animation would be complete without the other two siblings. In an effort to keep things simple, the characters of Billy and Bobby were designed with very few lines and body parts. Minimalism was key because of how little production time I had to execute this animation. The fewer moving parts the better and I had already used a generous amount with Andrea's character.

My favorite way to draw is using pencil and paper, but when those two tools aren't accessible, out comes my trusty **iPad**. One of my favorite drawing apps is **SketchBook Pro** from **Autodesk**. I can quickly sketch my concept drawings and ideas using several of the drawing tools. Using layers and a full color palette, you have pretty much everything at your fingertips (literally) to create simple grayscale drawings or elaborate works of full color artwork.

The one app that bridges the gap between all of my mobile devices, laptop and desktop machine is **Dropbox**. If you asked me what app I couldn't work without, **Dropbox** would be the one. With **Dropbox** I am able to upload files to my **Dropbox** account where they get stored to a web server (otherwise referred to as the *cloud*). Think of **Dropbox** as a virtual folder that can be accessed like a web page except that it behaves like a normal file folder.

In some cases, **Dropbox** will integrate with certain apps, allowing you to upload directly from within the interface. **SketchBook Pro** for **iPad** does integrate **Dropbox** but only to import a file; it is not designed to export to **Dropbox**. We'll have to get a little bit creative as to how to get the image off the **iPad**. The easiest work-around is to simply take a screen capture of the drawing while inside the **SketchBook Pro** app. Since preserving layers is not important, a screenshot works just fine. Hold down the Home and Power buttons simultaneously to grab the image, which will then be saved automatically to your **Camera Roll**.

Launch the **Dropbox** app on the **iPad** and tap the Uploads button in the upper left corner.

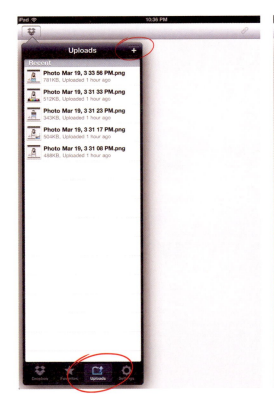

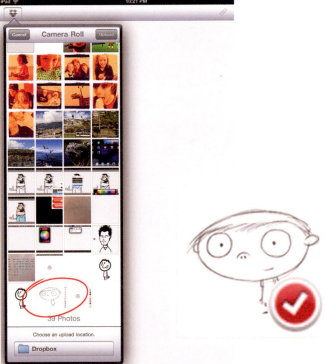

Verify that the **Uploads** category is selected from the menu at the bottom of the popup menu. You will see a small '**+**' symbol in the upper right corner that, when tapped, will provide a view of the **Camera Roll** and all of the images you have saved on your **iPad**.

With the **Camera Roll** in view, I just need to locate the screenshot of the character I drew and tap to select it. A red circle with a check will indicate the file is ready for upload to my **Dropbox** folder. I can even select multiple files for upload by tapping other thumbnails.

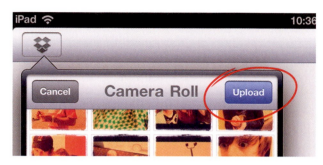

With my file selected for upload, all I need to do is tap the **Upload** button. **Dropbox** will immediately upload the file to my **Dropbox** folder where it can be accessed from any of my other mobile devices, my laptop or desktop machine.

On my **MacBook** Pro with **Dropbox** installed, I access my **Dropbox** folder by clicking a handy icon in the menu bar. From the drop-down menu I select **Open Dropbox Folder** to open a Finder window displaying the entire contents of my **Dropbox** account.

From the Finder window I can locate the files in my **Dropbox** account that were uploaded from my **iPad**. From here it's a rudimentary process to drag them to my local hard drive.

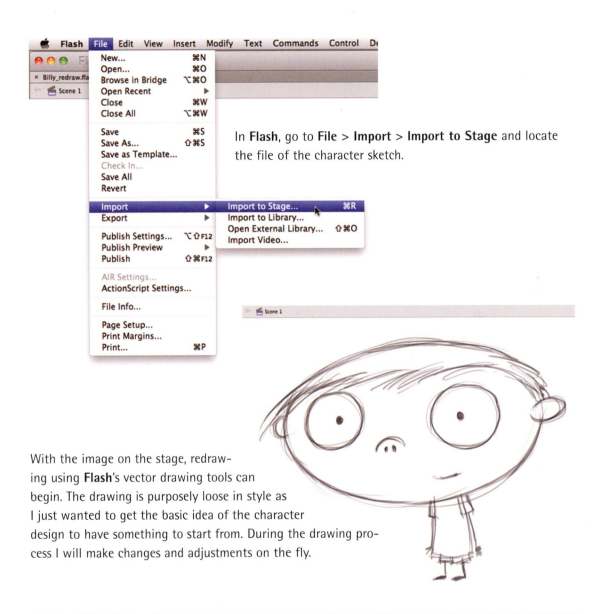

In **Flash**, go to **File > Import > Import to Stage** and locate the file of the character sketch.

With the image on the stage, redraw-
ing using **Flash**'s vector drawing tools can
begin. The drawing is purposely loose in style as
I just wanted to get the basic idea of the character
design to have something to start from. During the drawing pro-
cess I will make changes and adjustments on the fly.

With the image in frame 1, select frame 2 and insert a **Blank Keyframe** by pressing the **F7** key.

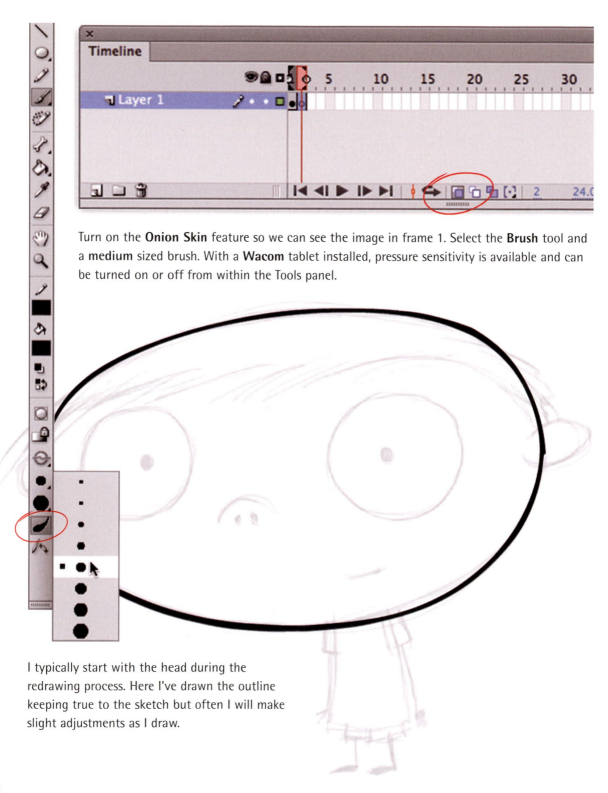

Turn on the **Onion Skin** feature so we can see the image in frame 1. Select the **Brush** tool and a **medium** sized brush. With a **Wacom** tablet installed, pressure sensitivity is available and can be turned on or off from within the Tools panel.

I typically start with the head during the redrawing process. Here I've drawn the outline keeping true to the sketch but often I will make slight adjustments as I draw.

Convert to Symbol

Name: billy_head

Type: Graphic

Registration:

Folder: Library root

Advanced ▶

OK

Cancel

Using the **Bucket** tool, the head gets filled with white. My vision for this animation was to keep it almost entirely black and white. Limited color translates to less time spent mixing and picking an entire color palette. It may not be that much of a time saver, but every little bit helps when you are working to a strict deadline. With the entire head selected, convert it to a symbol by pressing the **F8** key. Name it appropriately and select **Graphic** using the **Type** drop-down menu.

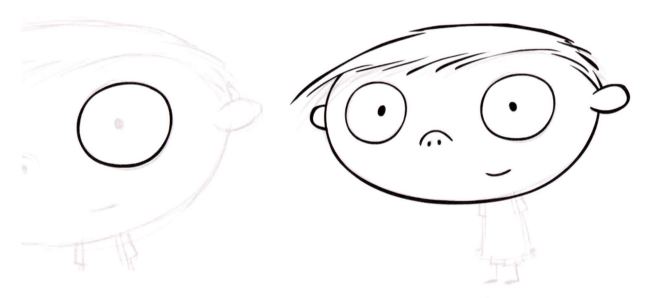

Moving on to other features, here I have outlined the eye. Just as I did with the head, I gave it a fill of white and then converted it to a **Graphic** symbol.

Here is the head completely redrawn and comprised of individual **Graphic** symbols. There are a total of 10 symbols that complete this image: head, hair, two ears, two eyes, two pupils, nose and mouth.

123

Just like the head and all its features, the rest of the body was redrawn the same way. The key here is, although they may all be separate symbols, they should look like a complete drawing when positioned in place.

Here I have all the symbols selected so you can see that everything is a separate object. Before I could start animating, there were a few more things I needed to do to set up this character to insure a smooth animation process.

Here's the same character in exploded view. As previously mentioned, my time was limited which dictated the simplicity of the character. Fewer parts to move meant less time spent animating. But I didn't want to sacrifice the quality of the animation. After all, I was going to be putting this out there for the world to see, I still wanted it to be enjoyable and entertaining. With all the symbols in place, it was time to set up the character for animation.

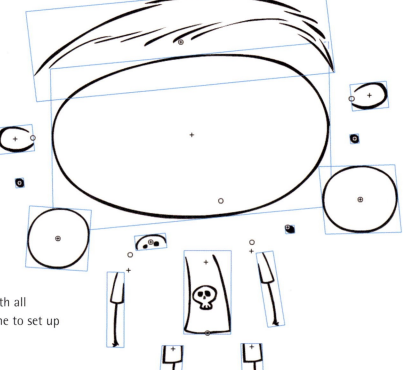

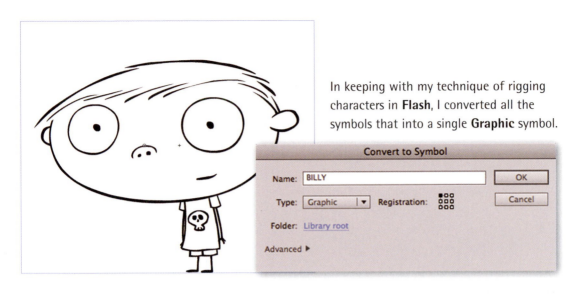

In keeping with my technique of rigging characters in **Flash**, I converted all the symbols that into a single **Graphic** symbol.

Inside the 'Billy' symbol, the symbols that comprised the head were converted to a single **Graphic** symbol.

With all symbols of the head selected, right-click over them and select **Distribute to Layers**. **Flash** will place each symbol in its own layer and adopt the symbol name to become the layer name. You just killed two birds with one stone. Pretty cool huh? And it didn't require a plugin.

Billy's blink animation was created the same way as Andrea's. Using the **Onion Skin** feature I hand-drew each frame to make the eye close. Then I copied each frame and pasted them to duplicate the animation. Then I selected the duplicated range of frames and reversed the animation using the right-click popup menu selection.

Just like the head and all its features, the rest of the body gets redrawn the same way. The key here is, although they may all be separate symbols, they should look like a complete drawing when positioned in place.

To keep the amount of work to a minimum I made sure as I was designing that I could use the same mouth for each character. So the mouth a created for Andrea is also the same mouth for Billy and eventually Bobby. This way I didn't need to create three different sets of mouth phenoms.

Nesting is not limited to eyes and mouths. You can nest just about anything you want. I like to nest arm poses within the arm symbol itself.

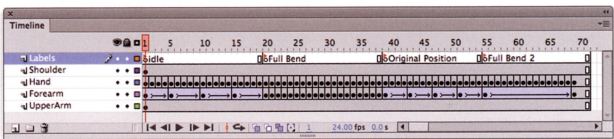

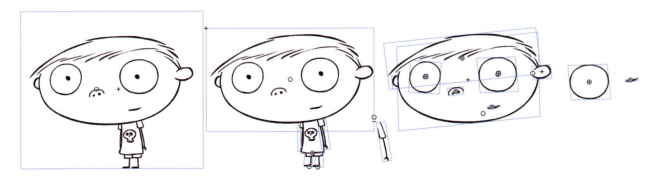

Just to provide a different visual hierarchy of how I set up these characters, the Billy character is self-contained within a **Graphic** symbol. Inside that symbol are the body symbols and the head symbol. Inside the arm symbol are all of the arm poses. Inside the head symbol are all of the individual head parts. Inside the eye symbol is the blink animation and inside the mouth symbol are all of the mouth phenoms.

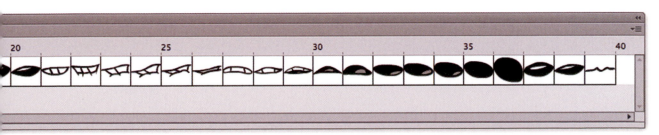

The character of Bobby is no different from the previous characters in terms of setup. The entire character is nested inside a **Graphic** symbol named 'Bobby'. This was the easiest of the three characters to animate since he held the same pose for the entire animation.

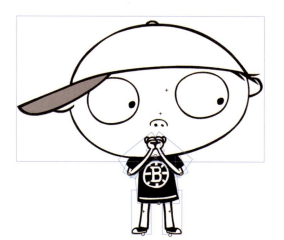

Within the 'Bobby' symbol are the individual body symbols and the head symbol. There was no need for additional arm poses. The blink animation I created for Billy's character was used for the Bobby character as well.

The head symbol contains all of the facial features. Inside the eyes is the blink animation and inside the mouth symbol are the mouth phenoms. And as you may have guessed, this is the same mouth used for the other two characters.

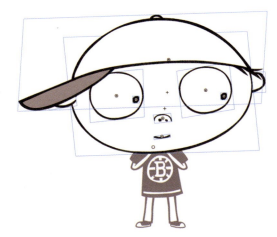

Flash Document Setup

It was finally time to dive into **Adobe Flash CS6 Professional**, roll up my sleeves and start building the actual animation. With the recent popularity of mobile devices lacking **Flash** support (*cough* **iPhone** *cough* **iPad**), publishing an **SWF** to the web was not going to reach the largest possible audience. While the **SWF** format has its advantages, if it can be viewed by only a fraction of my audience, it won't really matter. Exporting to video format solves this issue easily because almost every device supports **YouTube** and **Vimeo** embedded media. I intended to export this entire animation in video format and upload to **YouTube** and **Vimeo**. This insured it would reach the biggest audience possible.

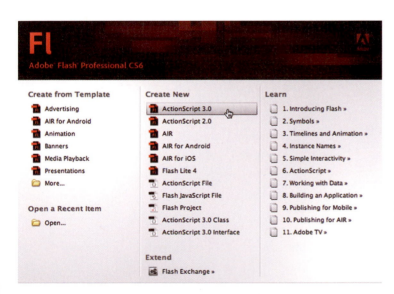

On the **Flash** splash screen, create a new document by clicking **ActionScript 3.0** or **ActionScript 2.0**. It doesn't matter what version of **ActionScript** the document supports because we won't be using any **ActionScript** in the document anyway.

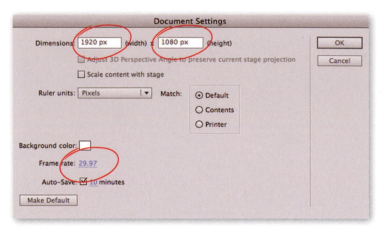

Adobe supplied a new way to export animation to **Quicktime** format with the release of Creative Suite 3. The new **Quicktime Exporter** remains unchanged in **Flash CS6**. The Exporter not only allows you to export timeline animation as a **Quicktime** movie file, but dynamically generate (**ActionScript**) content as well. So what does this mean for those of you creating timeline animation? Well, first it's important to understand just how the Exporter works and how to set up the **Flash** document to insure the exported movie file works as it should.

Let's first work backwards by determining the intended platform for the animation. We know we're going to upload to **YouTube** and **Vimeo** so it's best to set the stage size to the maximum size supported by both services: **1920 x 1080**. NTSC video format uses a frame rate of 29.97 but there's a more important reason why you might want to use this frame rate in **Flash**. If a frame rate other than 29.97 is used, the Exporter may produce a movie file with unexpected results. I'm not sure if this is a problem with the **Flash Quicktime Exporter** or with **Quicktime** but the results can be described as distortion of the image or artifacting, where portions of images in some frames break apart.

To demonstrate this problem I am using a simple looping animation of the **Starling Framework** bird I created for **gamua.com/starling**. The animation is only 14 frames long and nested inside a looping symbol on the stage. The **Flash** document is set to **24fps**.

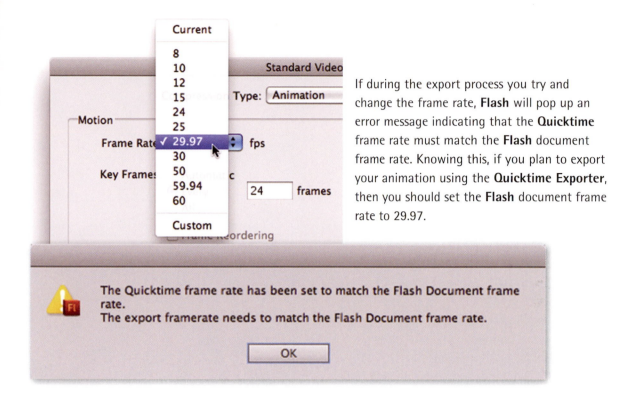

If during the export process you try and change the frame rate, **Flash** will pop up an error message indicating that the **Quicktime** frame rate must match the **Flash** document frame rate. Knowing this, if you plan to export your animation using the **Quicktime Exporter**, then you should set the **Flash** document frame rate to 29.97.

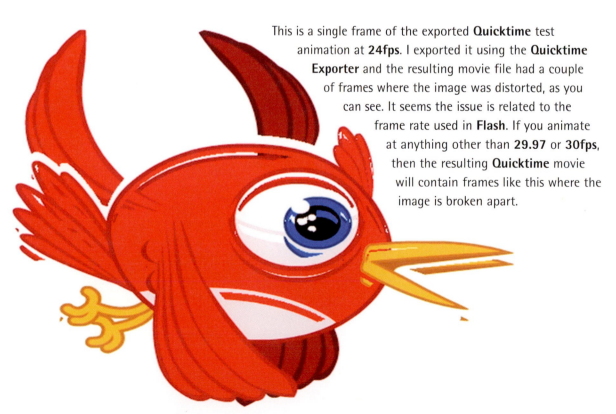

This is a single frame of the exported **Quicktime** test animation at **24fps**. I exported it using the **Quicktime Exporter** and the resulting movie file had a couple of frames where the image was distorted, as you can see. It seems the issue is related to the frame rate used in **Flash**. If you animate at anything other than **29.97** or **30fps**, then the resulting **Quicktime** movie will contain frames like this where the image is broken apart.

If I change the frame rate in the **Flash** document to **29.97fps** and export a new **Quicktime** movie, the file plays without any visual flaws. This means that if you plan on exporting your animation using the **Flash Quicktime Exporter**, then you will need to animate in **Flash** at **29.97fps**. I must also give credit where credit is due. **Pam Stalker**, a friend and fellow **Flash** animator, discovered the frame rate issue with the **Quicktime Exporter** and emailed me with the **29.97fps** solution. For that I owe her a huge thank you.

Setting up the **Flash** document for video export needs nothing more than entering the desired stage width and height and if using the **Flash Quicktime Exporter**, use **29.97fps**. Each of these properties can be edited by clicking anywhere on the stage and expanding the **Properties** category in the **Properties** panel.

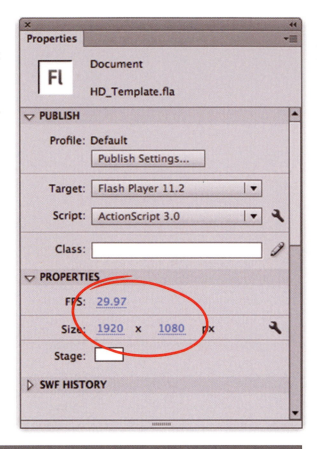

Title and action safety guidelines are used to insure the most important information doesn't get cut off. The darker gray border represents the area considered as the overscan: the active picture that falls outside of the safety zone. Never assume your content will be seen in this margin across all televisions. The lighter gray border represents the area that will likely be the edge of the viewable screen on most televisions. Anything within this margin will likely end up against the edge of the television screen.

The safest zone is the large white area here in the middle. Now I realize your video file may be intended for web where none of these guidelines matter since 100 percent of the stage will be viewable. But you never know when you or the client may decide to show your work on a television display. Best to be safe and keep within the safety zone.

With each of my characters assembled and nested within their own unique **Graphic** symbols, I added them to a new document that would eventually be the main project file for my animation. You can either click and drag each symbol from one open doc to another or copy and paste them. Either way I recommend having each character in its own **Flash** document as well as the final project file as well. It's never best practice to have all your graphics in a single document in the event it becomes corrupt for any reason.

As I demonstrated earlier, each character has its own unique hierarchy of nested symbols. With all three characters in three separate symbols on a single stage, I created one more level of nesting by selecting all three characters and converting them all to a single symbol I name 'Master'. This allowed me to easily control the scale and placement of all three characters relative to the width and height of the stage.

2

The next step was to import the audio. Add a new layer by clicking the **New Layer** button in the lower left corner of the **Timeline** panel. Name the layer '**Audio**' or something equally descriptive.

With the new layer selected, go to **File > Import > Import to Stage** to locate and import the audio file to the new layer. Once imported, select frame 1 of the sound layer containing the sound file and make sure the **Sync** behavior is set to **Stream**. By default **Flash** will set imported audio to Event but for frame-based animation that relies on being in sync with the audio, It is important for the sound to be set to **Stream**. **Stream** will embed the sound into the timeline and make it frame-dependent.

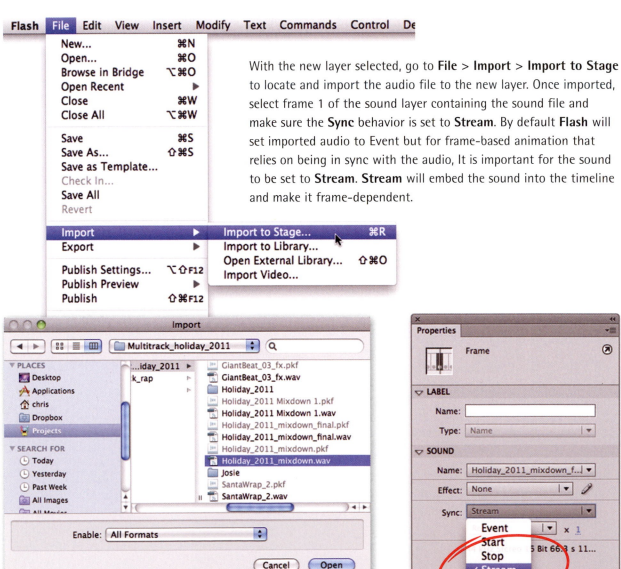

Insert enough frames to span the length of the audio. The quickest way to do this is to click a frame a few hundred frames down the timeline and press the **F5** (**Insert Frames**) key. Repeat this procedure until you reach the end of the audio. My timeline was around 2000 frames and just over 65 seconds long.

Almost the entire animation would be executed within the nested timelines. With the audio on the main **Timeline** we will be able to play back the animation and hear the audio, but the audio will not play within the nested timelines. The audio needs to reside in each nested timeline so it can be listened to while animating in these timelines. We also need to make sure all nested timelines have the same number of frames as the main timeline. This insures the entire animation will play.

Copy the first frame containing the audio in the main timeline by right-clicking over it and selecting **Copy Frames** from the popup menu.

Double-click the **MASTER** symbol that contains the three characters and add a new layer. Right-click over frame 1 of the new layer and select **Paste Frames** from the popup menu. The audio will be pasted in to the layer and will have the same **Stream** property applied to it. Double-click the symbol containing the Andrea character, create a new layer and paste the audio into frame 1 just as we did in the parent timeline.

Scene 1 | MASTER | ANDREA | Andrea_head

I wanted Andrea's head to bob up and down to the beat of the audio while swaying side to side along with her body. This style of movement required several layers of nested synced animation.

The first step was to animate the head bobbing up and down to the timing of the audio recording. After double-clicking the head symbol to edit the head parts, I played the timeline to listen to the audio to get a feel for the rhythm and timing. I listened for the downbeat and inserted keyframes across all of the layers on the frame where the downbeat resided. I then listened for the next downbeat and added another set of keyframes on this frame as well. These keyframes were the beginning and end of the initial head animation.

At approximately the mid-point between these keyframes I inserted more keyframes across all symbol layers. This was the frame where I edited the symbols on the stage to create the head movement. I would eventually apply a motion tween across these layers and keyframes but for now was concentrating on the initial pose of the character's head parts.

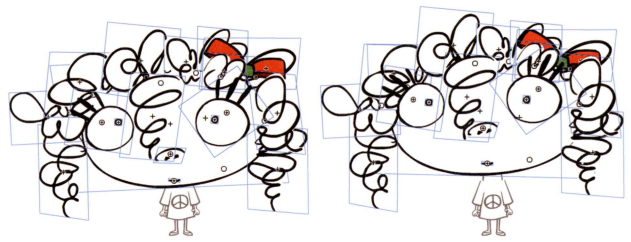

The movement of each symbol between keyframes is relatively subtle as seen between the two poses above. The entire head is moved up about 10 pixels. The mouth is moved up a bit more as you can tell from the distance between the mouth and the lower edge of her chin. The nose moves a greater distance than other symbols to provide the illusion that it is closer to us. Her eyes are moved up and almost over portions of her hair. Symbols that are below other symbols, such as her hair, move less to imply they are further away. Once the motion tweens are applied, the illusion of depth will take effect.

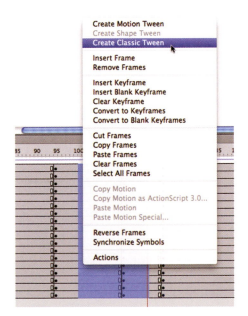

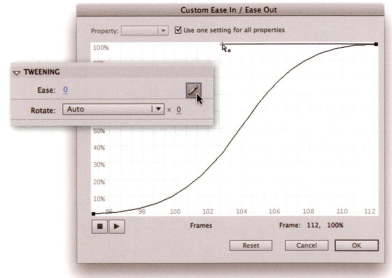

To apply the **Classic Tween**, click and drag across all layers and across a portion of frames before and after the middle keyframes. Right-click within the highlighted area and select **Create Classic Tween** from the popup menu.

With the **Classic Tween** applied and still highlighted across all layers, click the pencil icon in the **Tweening** category of the **Properties** panel. This launches the **Custom Ease** panel where the ease can be controlled using a path. I prefer to soften the movement of tweens with easing in and easing out. To do this with the custom curve, click and drag the handles on each end until the path resembles a soft 'S' curve (above).

EaseCaddy

As powerful as the **Custom Ease** panel is, it still requires several clicks to apply a custom ease. There's no option in **Flash** to apply a tween with automatic easing and no option to save an ease as a preset. If you tween a lot, applying custom eases can add up to a lot of clicking, which is where **EaseCaddy** comes in. Developed by **Justin Putney** of **Ajar Productions**, the **EaseCaddy** extension takes easing beyond **Flash** as a stand-alone panel that comes with four easing presets. The strength of Ease Caddy is the ability to create and save your own custom eases. With a tween selected, click on an ease preset and click Apply. That's less than half the clicks it takes using the default **Flash Custom Ease** panel. **EaseCaddy** presets can be applied to **Classic** and the **New Motion Tweens**.

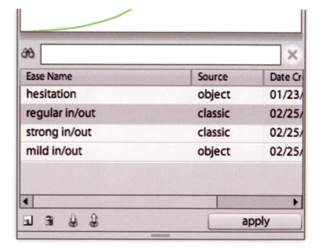

To apply an **EaseCaddy** preset, select a frame in a motion tween span. If you purchased the Pro version of **EaseCaddy** you can apply a custom ease to multiple tweens at one time.

With the tween selected, select one of the presets from the Ease list field and then click **Apply**. The ease will be automatically applied to the tween span. If you purchased the Pro version you can apply an ease preset to multiple tweens.

My favorite **EaseCaddy** feature is the ability to save my eases so they can be reused with just a single click. Once I've created an ease using the **Flash Custom Ease** curve and I know I'll want to reuse it again, I'll add it to **EaseCaddy** as a preset. To do this, select a frame in the tween and click the **New Ease** button in the lower left corner of the **EaseCaddy** panel.

This will prompt a popup where you can provide a name for the ease that's applied to the selected tween. I recommend a descriptive name or something that indicates the nature of the ease behavior for future reference. Click **OK**.

The new custom ease will be added to the list in the **EaseCaddy** panel and can be applied to any future tween spans. There's a handy search filter for those who have saved a large number of presets and wish to find them using keywords. In the interest of sharing, Justin has provided Import and Export buttons so you can share your eases in **XML** format.

Click the Export button and the **Export Eases** panel will provide the option to export one or all of your presets to **XML** format.

Learn more about using the **EaseCaddy** at **ajarproductions.com/ pages/products/easecaddy/**.

Here's the complete timeline once the head animation is finished. At this stage I'm not worried about lip-syncing or eye blinks. Those are the details that come later. For now I am concentrating on the larger motion. Think of this as an oil painting where the broad strokes are painted first in order to compose the basic shapes, darks, lights and undertones of color. As the painter continues his masterpiece, the brush strokes get smaller as more detail is added. Lip-syncing and blinking are those final details to be added at the end. For now I concentrate on the broad strokes.

Scene 1 MASTER ANDREA

With the head motion animated throughout the entire audio, it's time to return to the parent timeline containing the head symbol and body symbols. This is the timeline where I animate the full body poses for the character.

With the **Onion Skin** tool turned on and set so that I can see the content in just the previous frame, I use the **Free Transform** tool to rotate and position the body parts to create a new pose.

Posing the character is much easier on this level because there are only a few symbols to deal with. Remember, the entire head is a single symbol with each facial feature contained within it. This allows you to focus on just the key poses of the character.

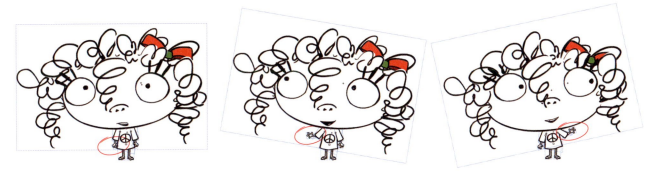

You will notice in the images above that the hands change from one pose to the next. There are a couple of ways to achieve this using **Flash**. Swapping one symbol for another symbol from the **Library** has been the most used method since the beginning of **Flash** animation. I prefer a better way which involves nesting.

Inside the **Hand** symbol reside four additional hand poses, each in their own keyframe. I drew each hand with the **Onion Skin** tool on so I could see the previous drawing and use it as a reference point for where the wrist connects with the arm.

In the parent timeline (the timeline that contains the hand symbol), select the instance of the hand symbol and in the **Looping** section of the **Properties** panel, select **Single Frame** from the **Options** drop-down menu and then type in the frame number that corresponds to the hand you want to be visible in the animation.

To change the visibility of one nested frame to another, you need to insert a keyframe and then change the frame number of the instance. If you are using **Motion Tweens** to animate, it's intuitive to change the frame at the beginning or end of the **Motion Tween**. But the object being tweened is at rest in the first and last keyframes of the tween, which results in a noticeably abrupt change in hand poses. Here's my tip on how to change hand gestures in a way that will look smooth and natural.

Here's a section of the timeline where the character is Motion Tweened from one pose to another. The hand symbol is set to **Single Frame** with frame 4 as the visible frame containing the hand pose pictured in the above screenshot. Most importantly, I have already applied my ease in/ease out to these motion tweens.

Instead of changing the frame of the hand symbol in the first or last keyframe, I click on a frame in the middle of the tween and press the **F6** key to insert a keyframe. The idea here is to change the hand pose where the hand is moving at its fastest rate to make it less jarring visually. With easing in/out applied, the symbol moves its fastest in the middle of the Motion Tween.

Click on the next frame and press **F6** again to insert another keyframe. This is the keyframe where the hand symbol pose is changed. Since the hand is moving at its fastest rate of speed in these frames, the switch from one hand pose to another is difficult to see.

Properties

Graphic

Instance of: andrea_hand Swap...

▷ POSITION AND SIZE
▷ COLOR EFFECT
▽ LOOPING

Options: Single Frame

First: 4

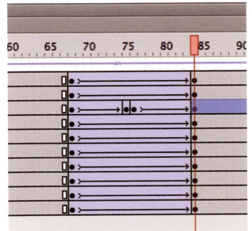

In the last keyframe, select the hand symbol and change its frame property so that the same hand pose is visible as it is in the previous keyframe.

As you can see the entire arm animation starts with a specific hand pose, then changes mid-tween to a new hand pose and eventually comes to rest with the new hand pose. The overall motion of the arm and hand is smooth and natural as the change in hands goes undetected to the naked eye. The easing curve is the key to the smoothness of the hand changing. The curve allows the entire arm to move at its fastest rate in the middle of the motion tween, which is where I take advantage by changing the hand pose so it becomes harder to detect.

143

The next weapon in my animation arsenal is the **FrameSync** extension from, once again, **Justin Putney** of **Ajar Productions**. As you've seen throughout this chapter, my main method of animating in Adobe **Flash** is to nest animations within **Graphic** symbols and then control the instance of the symbol using the **Properties** panel's **Looping** options. As tried and true as this method is, there's room for improvement.

Using **Flash**'s **Properties** panel requires the following sequence:

▶ Click on the frame containing the symbol.

▶ Press the **F6** key to insert a keyframe.

▶ Click the instance of the symbol containing the nested frames to focus it.

▶ In the **Properties** panel **Looping** options menu, select **Loop**, **Play Once** or **Single Frame**.

▶ Click in the **Frame Number** input field and type in the desired frame number.

All of those tasks combined equate to a minimum of five clicks and one key press for every frame instance you want to change. A short animation can contain hundreds if not thousands of keyframes. Multiply this by five and you can see how controlling nested hands, blinks, mouths and more can add up to a lot of clicking by the time the animation is complete. There has to be a better way.

The **FrameSync** extension revolutionizes how **Flash** animators work with nested frames in **Graphic** symbols. Simply put, the FrameSync panel is like the **Properties** panel on steroids. **FrameSync** is a free download from **ajarproductions.com** and installs using the Adobe Extension Manager that comes with **Adobe Flash**.

The advantage **FrameSync** has over the **Properties** panel is the way it streamlines the process of creating keyframes and controlling nested frames. It has single-handedly optimized my **Flash** animation workflow.

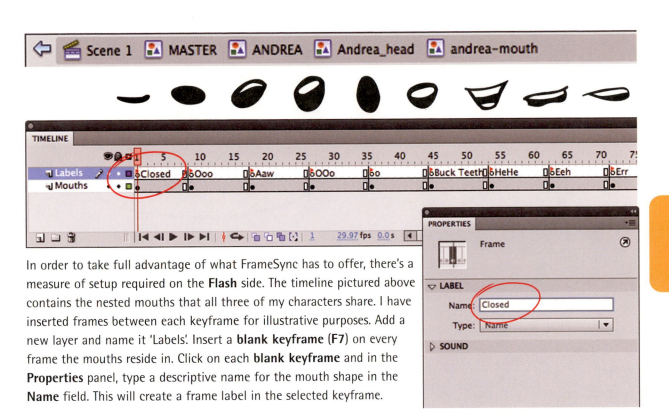

In order to take full advantage of what FrameSync has to offer, there's a measure of setup required on the **Flash** side. The timeline pictured above contains the nested mouths that all three of my characters share. I have inserted frames between each keyframe for illustrative purposes. Add a new layer and name it 'Labels'. Insert a **blank keyframe (F7)** on every frame the mouths reside in. Click on each **blank keyframe** and in the **Properties** panel, type a descriptive name for the mouth shape in the **Name** field. This will create a frame label in the selected keyframe.

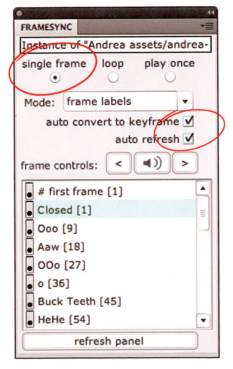

With all the **Frame Labels** in place, return to the parent timeline and launch the **FrameSync** panel by going to **Window > Other Panels > FrameSync**. Select **single frame** and check the **auto convert to keyframe** and **auto refresh options**. Select the instance of the mouth symbol on the stage. **FrameSync** will automatically detect and display the frames along with their frame labels inside the panel.

FrameSync also offers **frame control** buttons. Clicking the forward and reverse buttons will advance the play head respectively. The sound button will play the sound (if present) in the current frame. Having the ability to hear the frame of audio is very useful during the lip sync process to help determine the appropriate mouth shape.

145

Err [72]
Arrr [81]
Eeer [90]
Sss [99]
S [108]
Aa [117]
Aaa [126]
AAaaa [135]
O No Teeth [144]
Oo No Teeth [153]
oo No Teeth [162]

Position the frame indicator on the frame where the audio begins. The **FrameSync** panel will refresh to display the nested mouths and their respective labels. To change the mouth displayed on the stage, click directly on the frame label in the **FrameSync** panel. **FrameSync** will automatically insert a keyframe and update the mouth symbol to display the chosen nested mouth. We just killed another two birds with another stone.

Within the **FrameSync** panel, click the forward frame control button to advance to the next frame in the timeline.

Click the audio button to play the current frame's audio. This is very useful for choosing the next mouth shape needed for this frame.

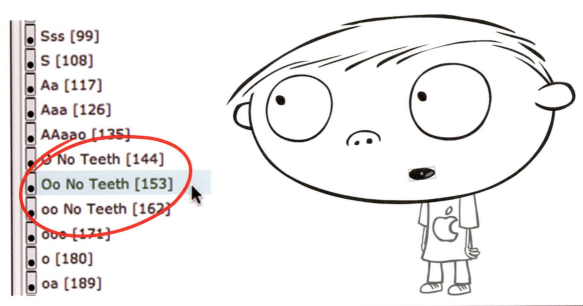

Sss [99]
S [108]
Aa [117]
Aaa [126]
AAaao [135]
O No Teeth [144]
Oo No Teeth [153]
oo No Teeth [162]
ooo [171]
o [180]
oa [189]

Based on the sound for the current frame, my chosen mouth shape is the one I assigned the label '**Oo No Teeth**'. Repeating the previous procedure, click on the frame description in the **FrameSync** panel and the instance is updated on the stage with a keyframe automatically inserted.

Without the **FrameSync** panel, to lip-sync a single frame using **Flash** alone requires a minimum of five mouse clicks and a keypress. My holiday animation is just over 66 seconds long. At 29.97 frames per second, that's almost 2000 frames. With three characters to lip sync (some more than others), that can add up to thousands of mouse clicks. **FrameSync** cuts that number down dramatically. I can change the instance of a **Graphic** symbol in just a single click with **FrameSync**.

FrameSync is compatible with **Flash MX 2004** and up. To download the extension for free, visit **ajarproductions.com/blog/2008/09/09/new-flash-extension-framesync**.

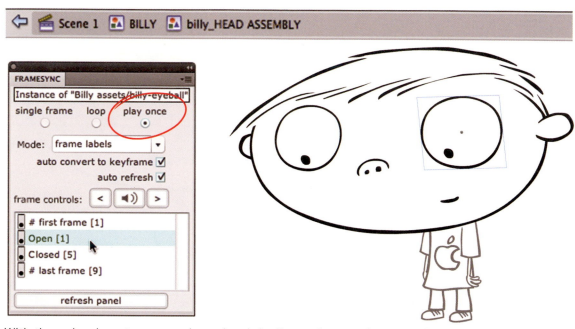

With the major character poses animated and the lip-syncing complete, one of the final steps in my workflow is to go through the timelines for each character and add the final touches: the blinks and eye movements. With the blink animation nested in the eye symbols, the **FrameSync** panel is used to add the blink animation to the timeline. The nested blink animation is a complete loop as the eye closes and then opens again. I select **play once** in the **FrameSync** panel and then click the **Open** label. This will play the blink animation cycle one time through, making the eye close and open again.

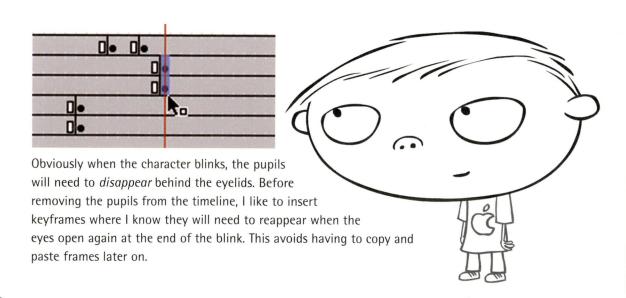

Obviously when the character blinks, the pupils will need to *disappear* behind the eyelids. Before removing the pupils from the timeline, I like to insert keyframes where I know they will need to reappear when the eyes open again at the end of the blink. This avoids having to copy and paste frames later on.

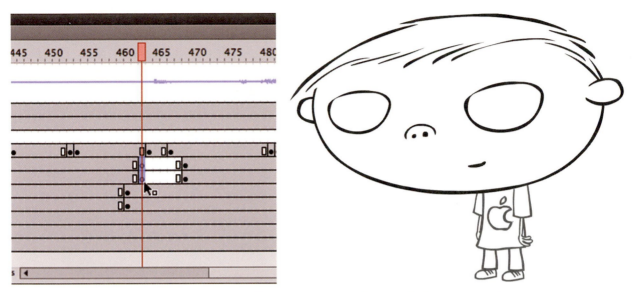

Drag the frame indicator back along the timeline and stop when the top of the eye drops down on or below the pupils. Insert two **blank keyframe**s on the layers that contain the pupils to remove them from the timeline. Play back the blink animation to make sure the effect looks OK. Removing the pupils will provide the illusion of the eyelid coming over the front of the pupils and hiding them from view.

You may notice when we shift our own eyes to look in a different direction, it's often preceded by the involuntary act of blinking. As an animator I try to have my art imitate life as much as possible. I'll use blinks to change the direction the character is looking because it makes them look just a little more natural. In the keyframes that I created on the previous page, I select and reposition the pupils so the Billy character is looking elsewhere. It's not necessary to reposition the pupils each time the character blinks but it can sometimes be useful to do so right after a blink.

smartmouth

As if FrameSync wasn't enough, Justin decided to take lip-syncing a step further by automating the process. Introducing **SmartMouth**, another **Flash** extension from **Ajar Productions** that automatically analyses vocal audio tracks and assigns your mouth shapes based on the sound! All of this is done entirely within the **Flash** authoring tool.

After importing your vocal audio into **Flash** and creating all necessary mouth shapes, launch the **SmartMouth** extension from the Commands menu. The **SmartMouth** panel will automatically detect the audio layer and the layer containing the mouth symbol. **SmartMouth** can also be customized based on your preferences. In the **Mode** section,

Labels has been automatically selected because **SmartMouth** has detected **Frame Labels** in the mouth symbol. Click the **Advanced** button for more advanced options.

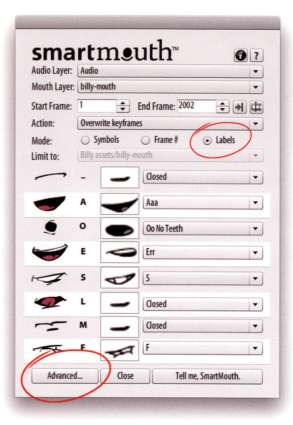

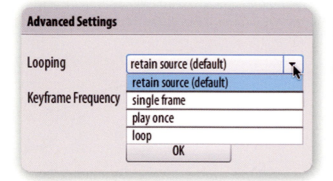

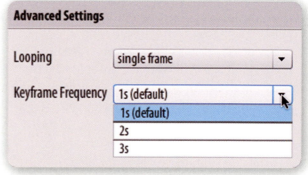

The **Looping** drop-down menu provides options to select how the **Graphic** symbol is treated on the timeline. Select from **retain source** (default), **single frame**, **play once** or **loop**. If you choose play once or loop, the nested mouth timeline may continue to play throughout any inserted frames on the mouth layer.

The **Keyframe Frequency** option tells **SmartMouth** to create keyframes on every single frame (1s), every other frame (2s) or every third frame (3s). This is useful depending on the frame rate of your document. At 30fps and with the keyframe frequency set to 1s, the rapid nature of the mouths changing may not look natural. For faster frame rates you may want to set the frequency to 2s or even 3s for a more natural lip-sync.

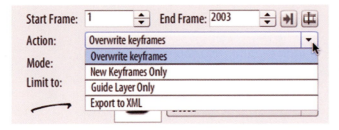

In the **Action** drop-down menu, force **SmartMouth** to overwrite any existing keyframes, generate new keyframes only, create a guide layer with keyframes and frame label information pulled from the nested mouth symbol or export the data to **XML** format.

With all settings in place, click the **Tell me, SmartMouth** button to run the extension.

SmartMouth will begin analyzing the audio and assigning the appropriate mouth shapes to the timeline. A progress window will launch, showing **SmartMouth** hard at work. The entire process is relatively quick depending on the length of your audio. A minute of audio took **SmartMouth** approximately 30 seconds to analyzes and assign mouths to. This is an amazing improvement over my traditional workflow where a minute of audio would take me upwards of an hour to lip-sync manually.

With the analysis complete and **SmartMouth** finished assigning mouths to audio, the mouth layer is now populated with keyframes. Play back the timeline to see how accurate **SmartMouth** was at deciding what mouth was best for the audio. There's a chance **SmartMouth** didn't reach perfection but you can easily go back and edit the areas of the timeline that need attention manually.

Learn more about **SmartMouth** by going to
ajarproductions.com/pages/products/smartmouth

The Quicktime Exporter

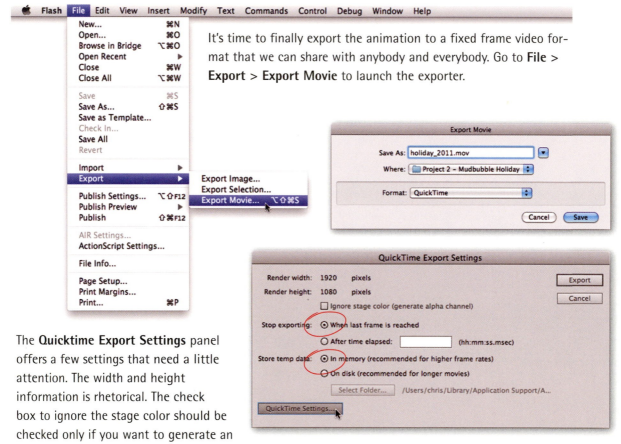

It's time to finally export the animation to a fixed frame video format that we can share with anybody and everybody. Go to **File > Export > Export Movie** to launch the exporter.

The **Quicktime Export Settings** panel offers a few settings that need a little attention. The width and height information is rhetorical. The check box to ignore the stage color should be checked only if you want to generate an alpha channel in your exported file. I did not so I left this unchecked.

Stop exporting: Since our animation is all on the timeline, we can select **When last frame is reached** and let **Flash** detect the end of our animation for us. The **After time elapsed** option is for content generated by **ActionScript** that has no final frame.

Store temp data: This option can be a little confusing. **In memory** is recommended for higher frame rates and **On disk** is recommended for longer movies. In my case, almost all of my projects have high frame rates and long timelines. But I have found through trial and error **In memory** will suit most needs if you have a computer with a reasonable amount of RAM. If not, choose **On disk**.

To select **compression formats** click the **Quicktime Settings** button in the lower left corner.

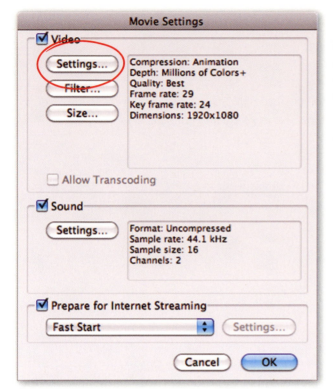

In the **Movie Settings** panel, click on the **Settings** button in the **Video** category to select a **compression format**. If you plan on uploading your video to a web based video portal such as **YouTube** or **Vimeo**, select the **H.264** format as it is widely supported and does a very good job of compressing the video while retaining quality.

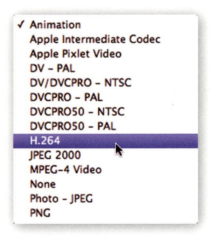

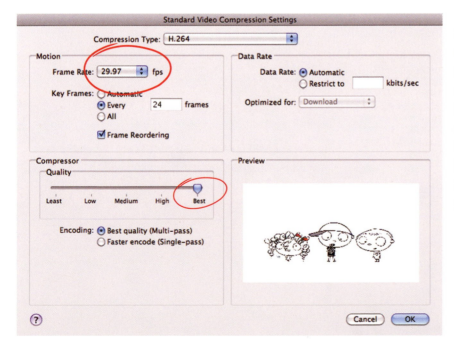

In the **Standard Video Compression Settings** window, insure the **Frame Rate** is set to **Current** or **29.97** to match the **Flash** document frame rate. By default, **Quality** is set to High but I prefer to move the slider to **Best**. This creates a larger file size but better quality. **Data Rate** can remain at the default **Automatic**.

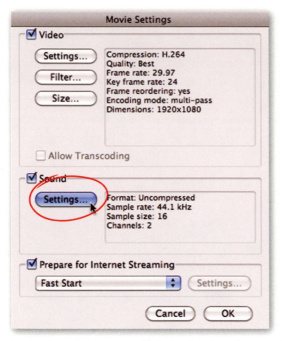

In the **Sound** category, click the **Settings** button. I prefer to keep my audio uncompressed but **YouTube** and **Vimeo** both recommend using **ACC (Advanced Audio Codec)**. In the audio settings popup, click the **Compressor** drop-down menu.

Select **MPEG-4** Audio from the list of compression types. **MPEG-4** format will allow you to choose **ACC** as an option in the next step.

Click on the **Options** button to access audio compression options.

Click **Options** and then choose **AAC** from the **Compressor** drop-down menu. While in the **Options** panel, set the **Bit Rate** to **320 kbits/second** because that is the highest bit rate **YouTube** and **Vimeo** support. Change the **Encoder Quality** from the default **Better** to **Best**. Click **OK**.

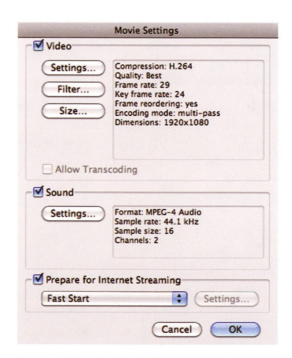

Your **Quicktime** export settings should look similar if not exactly like mine shown here.
Video
Compression: **H.264**
Quality: **Best**
Frame rate: **29.97**

Audio
Format: **MPEG-4**
Compression: **ACC**

I also leave **Prepare for Internet Streaming** checked so that the video does not have to be fully downloaded before playing. Click **OK**.

The **Quicktime Exporter** will play and record the content in the **Flash** player behind the scenes before rendering a file in **MOV** format.

Portability

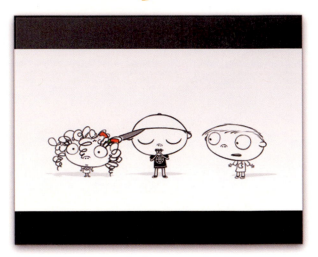

When the exporter is complete you will have a self-contained **Quicktime** movie file that can be shared across a variety of platforms. In the Frog Day Afternoon project, I explained how to upload to video sharing websites such as **YouTube** and **Vimeo**, but you may also want to have your animations on your portable device such as a smartphone or tablet. Having your animations on a portable device will allow you to show off your work to practically anyone anywhere without the need to be online.

The **iPhone** and **iPad** support a specific number of video formats. The easiest way to format your videos for these devices is to use **iTunes** or the **Quicktime** application. Launch the **iTunes** application and go to **File > Add to Library** and locate the **Quicktime** movie of your animation that was exported from **Flash**.

Connect your **iPhone** to your computer and allow it to sync with the **iTunes** application. Select the **Movie** category from the **iTunes** menu to display the videos in your **Library**. In the list of videos displayed, select the file you want to format for your **iPod** or **iPhone**.

holiday_2011

 ✓ holiday_2011 1:15

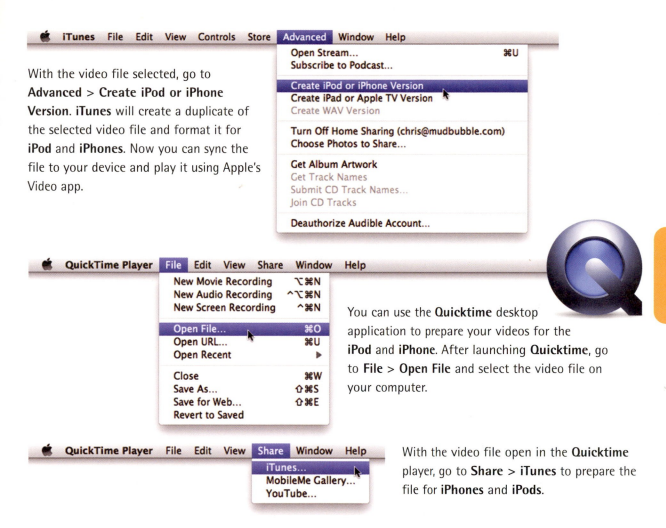

With the video file selected, go to **Advanced > Create iPod or iPhone Version**. **iTunes** will create a duplicate of the selected video file and format it for **iPod** and **iPhones**. Now you can sync the file to your device and play it using Apple's Video app.

You can use the **Quicktime** desktop application to prepare your videos for the **iPod** and **iPhone**. After launching **Quicktime**, go to **File > Open File** and select the video file on your computer.

With the video file open in the **Quicktime** player, go to **Share > iTunes** to prepare the file for **iPhones** and **iPods**.

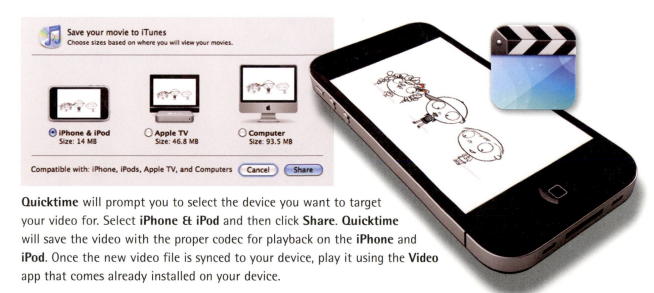

Quicktime will prompt you to select the device you want to target your video for. Select **iPhone & iPod** and then click **Share**. **Quicktime** will save the video with the proper codec for playback on the **iPhone** and **iPod**. Once the new video file is synced to your device, play it using the **Video** app that comes already installed on your device.

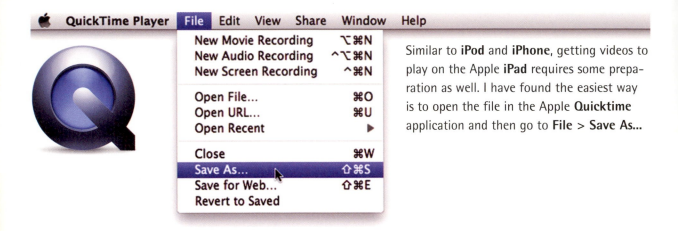

Similar to **iPod** and **iPhone**, getting videos to play on the Apple **iPad** requires some preparation as well. I have found the easiest way is to open the file in the Apple **Quicktime** application and then go to **File > Save As...**

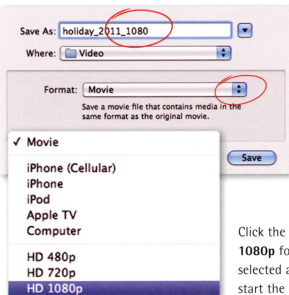

I like to append '**_1080**' to the file name to make it easier to identify later on.

Click the **Format** drop-down menu and select the **HD 1080p** format. With the file name set, the destination folder selected and the format set to **HD 1080p**, click **Save** to start the export process.

At just over one minute in length, my animation took only about three minutes to export to **iPad** compatible **HD 1080p** format.

Launch your **iTunes** application and go to **File > Add to Library...** If for some remote reason you do not have **iTunes** installed, visit **apple.com/itunes** to download it. You will need **iTunes** to sync audio, video, photos, apps and books to your **iPad** and **iPhone**.

Connect your **iPad** to your computer and wait a moment for **iTunes** to recognize your device. Select your device from the **Devices** section in the left menu and then click on the **Movies** category in the main **iTunes** window. In the **Movies** category, select the video file that you just added to the library and then click **Sync** to copy the video file to your **iPad**.

Once the syncing process is complete, tap the Videos icon (left) to launch **iPad**'s video app. Tap the icon that represents the video that you just synced, sit back and enjoy the fruits of your labor directly on your **iPad**.

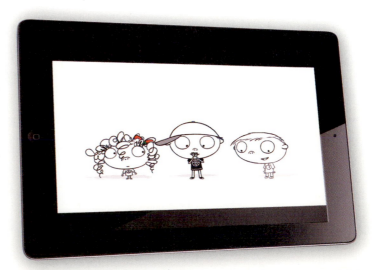

159

If you have an **Android** tablet, such as the **Samsung Galaxy Tab**, you can use an application called **Kies** to connect your device to your computer. With **Kies** you can sync data, import and export contacts, back up or restore your device and keep its software and firmware up to date. **Kies** is available for Windows and Mac computers.

Android tablets support the **H.264 MP4** format. The Adobe **Flash Exporter** supports **H.264 MOV Quicktime** format which will not play on an **Android** device. This means your video file must be converted to the **MP4** format before it can by synced to the device. There are countless video applications on the Internet that specialize in converting video files to **MP4** format. Most offer trial versions so you can try before you buy. The conversion process is usually straightforward. Most converters use a simple wizard style interface and within a handful of clicks or less, you'll have an **MP4** formatted file that will play on your **Android** device.

Launch the **Kies** application on your Mac or Windows and connect your **Android** device using a **USB** connection. Wait for **Kies** to recoginize your device and then go to **File > Add File to Library** and navigate to your **MP4** video file.

The **Kies** application will add your selected video file to its library where it can be viewed by selecting **Videos** from the **Library** menu in the left column. In the main window you can click on a video thumbnail and watch a preview of the movie.

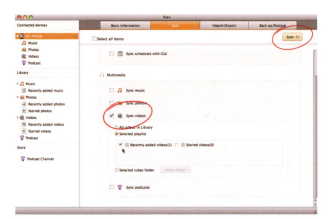

In the **Connected devices** section of the menu on the left, select your device. In the main window select the **Sync** tab and then in the **Multimedia** category check the **Sync videos** option. You can then select all videos in the library or just the selected videos in the playlist. With your video(s) selected click the **Sync** button.

With the **Kies** software you can connect to your device via a wi-fi connection if there's one available. This can be useful if you don't have a **USB** cable to connect with directly.

With the sync process complete you will see your video(s) listed in the **Videos** section within the **Connected devices** category.

With the sync process completed launch the video player application on your **Android** tablet and locate your video. To play the video just tap its thumbnail image. As an animator in the digital world it's a powerful thing to have the ability to carry your portfolio under your arm. Imagine the confidence you will have walking into your next big interview with a tablet full of your animations.

Project 3

Focal Press Solutions

Working with Focal Press as an author has been an overwhelmingly positive experience. So when they asked me to help with an animation project, I was very quick to say yes. The request was to design and animate a marketing video for a website promoting a number of informative solutions for media instructors, students and filmmakers. This project was unique in that they asked me to not only design and animate the video, but to provide the voiceover talent and music as well. The whole ball of wax was in my hands. I had to put on all my creative hats including those of art director, producer, storyboard designer, character designer, animator, composer, recorder, voice actor and coffee boy.

It was clear I was going to need a little help.

Thanks to some very talented friends I was able to produce a successful promotional video using Adobe Flash, Photoshop and Premiere Pro. This project will take you through the entire production process.

- ▸ Story
- ▸ Storyboarding
- ▸ Character Design
- ▸ Inverse kinematics
- ▸ Background Design
- ▸ Parallax Effect
- ▸ Voice Talent
- ▸ Music
- ▸ Scenes
- ▸ Adobe Premiere Pro
- ▸ Exporting

Story

Like most projects, it started with a script. The script was sent to me as a Word document. It was now my job to read through it several times and envision how this animation would look and feel.

We Have Your Solutions Animated Video

We see a college campus and approach an ivy-clad building. We enter. We see a door. On it, we see 'Professor Needs'. Door opens and we enter the office. We see Professor Needs at his desk, studying an envelope, addressed to him. He opens it up and takes out a piece of paper. He studies it. Finally, we see what's on the paper:

We have your solutions *(In ransom-note font).*

Suddenly, the phone rings, which startles the professor. He answers it.

(Altered voice): *We have your solutions. (Laughs maniacally)*

The professor looks to be in disbelief.

(Professor): *Where are they!?*

Cut to:

We move quickly across town and across the country to the Boston area. We zoom in on an office building and enter.

We see a door. The door opens and it reveals a staircase. We go down the staircase to a dark room. A light emits from behind another door. That door opens and we see a number of 'solutions' restrained. The camera pans across the different 'solutions':

The **Solutions***' have a sort of human form... maybe something like this – but less human. Each one is somehow labeled with their corresponding solution (i.e., Affordable Textbooks).*

Solutions:

Affordable Textbooks

Xplana (e-textbooks)

FilmSkills (the visual way to learn filmmaking)

e-resources (e-books and videos)

Practical Materials

Instructor Resources

Engaging Materials

Excellence in Filmmaking Award Sponsorship

The camera moves back out the door, and the door slams shut.

Cut back to the Professor who is still on the phone.

(Altered voice): *Professor Needs, we have your solutions. We won't charge a king's ransom for them. Instead, you'll have to pay very affordable prices. You won't see any triple-digit textbook costs here. Or in some cases (like with the Excellence in Filmmaking Award Sponsorship), you'll pay nothing at all* (Laughs maniacally...but midway through, it becomes a normal voice).

(Professor): *Wait... Focal Press, is that you?*

(Voice, trying to sound altered): *What? No, of course not.*

The Professor looks skeptical.

(Voice): *Yes, alright, it's us.*

(Professor): *I knew it. Only Focal Press could have all my solutions.*

(Voice): *Yes. And we are not really holding them hostage. The solutions were actually right in front of you all along.*

The Professor looks up and notices the Solutions are all standing awkwardly in his office, right in front of his desk. One of them waves to the Professor. It's pretty crowded in his office.

The Professor scans all the Solutions and smiles politely.

(Professor): *I'm going to need a bigger office.*

The Professor and the Voice start laughing. The image freezes mid-chuckle (like it's a cheesy sitcom).

Superimpose the following copy:

The Professor went on to adopt all the Solutions. They are living happily ever after.

Focal Press continues making Solutions.

Focal Press has been tempted to make some prank calls with the altered voice machine, but it has restrained itself.

No Solutions were harmed in the making of this video.

(Video ends]

From this script it was my job as the designer and animator to bring it to life. This is always the hardest part of the project. It was now in my hands to create something visually memorable - something that exceeded the client's expectations. I treat every project like a baseball game where it's my turn at bat in the bottom of the ninth inning with bases loaded and I need to hit a home run to win the game. It's time to one-up myself as a designer and an animator.

Storyboarding

I've been a fan of **Alex Fernandez**'s work for a long time. Alex is a brilliant storyboard artist whose art can be seen at **matadorstudio.com**. I often enjoy storyboarding but this time around I wanted to collaborate with someone to get a fresh perspective on the project at hand. I sent Alex the script and told him he had complete artistic license to come up with the visual story. Alex met my highest expectations as each shot was perfectly crafted from the script.

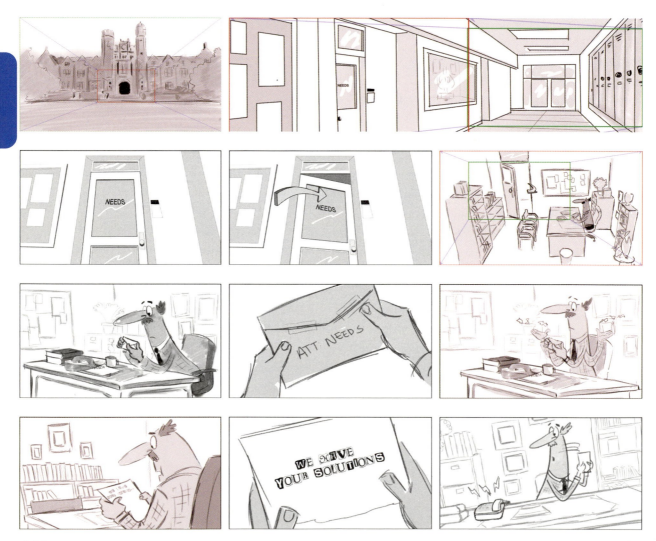

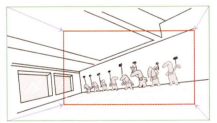

To imply camera movement, Alex uses two different colored rectangles over the shot. The green rectangle represents the visible area (or frame) of the initial shot. The red rectangle represents the last frame of the shot. The blue lines represent the intended motion of the camera. Placement of these rectangles is how a storyboard artist suggests the intended camera **panning** and **zooming**. Color-coded rectangles indicate a zoom shot. Zooming is a great technique for an establishing shot as it clearly emphasizes the setting for the story.

Adobe **Flash** doesn't have a 'camera', not technically anyway. If there's one thing **Flash** has taught me as an animator, it's how to work around limitations. With the storyboard as individual images the next step is to import them into **Flash** so I can create an animated storyboard or what is referred to as an **animatic**. An **animatic** would allow me to create the intended camera motions as Alex had implied, as well as give the entire animation a sense of motion and timing.

The quickest and easiest way to import a series of images into **Flash** is to name each individual file sequentially. Here I have provided the name '**Solutions_01.jpg**' for the first image, '**Solutions_02.jpg**' for the second image and so on.

In **Flash** go to File > Import > Import to Stage...

Flash will detect the numerical sequence and ask you if you want to import all of the images. Click **Yes**.

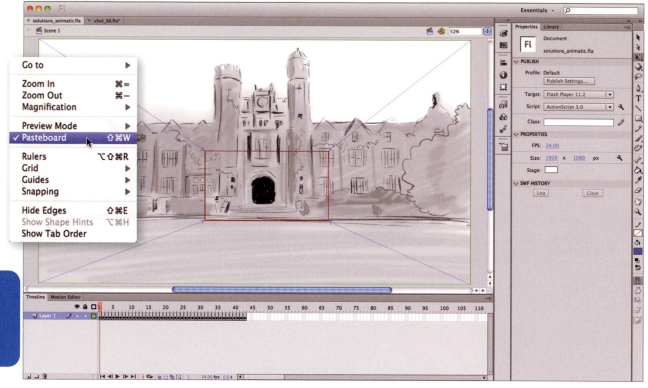

With the sequence fully imported each image will be placed on the timeline in **Layer 1**, each in its own keyframe. Here we can see the first image of the establishing shot on the stage. At this point make sure the **Flash** stage size is set to the same width and height as the imported images. I choose to work at **1920 x 1080** which is a **16:9 aspect ratio** for high definition video. I want to make sure I can see outside the stage area before I start scaling the image. **Flash** refers to the area outside the stage as the **Pasteboard** and it can be accessed by going to **View > Pasteboard**.

Here's what the timeline layer looks like with each image in its own keyframe. The next step will be to insert frames between each keyframe to extend the exposure of each frame. Inserting frames allows me to adjust the timing of each shot.

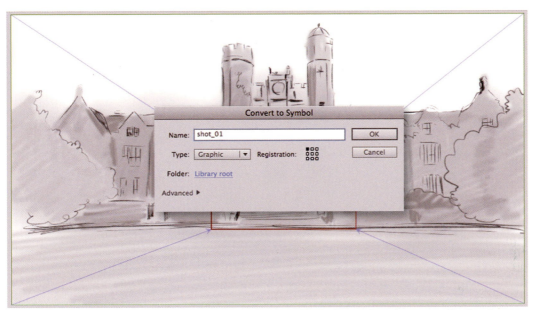

The first shot requires a camera zoom to provide the effect of entering the scene. To simulate this effect you must first **convert the image to a symbol** so we can apply a motion tween. Select the image and press the **F8** key. In the **Convert to Symbol** popup, type in an appropriate name and click **OK**.

Before we can create the zoom effect we need to insert frames. With the first keyframe selected press the **F5** (**Insert Frames**) key. Hold down the **F5** key or press it repeatedly until you've added your desired number of frames. I have added approximately 70-80 frames.

Start the zoom about one second (or 24 frames) in on the timeline by selecting frame 24 and pressing the **F6** key (**Insert Keyframe**). Set the end point of the zoom by inserting another keyframe around frame 70. Don't worry about the duration of the zoom at this point. We can make adjustments later.

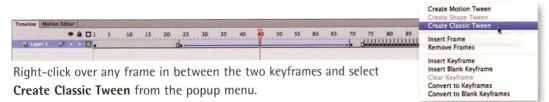

Right-click over any frame in between the two keyframes and select **Create Classic Tween** from the popup menu.

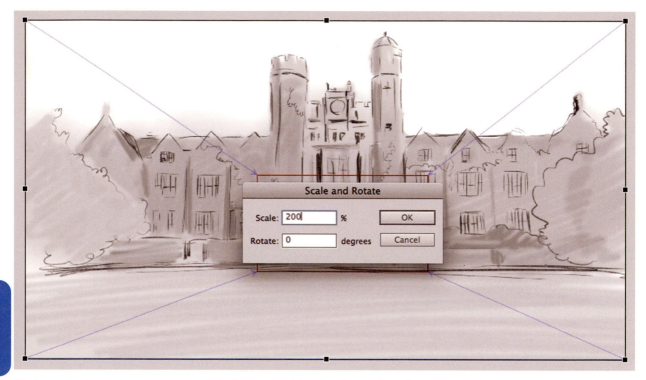

We haven't changed any property of the image in either keyframe, therefore nothing will happen if you play the timeline. For the zoom effect to work we need to scale the image in the last keyframe. Position the frame indicator on frame 70, select the **Free Transform** tool (**Q**) and then select the image on the stage. Hold down the **Shift** key to constrain its proportions and click and drag any of the four corner handles to scale the image larger than its original size.

Since we're dealing with a very large image, your screen resolution may not provide enough real estate to see beyond the boundaries of the **Flash** stage, which can make scaling difficult. The solution is to use the **Scale and Rotate** tool: **Modify > Transform > Scale and Rotate**. This panel allows you to type in a percentage value based on the amount you want to scale the image. Here I have doubled the size of the image using a value of **200%**.

With the image scaled so large, it can be hit and miss trying to position the image exactly where you want it within the viewable stage area. I have a quick and easy solution for this problem. With the symbol selected, adjust the amount of transparency in the **Color Effect** section of the **Properties** panel. Using the slider, adjust the amount of **Alpha** to about **25–30%**.

With the transparency added to the symbol it's much easier to position it relative to the stage behind it. The red outlines of the rectangle indicate the final camera position and should align with the stage itself.

With a little positioning and some slight scaling adjustments, the image perfectly aligns to the stage. You can now remove the transparency applied to the symbol using the **Properties** panel. Simply select **None** from the **Color Effect** drop-down menu.

The panning and zooming effect is best viewed when the area outside the stage is hidden. Go to **View > Pasteboard** to toggle its visibility. The resulting animation is represented by the sequence pictured above.

Motion Tweens interpolate movement at a consistent rate across the frames in which they are applied. The overall motion is linear, robotic and mechanical, which can cause panning and zooming to start and end abruptly in a visually jarring way.

The solution is to apply **easing** to the **Motion Tween**, specifically an **ease-in** and **ease-out** so that the zoom starts gradually, increases speed and then gradually comes to a stop over the course of the tween.

Select any frame in the **Motion Tween** in the timeline and then expand the **Tweening** section of the **Properties** panel. To the right of the **Ease** hot text slider is a button with a pencil icon. Clicking this will launch the **Custom Ease In / Ease Out panel**.

The **Custom Ease** panel represents easing with a path that can be customized. In its default state, the diagonal path represents no easing being applied. The handles on each end of the line represent the beginning and end of the selected motion tween. The tween strength is represented vertically along the left edge and the numbers along the bottom represent the corresponding frames in the timeline.

To apply easing at the beginning of the motion tween, click and drag the lower left handle as seen in the image to the right. This soft curve represents a gradual increase in the motion tween at the very beginning of the tween span.

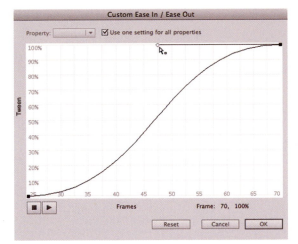

To apply easing at the end of the motion tween, click and drag the upper right handle as seen in the image to the left. The curve should now resemble what I refer to as a 'soft S' shape indicating a combination of easing in and out within the select tween(s).

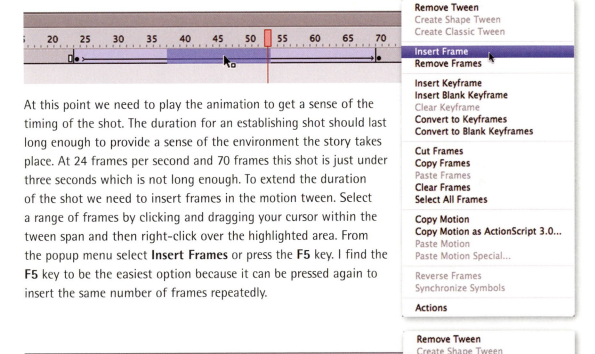

At this point we need to play the animation to get a sense of the timing of the shot. The duration for an establishing shot should last long enough to provide a sense of the environment the story takes place. At 24 frames per second and 70 frames this shot is just under three seconds which is not long enough. To extend the duration of the shot we need to insert frames in the motion tween. Select a range of frames by clicking and dragging your cursor within the tween span and then right-click over the highlighted area. From the popup menu select **Insert Frames** or press the **F5** key. I find the **F5** key to be the easiest option because it can be pressed again to insert the same number of frames repeatedly.

If the shot feels too long, removing frames is done by selecting a span of the motion tween, right-clicking over the highlighted area and selecting **Remove Frames** from the popup menu.

Another visual effect I frequently use when creating animatics is **crossfading** from one image to another. **Crossfading** is the transition between two different shots, unlike dissolving to or from black which is called a **fade**. A **crossfade** is used to create a soft transition between shots. To create a **crossfade** in **Flash** you need to use a **Motion Tween** with alpha transparency.

Since **Motion Tweens** need to reside on their own layer in order to work, you'll need to create a new layer for the image that will have the alpha fade effect applied to it.

With the new layer created, click and drag the keyframe containing the image from its original layer to the new layer, keeping it on the same frame number.

Decide how long you want the **crossfade** to last and then insert a keyframe (**F6**) on that frame.

Right-click over any frame in between the two keyframes and select **Create Classic Tween** from the popup menu. Now we just need to fade in the image using the alpha color effect. Position the frame indicator on the first keyframe of the **Motion Tween**.

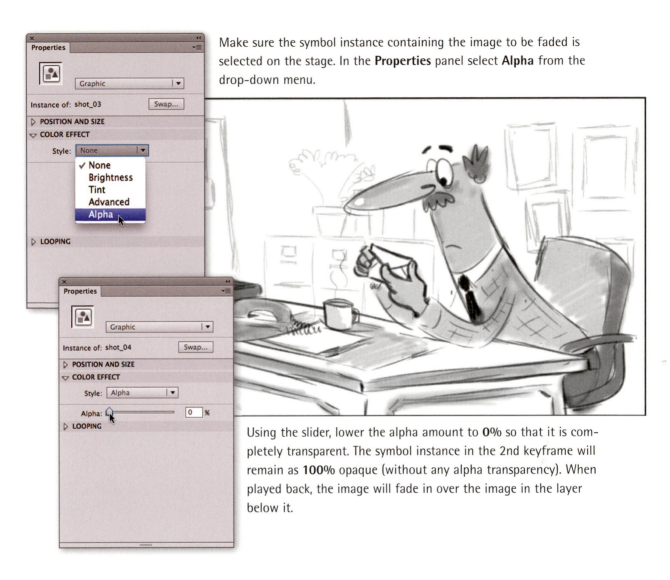

Make sure the symbol instance containing the image to be faded is selected on the stage. In the **Properties** panel select **Alpha** from the drop-down menu.

Using the slider, lower the alpha amount to **0%** so that it is completely transparent. The symbol instance in the 2nd keyframe will remain as **100%** opaque (without any alpha transparency). When played back, the image will fade in over the image in the layer below it.

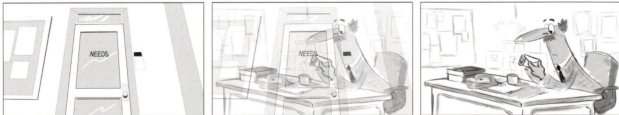

Here's what the **crossfade** looks like with one image fading out over the next image below. Creating the rest of the animatic involves inserting frames in between each shot and playing back the animation to get a general sense of the timing. You will not want to fine-tune the timing until you have the recorded audio but for now this animatic will give you and the client an overall idea of the style and pacing of the animation.

With the rest of the animatic timed out, it's time to export it to a format that can be shared with the client so they can watch it and then provide feedback and ultimately final approval. You have a couple of choices when it comes to formats:

 1 The **SWF** format can be used and embedded in an **HTML** page and put online. Sending the client the URL of the page containing the **SWF** will allow them to watch the storyboard via the **Adobe Flash Player**. The advantage of using the **Flash Player** is not having to worry about how to send large movie files. The disadvantage is there will be no way for the client to control the playback of the animatic within the **Flash Player** unless you build the controls yourself using **ActionScript**.

 2 The **Quicktime** format can be used and can also be embedded in a web page and can be streamed to the client via their browser. The **Quicktime** player has playback controls built in, making it easy for the client to pause, play, rewind and fast forward throughout the animatic. The disadvantage with **Quicktime** is that the file size can be large depending on its duration and compression settings.

 3 You can chose to export your animatic using the **Flash Quicktime Exporter** and then sharing the actual **MOV** file with the client using a **Dropbox** account. The advantage of using **Dropbox** is the security of the content is limited to those with whom I share my folder for this particular project. Copying a file to your **Dropbox** is as quick and easy as dragging from one **Finder** window to another.

My preference is to animate with my document set to **24 frames per second**. In the previous chapter I explained how the **Flash Quicktime Exporter** prefers the **Flash** document to be set to **29.97 frames per second** to avoid rendering issues in the final movie file. This poses an interesting problem. If I animate at 24 frames per second I won't be able to use the **Quicktime Exporter**. I'm going to need to adjust my workflow.

Another interesting problem is that the entire **Solutions** animation is going to be at least three minutes in length based on the length of the animatic. It's not always a good idea to have a single **Flash** document at this length, for two reasons:

1 The larger a **Flash** document gets, the greater the chances of it crashing and becoming corrupt increase.

2 It's easier and more efficient to manage smaller scenes as individual **Flash** files and then compile them later in a video editing application.

For these reasons I created a different workflow for the **Solutions** project:

1 Each shot in the animatic was a different **Flash** document averaging between five and ten seconds in duration.

2 Each shot was published from **Flash** to the **SWF** format.

3 The **SWF** files were imported directly into **Adobe Premiere** where they were reassembled on the timeline and edited to the audio soundtrack.

4 The final animation was exported directly from **Adobe Premiere Pro** for the web and mobile devices.

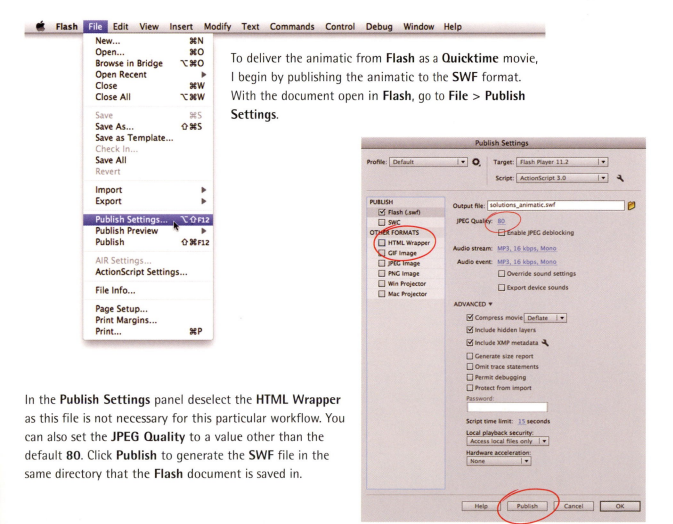

To deliver the animatic from **Flash** as a **Quicktime** movie, I begin by publishing the animatic to the **SWF** format. With the document open in **Flash**, go to **File > Publish Settings**.

In the **Publish Settings** panel deselect the **HTML Wrapper** as this file is not necessary for this particular workflow. You can also set the **JPEG Quality** to a value other than the default **80**. Click **Publish** to generate the **SWF** file in the same directory that the **Flash** document is saved in.

Character Design

The first character I designed was Professor Needs since he was the main character in the story. My initial sketches were close but didn't exactly have the look and feel we were going for. The character on the left with the very long nose did have potential and received good feedback from the client, but didn't quite meet our collective expectations. The character with the beard was also well received but didn't have the right personality. The character peering over his desk at the chicken was a concept sketch from a personal project that I thought I'd present to the client just in case it was what they were looking for, but it wasn't.

Round 2 of character sketches produced the character below which resonated with the client and the decision was made. Meet Professor Needs in sketch form. With client approval came the next step: redrawing him in **Flash** and rigging him for animation.

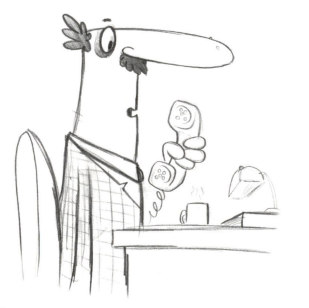

With the sketches scanned and imported into **Flash**, the re-drawing begins. Using the **Brush** tool I draw the nose first.

The most important part of this process is thinking about how the character will move. I kept the nose separate from the head because it might be fun if it wiggles a little.

Each part of the head is drawn on a new layer and converted to a **Graphic** symbol.

The mouth, eyes, pupils, brows and tufts of hair are all individual symbols on different layers. I may not animate each of these objects individually but at least I have the option to do so.

In keeping with the same character setup techniques discussed in the previous chapter, the head and all its parts are converted into a single **Graphic** symbol.

With the **Free Transform (Q)** tool, click on the head symbol and position the center point, represented by the small white circle, to the base of the neck where it meets the body. This will allow the head to 'hinge' naturally.

We only see this character's upper body because he sits behind a desk. There isn't one shot where we see the character from the waist down. He is always sitting behind his desk. So I wanted to add more detail to what little we do see. As a professor I wanted him to look conservative by wearing a brown plaid suit. I started by drawing the outline of the suit using the sketch as my reference.

With the body drawn, I filled the suit with a dark brown color. This would serve as the base color for the plaid pattern that I wanted to create. There are several ways to create plaid patterns and this one really takes advantage of the **Brush** tool's sub-selections. Mix and select a new color for the next step.

Click the brown suit color with the **Selection** tool (**V**). Select the **Brush** tool (B) and in the sub-selection menu in the **Tools** panel, select the **Paint Selection** setting. With the suit color selected, begin by painting vertical and horizontal stripes.

Don't worry about being messy and painting outside the selected area. Once you stop painting, the color will only appear within the selection. Continue painting stripes until you have a grid similar to the image on the right.

Here's what the suit looks like with the horizontal and vertical stripes complete. It's not quite the plaid look we're going for but it's close. We need just one more step.

Zoom in closer to the artwork to make this next step a little easier. Mix your third and final color for the plaid pattern. For this character I chose yellow. With the **Rectangle** tool with this new color as the fill (and no outline selected), draw a square directly within the stripes where the vertical and horizontal lines intersect.

Select the **Selection** tool (**V**) and make sure the **Snap** feature is on by clicking the **Magnet** icon in the **Tools** panel. Click and drag each corner of the square until they snap to opposing corners made by the stripes we painted earlier. Repeat this procedure for every intersection created by the horizontal and vertical stripes.

Voilà! When finished you will have a pattern that resembles a plaid texture. I finished off the ensemble by filling the shirt with green and the tie with purple. There's nothing like a character with a sense of style!

inverse kinematics

Adobe introduced a tool called **Bones** in **Creative Suite 4**. The **Bone** tool allows you to link objects together using **inverse kinematics**, a popular process in 2D and 3D animation programs that calculates the geometric rotation and position of linked objets. I use the **Bone** tool selectively and sparingly as opposed to relying on a single armature to control an entire character. This is because I prefer to combine different animation techniques within a single character. That said, the **Bone** tool is perfect for controlling arms and legs individually.

The professor's arm is comprised of three symbols: hand, forearm and upper arm. Having three symbols requires only two bones to link them together. The first bone will connect the upper arm to the forearm and the second bone will connect the forearm to the hand. It's very useful to have a third bone so you can apply different properties to it to control the hand symbol. For this reason I created an extra shape (represented by the red circle) and converted it to **Graphic** symbol.

With the **Bone** tool (M) selected, drag from the end of the upper arm to where the forearm overlaps at the elbow. This will allow the bone to snap to both symbols, linking them together. The first bone in any armature is the root bone and all subsequent bones will be child bones.

Click and drag again to link the forearm to the hand. Remember to start and end each bone where the symbols hinge together naturally, such as shoulders, elbows and wrists.

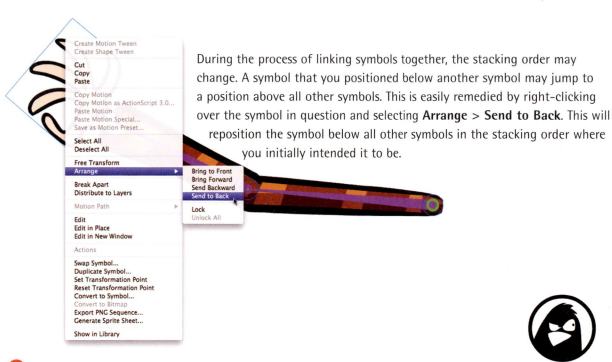

During the process of linking symbols together, the stacking order may change. A symbol that you positioned below another symbol may jump to a position above all other symbols. This is easily remedied by right-clicking over the symbol in question and selecting **Arrange > Send to Back**. This will reposition the symbol below all other symbols in the stacking order where you initially intended it to be.

The final bone has been connected to the **Graphic** symbol containing the red circle, the last symbol in the armature. During the process of linking symbols using the **Bone** tool, you will also notice that **Flash** has created a new layer named '**Armature 1**'. This layer will have a green span color to it to indicate it's an armature layer. As you position the frame indicator and articulate the arm armature, keyframes will be generated automatically. **Armature** layers can be renamed if you want to provide a little more description to their content.

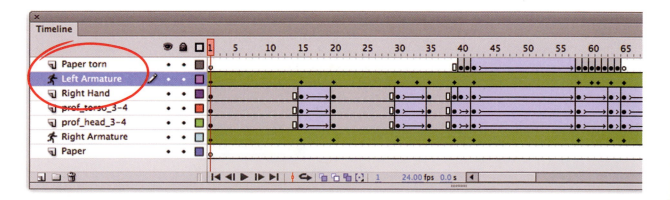

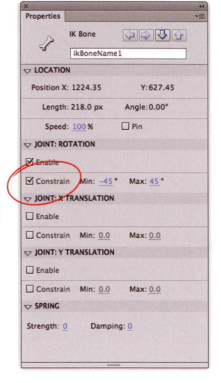

To take advantage of Bones turn on the **Constraint** option. To do this, select one of the bones using the **Selection (V)** tool. The **Properties** panel will update to reflect **Rotation** and **Translation** options. Check the **Constrain** option in the **Joint Rotation** section.

With **Constrain** turned on, you will notice a visual indicator that displays the range of articulation for the respective bone. By default, the range of rotation is **45** degrees.

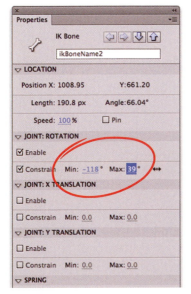

Adjust the amount of constraint using the hot text sliders by clicking and dragging horizontally over them. Alternatively you can click to select the text and type in the exact amount. I find it easier to drag over the value and watch the visual indicator rotate around the joint until it reaches the desired angle. Test the joint to insure the arm can't bend beyond its anatomical limits.

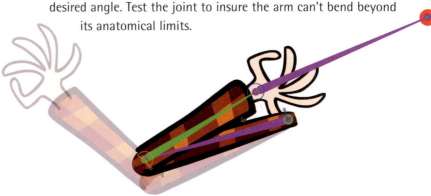

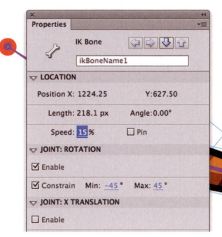

Properties

IK Bone

ikBoneName1

LOCATION

Position X: 1224.25 Y: 627.50

Length: 218.1 px Angle: 0.00°

Speed: **15** % ☐ Pin

JOINT: ROTATION

☑ Enable

☑ Constrain Min: −45 ° Max: 45 °

JOINT: X TRANSLATION

☐ Enable

The last step is to adjust the **Speed** of each bone in the armature. **Speed** controls how much resistance the bone has when being moved. The default speed is **100%** which applies no resistance to the bone. Adjusting the speed to **0%** will constrain the bone so it can't be moved at all. Using **Speed** adjustments, an armature can be adjusted to feel more realistic, as if it actually has weight to each individual bone. Select the *root bone* in the armature and adjust the speed value to around **15%**.

Select the forearm bone in the armature and adjust the amount of **Speed** to around **75%**. Leave the hand bone at its default **Speed** value so it moves without any resistance.

Properties

IK Bone

ikBoneName2

LOCATION

Position X: 1006.85 Y: 610.60

Length: 190.9 px Angle: 11.89°

Speed: **75** % ☐ Pin

JOINT: ROTATION

☑ Enable

☑ Constrain Min: −51 ° Max: 156 °

JOINT: X TRANSLATION

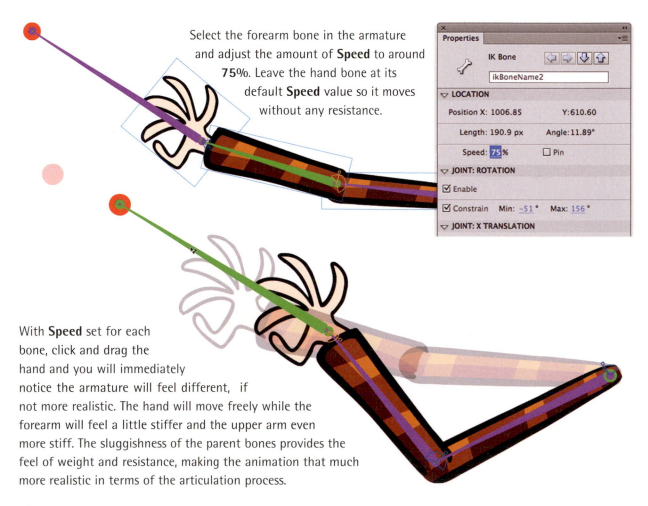

With **Speed** set for each bone, click and drag the hand and you will immediately notice the armature will feel different, if not more realistic. The hand will move freely while the forearm will feel a little stiffer and the upper arm even more stiff. The sluggishness of the parent bones provides the feel of weight and resistance, making the animation that much more realistic in terms of the articulation process.

Scene 1 PROF_PACK_BEHIND_DESK

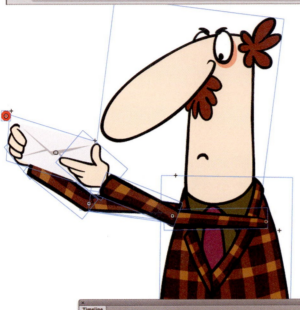

In terms of character setup, Professor Needs is nested inside a **Graphic** symbol named **PROF_ PACK_BEHIND_DESK**. Inside this symbol are seven layers that contain all of the necessary symbols for this scene. His head is a single symbol that has all of the individual head symbols nested inside (similar to how I setup the character in my holiday animations earlier in this book). All the arm symbols reside on **Armature** layers and the body is a single **Graphic** on its own layer. Since we only see Professor Needs behind his desk, there was no need to create the lower half of his body for these shots.

If you have a Bone armature in a separate document or timeline that you want to use, or if you need to move an **IK span** to a different timeline, **right-click** over the span and choose **Copy Frames** from the popup menu. Go to the document or symbol you want to move the **IK span** to and **right-click** over a blank keyframe and choose **Paste Frames** from the popup menu.

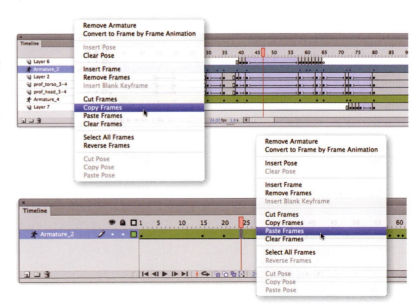

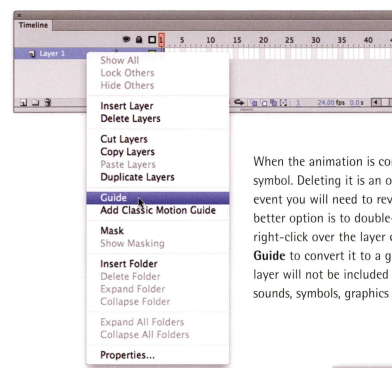

When the animation is complete, it's time to remove the extra symbol. Deleting it is an option but not a very good one in the event you will need to revise the animation in the future. The better option is to double-click the **Graphic** symbol to edit it, right-click over the layer containing the circle art and then select **Guide** to convert it to a guide layer. Any content in a Guide layer will not be included during the export process. This includes sounds, symbols, graphics and **ActionScript**.

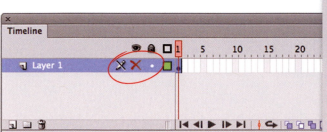

The third option is to simply turn off the visibility of the layer by clicking inside the layer just below the eye icon. To make sure all invisible layers are not included during export, go to **File > Publish Settings** and uncheck the **Include hidden layers** option. This method allows the contents of the symbol to be visible in all parent layers, making it easy to work with when animating or editing.

Background Design

I've always treated my backgrounds as another character. Backgrounds should have a unique style and personality that compliments the characters. Backgrounds can also help provide a unique look and feel for the entire animation. For these reasons I typically put as much thought into the background design as I do the character design.

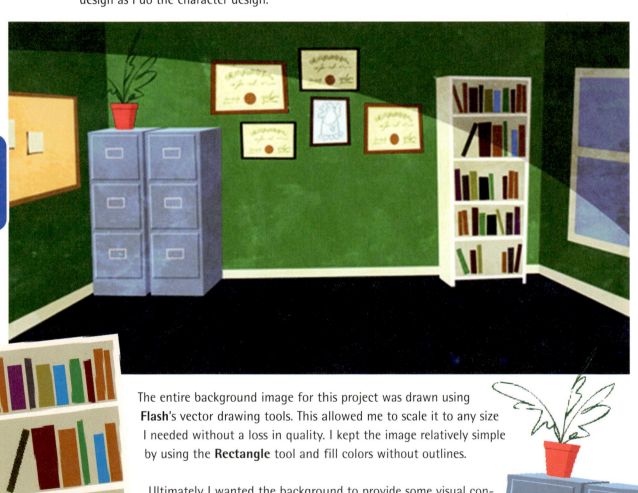

The entire background image for this project was drawn using **Flash**'s vector drawing tools. This allowed me to scale it to any size I needed without a loss in quality. I kept the image relatively simple by using the **Rectangle** tool and fill colors without outlines.

Ultimately I wanted the background to provide some visual contrast with the character and as it was here, the character might get a little lost in all the flat bright colors. Professor Needs will eventually be placed in between the chair and the desk and it would be nice if there was some color contrast between him and his surroundings.

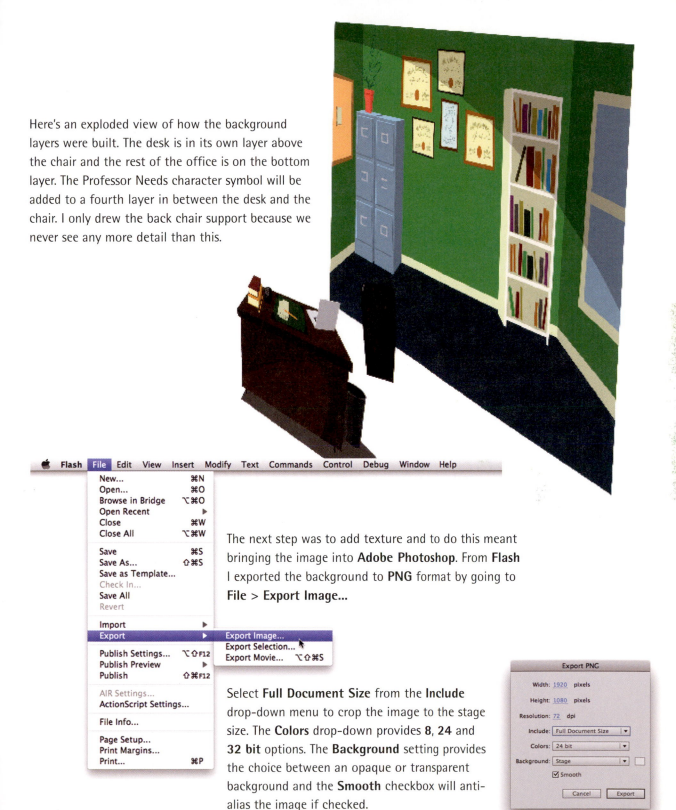

Here's an exploded view of how the background layers were built. The desk is in its own layer above the chair and the rest of the office is on the bottom layer. The Professor Needs character symbol will be added to a fourth layer in between the desk and the chair. I only drew the back chair support because we never see any more detail than this.

The next step was to add texture and to do this meant bringing the image into **Adobe Photoshop**. From **Flash** I exported the background to **PNG** format by going to **File > Export Image...**

Select **Full Document Size** from the **Include** drop-down menu to crop the image to the stage size. The **Colors** drop-down provides **8**, **24** and **32 bit** options. The **Background** setting provides the choice between an opaque or transparent background and the **Smooth** checkbox will anti-alias the image if checked.

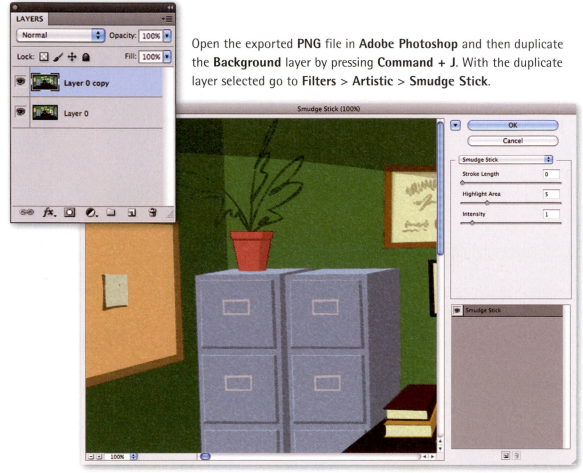

Open the exported **PNG** file in **Adobe Photoshop** and then duplicate the **Background** layer by pressing **Command + J**. With the duplicate layer selected go to **Filters > Artistic > Smudge Stick**.

Set the **Stroke Length** to **0**. Move the **Highlight Area** to a value of **5** and set the **Intensity** to **1**. Click **OK** and then set the layer opacity to **50%**. This tones the overall filter down a bit. To help it blend even more with the original background layer below it, set the **Blend Mode** to **Overlay**. Click **OK**.

Set the **Blend Mode** of this layer to **Overlay** so it blends with the original layer below it. **Overlay** blends in a way that makes light areas lighter and dark areas darker.

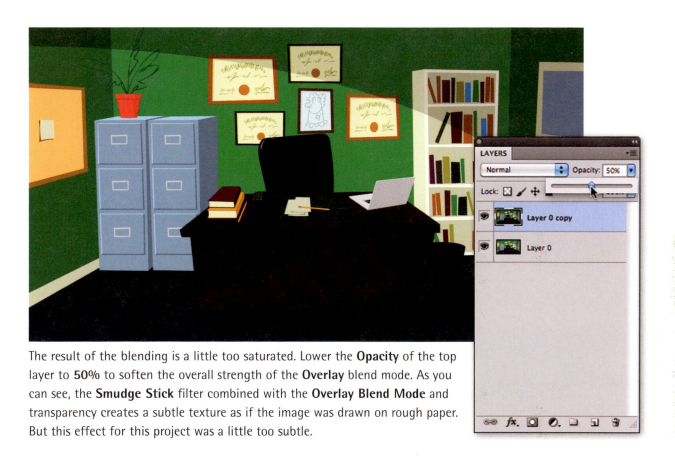

The result of the blending is a little too saturated. Lower the **Opacity** of the top layer to **50%** to soften the overall strength of the **Overlay** blend mode. As you can see, the **Smudge Stick** filter combined with the **Overlay Blend Mode** and transparency creates a subtle texture as if the image was drawn on rough paper. But this effect for this project was a little too subtle.

It's time to add some real texture to the background. These are two texture images from my folder collection. Similar textures can be found online but you can easily create them yourself by crumpling up paper, taking a photo of it and bringing the photo into **Photoshop** to add contrast and possibly some color. You don't even need a professional DSLR camera to shoot the image as most smartphones come with quality cameras built in. I recommend shooting the textured images outside on a sunny day as the sun provides a perfect source of natural light.

Open the first texture in **Photoshop** and paste it into the background file in a layer above the background layers. With the texture layer selected, apply the **Divide** blend mode. The **Divide** blend mode simply divides the color of the pixel values between the image in the layer and the image in the layer below it. The end result blends the texture image with the background image as seen below.

The background is starting to take shape. We have a pretty nice texture added to it but for me it's just a little bit too distracting due to its contrast. The easiest way to remove some of the contrast of the texture is to lower the opacity of its layer. Using the **Opacity slider** I adjusted the amount of opacity to about **30%**. Your texture and amount of opacity may differ based on your design preference.

Adding a single texture may be plenty in most cases, but for this project I added the second texture for an even richer look to the backgrounds. After opening the second texture image, copy and paste it into the background layer. This time select **Color Burn** from the blend mode drop-down menu. The **Color Burn** mode darkens the layer below it while inverting and then dividing it based on the results. The more darks present in the bottom layer, the more it blends with them. This produces a very dark and rich effect.

The **Color Burn** produced a very dark and rich effect with the texture. Adjusting the opacity of the layer helped balance the texture evenly throughout the image. Now the background has a rich texture giving it a lot more character and interest. The rich textures will provide a great backdrop to the vector character when brought back into **Flash**. Save the image as a **PNG** from **Photoshop** so it can be imported into **Flash**.

Parallax Effect

The establishing shot for this project required a camera zoom as we know from the storyboard. This was a perfect opportunity to add an effect referred to as the **Parallax effect**. The **Parallax effect** creates the illusion of 3 dimensional space between objects on different layers by moving them at different rates of speed.

The sky artwork is on its own layer and will not need to be animated. Objects furthest in the distance move less or not at all. The illusion is more convincing when there's a visual contrast of motion between static objects and objects in motion.

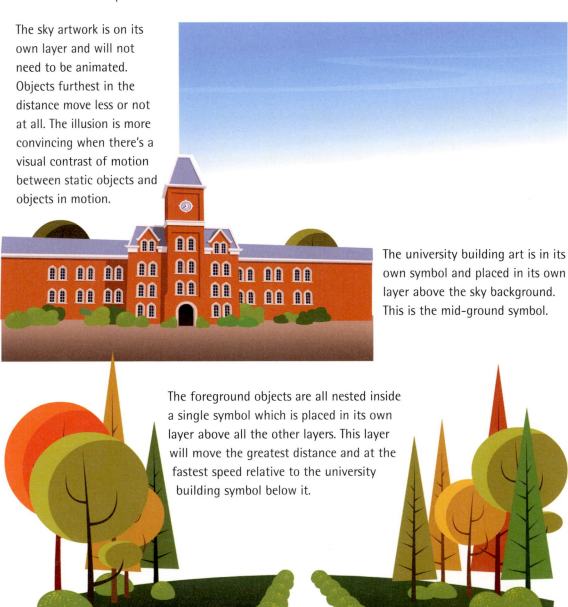

The university building art is in its own symbol and placed in its own layer above the sky background. This is the mid-ground symbol.

The foreground objects are all nested inside a single symbol which is placed in its own layer above all the other layers. This layer will move the greatest distance and at the fastest speed relative to the university building symbol below it.

With each object positioned in the first frame, the next step is to apply motion tweens to the foreground symbols and the mid-ground symbols. I start the motion tweens several frames into the timeline to provide some frames for editing convenience later on in **Premiere Pro**. **Classic** or the new **Motion Tween** can be used here. I chose the new **Motion Tween**.

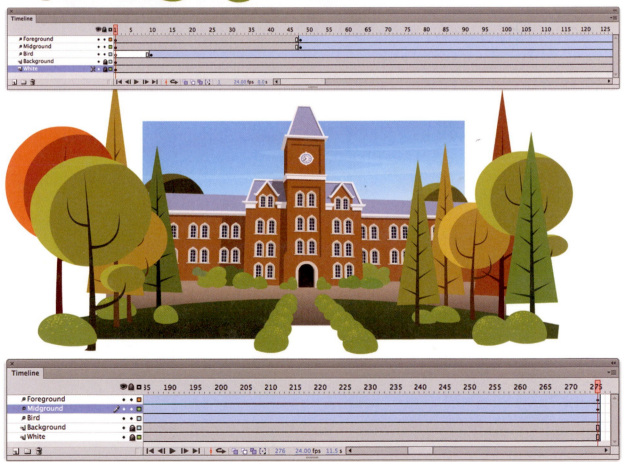

In the final keyframe I scaled the foreground symbol much larger than the university building symbol and even stretched it slightly wider using the **Free Transform** tool. The university symbol was scaled about half as large as the foreground symbol. The difference in scaling between these objects provides the illusion of three-dimensional space between them.

Here's the complete sequence of the camera zoom with the **Parallax effect** applied. It's easy to exaggerate the scaling of the symbols too much, causing the effect to become distracting. Subtle variations between the scaling of objects can often lend to a more convincing effect. You could take this same **Parallax effect** even further by separating the foreground trees and bushes into their own layers and scaling them all at slightly different rates of speed. It's up to you as to how realistic you want the animation to be.

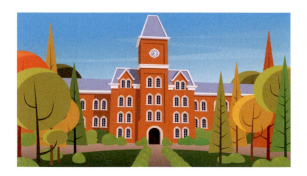
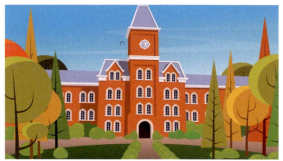
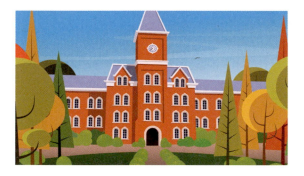

Voice Talent

Since my talents are severely lacking in the voice-over department, I enlisted the expertise of a good friend who happens to be a talented voice over actor in his spare time. **Timothy Button** lives in New Jersey, about a five hour drive from where I live which meant I had to work with Tim remotely throughout the entire project.

I sent Tim the script to help him come up with possible voice ideas that would fit the characters. Tim had two characters to create voices for, Professor Needs and the altered voice on the other end of the phone.

Before Tim could record the entire script we needed to make sure the client (**Focal Press**) liked the voices. Using **Garage Band** and a quality condenser microphone, Tim recorded a couple of lines for each character so they could be sent to them for approval. Tim pretty much nailed the voice of Professor Needs in the first take. We all agreed the voice fit the character perfectly. The altered voice was a little trickier as it relied on a very specific audio effect that disguises the voice. After a couple of revisions, we got the effect right and we had our voices.

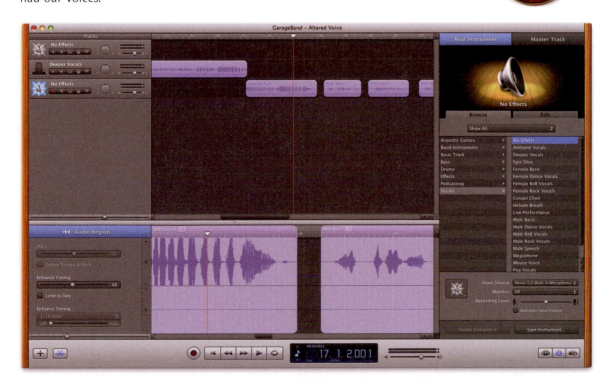

music

Having spent most of my life as an active musician has awarded me with several talented musician friends. One of the most talented musicians I know is Baltimore-based **Mike Powers**. Mike has been a performing musician since age eight and now makes Las Vegas his home. Recent studio projects include remixes for **Indaba Music**, featuring **K'naan**, **Jane's Addiction**, **Rufus Wainwright** and **Paul Simon**. The production music for **Solutions** was written and recorded by **Mike and the MP Mobile Unit**. Currently he can be seen performing with **Sony/Epic** artist **Michael Grimm**.

I was pleasantly surprised to learn that Mike was not only excited to work on the **Solutions** project, but was also available. I sent him the script and gave him a general description of the tone and vibe of the project. The client and I agreed that a soundtrack similar to a *James Bond* theme would be well suited. Mike obliged and within a few days he sent me exactly what we were looking for.

The original version of Mike's soundtrack was over a minute long, 1:07 to precise. Since the entire animation was approximately three minutes in duration, it didn't make sense to have the opening soundtrack last a third of the entire project.

I opened the audio file in **Adobe Audition** and edited it down to a more reasonable 34 seconds. I removed a portion of the middle section and kept the ending. All I had to do was make sure the edit was a smooth transition. The edited 34 second audio would now provide a perfect soundtrack for the opening title sequence.

Adding music to your animation can provide a specific mood or tone to the scene. There are a couple of shots in the **Solutions** project where I wanted to have a dramatic background soundtrack. I decided to search **iStockphoto** for some samples of suspenseful music. What I found worked perfectly for the shots that required a sense of drama and suspense.

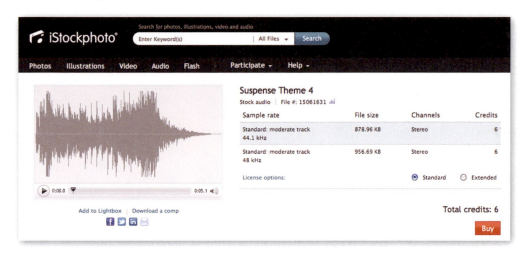

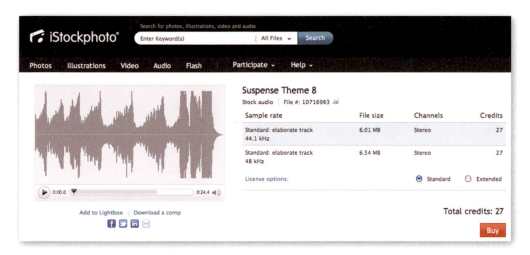

After downloading each audio file from **iStockphoto** to my computer, I eventually imported them into the **Adobe Premiere Pro** project that I had created to edit together all of the individual scenes that were animated in **Flash**. I will explain how I integrate **Premiere Pro** with **Flash** later in this chapter.

scenes

Using the storyboard as my guide, I created new documents for every shot. This workflow is not uncommon in the realm of large scale production animation. It's much easier to manage files that are as short as five to ten seconds in duration. Short animated scenes are also easier to share via the Internet if you work remotely since the file sizes are usually small. The scenes below are a smattering of shots from the **Solutions** animation to illustrate how the project was broken down into individual scenes.

Establishing shot: 11.5 seconds

Office door: 6.8 seconds

Receiving letter shot: 4.2 seconds

Open letter: 5.7 seconds

Incoming call: 3.6 seconds

Answering phone: 10.9 seconds

Transition effect: 1.0 seconds

Establishing shot: 4.7 seconds

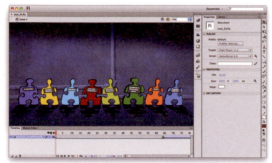
Hostages wide shot: 20.8 seconds

Office wide shot: 12.4 seconds

Office medium shot: 12.4 seconds

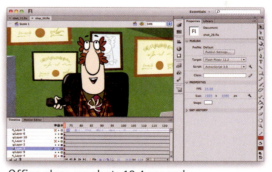
Office close-up shot: 12.4 seconds

Each scene was exported to the **SWF** format, but before doing so I wanted to make sure any imported audio was not included with the **SWF** file. The reason is, each **SWF** would be imported into **Adobe Premiere Pro** as well as the entire audio soundtrack as a separate file. I did not want the audio in the **SWF** to interfere with the imported high quality soundtrack in **Premiere Pro**. Each **SWF** file would become my footage that I would stitch together in the **Premiere Pro** timeline using the soundtrack as my guide. As long as the frame rate in my **Premiere Pro** project was the same as my **Flash** documents, everything would sync together perfectly.

Pr Adobe Premiere Pro

With all the animation complete and my audio as high quality stereo files, it was time to assemble the entire animation using **Adobe Premiere Pro**. Upon launch of **Premiere Pro**, select **New Project** from the start screen.

In the **New Project** panel, the default settings for **Video** and **Audio** will suffice in most situations. The **Capture** setting is irrelevant because I am not capturing video for this project. Click the **Browse** button in the lower left corner to select the directory you want the project to be saved in and provide a project name.

In the **Sequence Settings** window select **24.00 frames/second** from the **Timebase** drop-down menu. In the **Video** category type in **1920** and **1080** in the horizontal and vertical fields respectively.

Set the **Pixel Aspect Ratio** to **Square Pixels (1.0)** to preserve the original aspect ratio. **Fields** and **Display Format** can be changed based on your preference. I like to use **No Fields (Progressive Scan)** and **24fps Timecode** since this is the frame rate of the animation.

Audio Sample Rate should match the audio being used in the project. For **Solutions** the sample rate used is **48000 Hz**. Provide a sequence name and then click **OK**.

The **Premiere Pro** workspace will appear with all of the previous settings applied.

Inside the Project panel you can right-click and select **Import** to locate and import your audio and **SWF** files. If you need to edit any of the animation in the original **Flash** files, just export the new **SWF** and overwrite the original **SWF**. **Premiere Pro** will automatically update the imported **SWF** in the **Project** panel and the timeline sequence as long as the file name or directory has not changed.

This is what my **Project** panel looks like with all of my assets imported. Clicking on any asset will update the preview window in the upper left corner. You can even preview the footage by clicking the little play button next to the thumbnail image.

If you select an audio file, you can preview the sound in the preview window by clicking the same play button.

Assembling the shots together in sync with the audio begins by dragging and dropping the audio files on an **Audio Track** layer. In some cases you may have multiple files that have to overlap each other. One example of this is a musical soundtrack playing below the voiceover audio. In **Premiere Pro** you can create additional audio tracks to accommodate your project.

To add tracks to your project, go to **Sequence > Add Tracks...**

In the **Add Tracks** panel, use the hot text sliders to enter the number of new tracks you want and select where in the timeline those tracks will reside using the **Placement** drop-down menus.

All of the titles were created using **Premiere Pro**'s title tool. Choose **Title > New Title** to launch the **Title** panel.

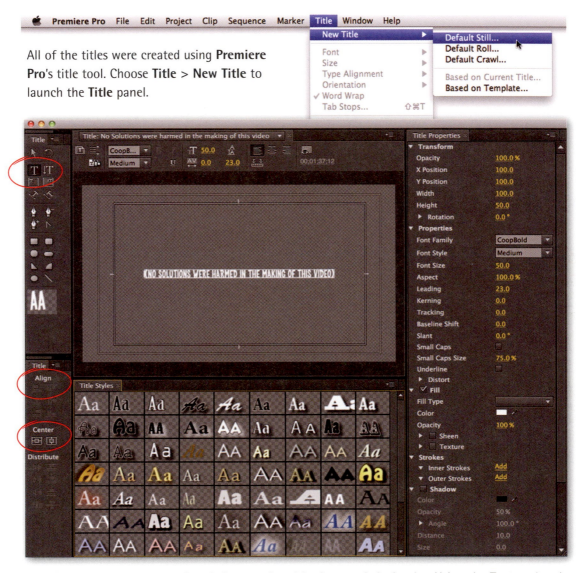

The **Title** panel boasts several tools for creating titles in a myriad of styles. Using the **Text** tool and an installed font of my liking, I typed the title and positioned it using the **Align** and **Center** tools.

There are several other tools to edit your title in the **Tools Properties** panel. You can adjust the opacity, position width and height of the text field as well as select the font, font style, font size, leading, kerning and color to name a few. You can even add strokes to the font and a drop shadow as well. When finished just close the **Title** panel and the title slide will be added to your **Project** panel. Drag and drop the title from the **Project** panel to the new video track in the **Premiere Pro** timeline.

One of the final editing tasks for the **Solutions** project was to add transition effects between some of the shots. The **Cross Dissolve** is often a good choice to create a soft transition between two different scenes by blending one scene into the other using transparency.

In the **Effects** panel, click the **Video Transitions** folder and then click the **Dissolve** folder to locate the **Cross Dissolve** effect. Drag the **Cross Dissolve** effect from the **Effects** panel to the timeline and drop it directly over the edit point between the two scenes you want the transition effect to be applied to.

By default, the **Cross Dissolve** transition will have a **1 second** duration. You can edit the duration of the effect using the **Effect Controls** panel. Use the **Duration** hot text slider to enter a new value.

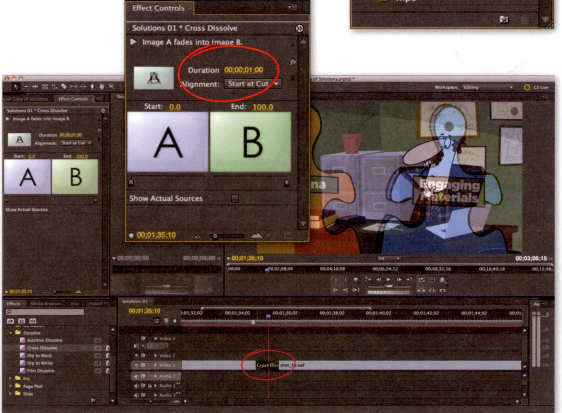

Exporting

With all of the edits complete, titles in place and transition effects applied, it's time to export the entire sequence to a file format that can be shared on the web and mobile devices. Begin the export process by going to **File > Export > Media**.

The **Export Settings** window will launch, providing you with a source window where you can preview, play, trim or crop the video. The right side of the window contains the export settings and format options for both video and audio.

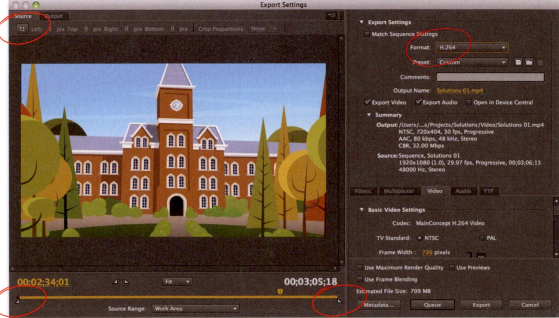

For the **Solutions** project there was no need to use the **Crop** or **Trim** tools. However, choosing the right video and audio format was important. In the **Export Settings** click the drop-down menu to choose from a long list of compression formats.

Audio Interchange File Format
Audio Only
DPX
F4V
FLV
○ H.264
H.264 Blu-ray
JPEG
MP3
MPEG2
MPEG2 Blu-ray
MPEG2-DVD
MPEG4
MXF OP1a
P2 Movie
PNG
QuickTime
TIFF
Targa
Waveform audio file

From the **Format** drop-down list select the **H.264** format which is a widely supported compression standard across several of today's most popular platforms.

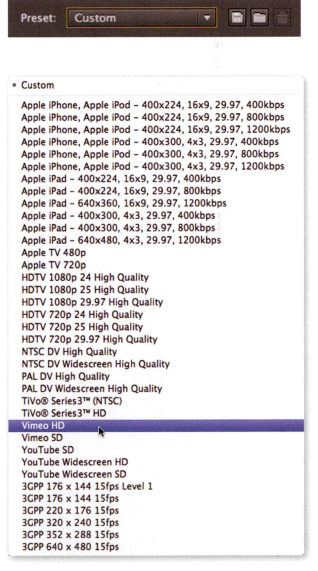

Preset: Custom

• Custom
Apple iPhone, Apple iPod – 400x224, 16x9, 29.97, 400kbps
Apple iPhone, Apple iPod – 400x224, 16x9, 29.97, 800kbps
Apple iPhone, Apple iPod – 400x224, 16x9, 29.97, 1200kbps
Apple iPhone, Apple iPod – 400x300, 4x3, 29.97, 400kbps
Apple iPhone, Apple iPod – 400x300, 4x3, 29.97, 800kbps
Apple iPhone, Apple iPod – 400x300, 4x3, 29.97, 1200kbps
Apple iPad – 400x224, 16x9, 29.97, 400kbps
Apple iPad – 400x224, 16x9, 29.97, 800kbps
Apple iPad – 640x360, 16x9, 29.97, 1200kbps
Apple iPad – 400x300, 4x3, 29.97, 400kbps
Apple iPad – 400x300, 4x3, 29.97, 800kbps
Apple iPad – 640x480, 4x3, 29.97, 1200kbps
Apple TV 480p
Apple TV 720p
HDTV 1080p 24 High Quality
HDTV 1080p 25 High Quality
HDTV 1080p 29.97 High Quality
HDTV 720p 24 High Quality
HDTV 720p 25 High Quality
HDTV 720p 29.97 High Quality
NTSC DV High Quality
NTSC DV Widescreen High Quality
PAL DV High Quality
PAL DV Widescreen High Quality
TiVo® Series3™ (NTSC)
TiVo® Series3™ HD
Vimeo HD
Vimeo SD
YouTube SD
YouTube Widescreen HD
YouTube Widescreen SD
3GPP 176 x 144 15fps Level 1
3GPP 176 x 144 15fps
3GPP 220 x 176 15fps
3GPP 320 x 240 15fps
3GPP 352 x 288 15fps
3GPP 640 x 480 15fps

Click the **Preset** drop-down menu to select from a variety of formats that cater to several of today's popular devices and video websites. **Premiere Pro** makes it nice and easy to prepare the file for whatever platform you wish to target. For this example I have selected **Vimeo HD** which will export the video suitable for **HD** playback on **vimeo.com**.

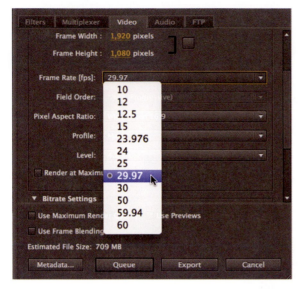

Select the **Video** tab and then click the **Frame Rate** drop-down menu to select the frame rate of the video. Select **29.97** since that is the standard for **NTSC** video.

I always check the **Use Maximum Render Quality** option for an overall higher quality to the video. It's worth noting, with this option selected the render time will be longer.

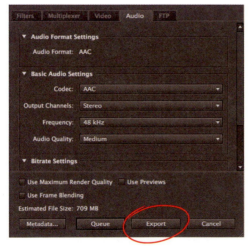

Select the **Audio** tab to choose an audio codec. The **AAC** codec is widely supported and typically your best format choice for audio.

Click **Output Channels** and select **Stereo**. Set the frequency to match the audio used in your project. In my case it is set to **48 kHz**.

The **Audio Quality** setting choices are **Low**, **Medium** and **High** and I recommend either **Medium** or **High**.

Click **Export** to start the rendering process.

Your rendering time depends on a number of variables such as the length of your video, the number of effects applied and the amount of compression.

With the export process complete, the final animation can be played within the **Quicktime Player**. Using my **Dropbox** account, I copied this video file to a shared folder so the client could easily download it.

The client built a website for their **We Have Your Solutions** marketing campaign where they embedded the animated video.

Project 4

Going mobile

If technology is a fashion, then the latest trend in hardware may be less is more. Hardware is diminishing and I predict it will eventually disappear completely, at least to the naked eye. I recently found an old photo of my home office and it reminded me just how complicated my computer used to be. My main workstation was a large desktop CPU with two bulky 21-inch CRT monitors, a keyboard, a mouse, a 12-inch graphics tablet, external hard drives and a twisted nest of cables and wires.

My current workstation is a 15-inch laptop.

That was then...this is now. What's next? Mobile apps have been around for a while but as a designer I've been increasingly turning to the tablet to supplement my creative process. I won't even think about entering a work-related meeting without a tablet and a stylus under my arm so I can take notes or design something on the fly. Portability is the new black!

- My Portable Studio
- Adobe Photoshop Touch
- ArtRage
- Adobe Ideas
- Wacom Inkling
- Doink Animation
- Paper
- PoseBook
- Animation HD
- Animation Desk
- SketchBook Pro
- SketchBook Ink
- Procreate
- ZenBrush
- Bamboo Paper

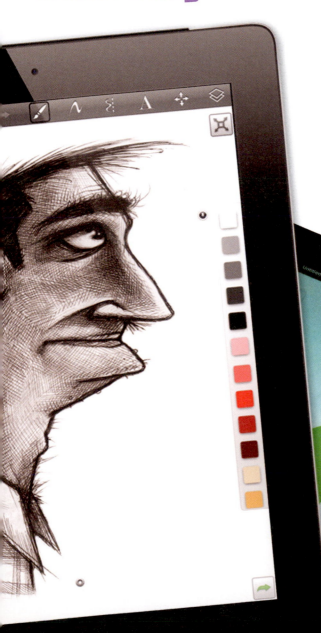

my Portable Studio

Mobile devices now offer the designer the option to still be productive when away from their desk. No longer do you have to sacrifice your creative process when you are without your laptop or desktop computer. With an **iPad** or similar mobile tablet, you literally have a creative studio under your arm, in your lap or backpack during that long morning commute on the train, or that flight across the country, or wherever you may find yourself in transit.

I have a pretty good collection of creative apps that either I have discovered on my own or were recommended by friends. By the time this book appears in print the number of apps will have likely doubled. For now, allow me to show you the ones I do have and why they are some of my best productivity tools when it comes to design and animation.

My workflow changed forever with the introduction of mobile tablets. When **Apple** announced the first generation **iPad**, I was intrigued but not convinced it was something I needed. After all, I had a new **MacBook Pro** that did everything an **iPad** could do but better. I was a bit naive. Soon after mobile tablets hit the market, productivity apps were being developed. We already knew how great mobile devices were for playing games, but I couldn't really justify the purchase of a tablet unless I could be productive with it.

I live on the east coast of USA and at the time I worked for a Los Angeles based game developer. This job meant having to make an occasional 2800 mile commute and also meant long hours in an airplane attempting to get work done. The one thing I try to avoid doing on a commercial aircraft is to open my laptop. I'm 6ft 3in tall and can never angle the screen enough to actually see it. Even if I could use a laptop on a plane, there's always the risk of unexpected turbulence while an open beverage is being passed over it. No way. My **MacBook** is too precious and expensive for it to die so senselessly. As soon as I learned about productivity apps for the iPad, I went to the nearest Apple store and bought one. I had another trip to the west coast approaching so I installed a word processing app called **Pages** and a draw-

ing app called **SketchBook Pro**. I now had a way to be productive during my cross-country commute. Today there are hundreds of thousands of apps to choose from, many of them apps for sketching, drawing, designing and even animating.

Mobile tablets and smartphones are designed to be used with your finger, but for a little more precision you can take advantage of the many available stylus options. **Ten One Design** offers the **Pogo Sketch** and the **Pogo Sketch Pro**. Both styluses work well for any tablet device and are smooth and responsive. As of this writing **Ten One Design** is working on a new pen with the code name '**Blue Tiger**'. The advantage **Blue Tiger** will have over other styluses is pressure sensitivity and responding through the **iPad** via **Bluetooth 4.0** connectivity. **Ten One Design** is developing its own drawing application to work with the new stylus and they provide the **SDK** for developers to integrate **Ten One Design**'s code into their own applications. Learn more by going to **tenonedesign.com/bluetiger**.

The **Bamboo** is **Wacom**'s offering in the mobile stylus market. The body of the **Bamboo** is slightly thicker than a number 2 pencil which makes it easier to handle between the fingers. The stylus is well balanced overall and has just the right amount of needed weight. The majority of its body has a comfortable rubber coating that provides just the right amount of grip and comfort when writing or drawing for long periods.

The **Cosmonaut** is a new **iPad** stylus from **Studio Neat** with an interesting and original design aesthetic. It's thick. It's twice as thick as the **Bamboo** yet is surprisingly accurate. The thickness also lends itself to being very easy on the fingers — not unlike writing with a dry erase marker on a whiteboard.

There are plenty of other styluses on the market and by the time this book goes to print there will likely be more. The styluses represented here were chosen because I discovered them or they were recommended by friends.

Adobe Photoshop Touch

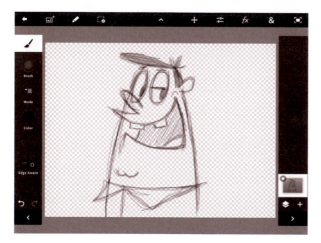

Adobe Photoshop Touch is a feature-rich app that is a must-have if you are a designer with a mobile tablet. There are so many different ways to work within **Photoshop Touch** it practically justifies its own book. Let's start with a simple project involving a concept sketch of a character for a client project. Using the **Brush** tool and on a single layer, I quickly sketched the initial design.

You can control the **Brush** size as well as its hardness, flow and opacity with the use of sliders. Access these options by tapping the **Brush** button underneath the **Brush** tool icon. Tap/drag on the dark gray horizontal area below **Size** and above **Hardness** to change their values. **Flow** and **Opacity** have a different slider design but work the same way. Unfortunately it can be an exercise in patience trying to dial in a brush size value of, say, **2**. A more precise way to change size values would be good here.

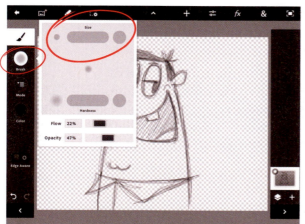

With my character roughed out, it's time to add a little color. I prefer to take advantage of **Photoshop Touch**'s layer support and keep my colors separate from the line drawing. In the lower right corner, tap the '**+**' button and then tap on **Empty Layer** from the popup menu.

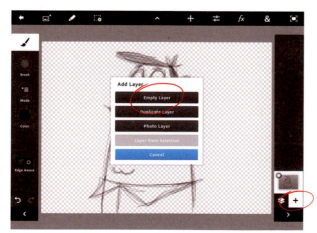

Tap the **Color** button to launch the color mixer. Tap anywhere inside the color gradient to pick a color. You can switch to using sliders to mix your colors based on hue, saturation and brightness. The third icon launches the Swatches panel where you can manage your saved colors.

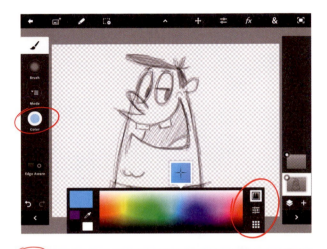

With color added, it's time to send this to the client for feedback. Tap the arrow icon in the upper left corner to prompt the **Save** popup menu. Tap on **Save** to save the file and return to the start screen.

With the launch of **Adobe Touch Apps** came the launch of the **Adobe Creative Cloud**, a cloud-based service from Adobe where you can share your work with others. Files created in any of the **Adobe Touch Apps** can be synced to the **Creative Cloud** and further edited using **Adobe** desktop applications.

Tap the **Creative Cloud** icon in the menu bar. From the drop-down menu you will be given the option to **Upload** selected files to the Creative Cloud or **Launch** the Creative Cloud website. Since I already have a **Creative Cloud** account, I just need to select **Upload to the Creative Cloud**.

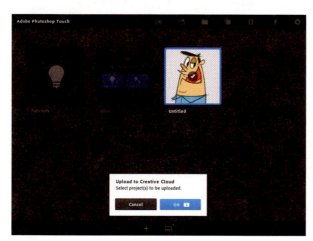

Tap on the thumbnail of the file you want to upload to the **Creative Cloud**. You can tap to select multiple files to batch upload as well but as you can see here, I had only one file at the time as I had recently installed the app. Once the file is synced to the **Creative Cloud**, I can then access it from my laptop or desktop and continue editing it in a different program. The other option is to stay within the mobile platform and continue editing the image in another app.

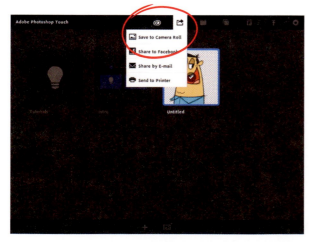

Adobe Ideas is a vector-based drawing app and perfect for sketching ideas or, in this example, tracing a bitmap sketch using vectors. The native format for Photoshop Touch is the **.psdx** format which can be opened with **Photoshop CS5** with the required plugin (**https://creative.adobe. com/downloads**). You can also save to **JPEG** or **PNG** format which is the only option if you want to edit in a different app. To save to these formats, tap the **Export** button and then tap **Save to Camera Roll**.

In the **Save to Camera Roll** popup, tap the down arrow to choose between **JPEG** and **PNG** formats.

Select your preferred format by tapping on either **JPEG** or **PNG** formats. I have selected **JPEG** format because I'm going to be using this image as reference only and I'm not concerned about compressing it and sacrificing a little quality.

Tap **OK** when you've selected your choice of format. The image will be saved to the **Camera Roll** on the **iPad** and accessed via the **Photos** app.

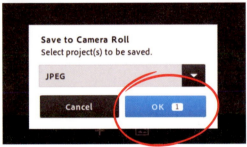

4

I have two different photographs that I shot while on a trip to Ecuador. The first image is of an eagle in flight over land and the other image is at sea during an incredibly beautiful sunset.

The challenge is to remove the eagle from image 1 and place it in the setting of image 2 while making it look as natural as possible. It's pretty obvious the lighting is very different between the two images, which will pose the biggest challenge in terms of how convincing the end result will look.

The first step is to upload the images from my computer to the **Creative Cloud** so they can be downloaded from within the **Photoshop Touch** app. After having logged in via your browser, click the **Upload Files** button and select the image(s) you want to sync to your **Creative Cloud** account.

My files

Start a new file in **Photoshop Touch**. Tap the **Add Layer** button represented by the **+** icon in the lower right corner to launch the **Add Layer** popup menu. Tap on **Photo Layer** to add a photo to the file.

Tap **Creative Cloud** in the left column and then tap the image thumbnail in the gallery section on the right. The image will be downloaded and placed in the photo layer in **Photoshop Touch**.

With the import complete, the image is presented with tools to scale, rotate and position it relative to the canvas. I want the image to fill the entire viewable area so I tap and drag one of the corner handles to scale it. Tap and drag anywhere on the image itself to position it on the canvas. Once you are satisfied with the results, tap the **Done** button.

Photoshop Touch does not support batch importing of images. To add additional images to the file the same steps will need to be repeated. Tap the **Add Layer** icon, tap **Photo Layer** and then navigate to the location of the image and tap **Add**.

Make sure the eagle image layer is above the sunset layer. If it is not, tap and drag the layer image to change the layer order. Let's start by selecting the eagle so it can be isolated from the sky. To access all of the available tools, tap the currently selected tool from the left tool bar.

The easiest way to make a selection in **Photoshop Touch** is using the **Scribble Selection** tool. The **Scribble Selection** tool is grouped with the **Magic Wand** tool and may be hidden. Tap and hold the **Magic Wand** tool to expand the tool bar and then tap the **Scribble Selection** tool icon.

With the **Scribble** tool selected, tap the **Keep** icon and paint around the inner edges of the eagle. You do not have to be very precise while painting the selection area. Following the general contour of the eagle's shape will suffice. To make it easier to paint within complex areas such as the feathers of the wing, zoom in by using two fingers to pinch outward.

While zoomed in, use two fingers to scroll across the image and continue painting the eagle's outline.

With the outline complete, tap the **Remove** button and paint around the outside edge of the eagle. Accuracy is not critical with this step. The tool does a great job of understanding what should not be selected.

Sometimes the **Scribble** tool will miss an area depending on the color contrast between the intended selection and the its neighboring colors.

With the **Scribble** tool selected and **Remove** still active, paint over the area that was accidentally included in the selection. As you can see here I am still zoomed in as close as possible to help my accuracy while painting.

Once the selection looks good, tap the **Select** drop-down menu and then tap the **Refine Edge** tool.

The **Refine Edge** tool reveals the areas of the selection that need to be refined. The area in between the eagle's feathers is clearly part of the selection and needs to be cleaned up.

Tap the **Size** button in the tool panel along the bottom edge and adjust the size of the **Refine Edge** tool by using the slider in the popup window. Once again, I recommend scaling the image as large as possible and using a small brush size to refine the smaller detail areas.

Paint along the edges of the outline to refine the edge until the background is no longer part of the selection.

Once you are satisfied with the selection, tap the **OK** button.

The eagle now has an accurate selection indicated by the 'marching ants' and is ready to be removed from its original background setting. Click the '**+**' symbol in the Layers tool bar in the lower right corner and then tap the **Layer from Selection** button from the **Add Layer** menu.

With the eagle in its own layer there's no need to keep the original background layer that the eagle came from. Select the layer containing the original background and then tap the layers icon and then tap **Delete Layer**. The sunset background will now be visible behind the eagle.

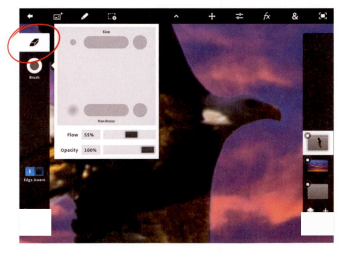

In some cases, a little manual clean-up may be necessary for the image that was selected to its own layer. The **Eraser** tool can make short work by painting any unwanted pixels. Adjusting the Eraser's brush size and opacity can help in tight spaces.

The sunset background has a dramatically different color palette to the original sky background. The shots were taken at different times on different days. The sunset background has much warmer color values and the eagle doesn't look as convincing against the sunset as it could. Before making adjustments to the eagle, tap the '+' icon and then tap **Duplicate Layer** to make a copy of the eagle.

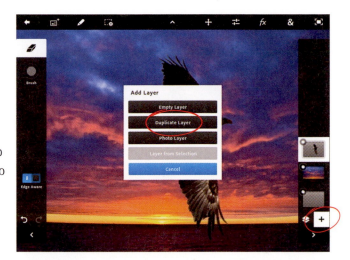

With the duplicated eagle layer selected, tap the **Adjustments** icon to launch the **Adjustments** menu, then tap the **Color Balance** thumbnail.

Using the **Color Balance** sliders I adjusted the amount of red to **26%**. I left the **Green** slider untouched and increased **Blue** by **6%**. With just these two small tweaks to the color balance, the eagle is starting to look relatively convincing against its new background.

With the eagle on its own layer, it's easy to scale, rotate and position the eagle anywhere within the scene. From the top menu, tap the **Transform** icon.

Tap and drag the rotate handle to rotate the image. Tap and drag one of the corner handles to scale it and tap and drag anywhere inside the image to position it.

As nice as the background is, I wanted its colors to be slightly brighter and stronger. One final adjustment was necessary. **Photoshop Touch** provides the ability to adjust the image using **Curves**. Tap the **Adjustment** icon and then tap the **Curves** tool.

The **Curves** graph provides the option to adjust the curves of the image relative to its red, green and blue values individually. Tap a color value on the left side of the **Curves** window and then tap and drag the curve to adjust the image. When you're happy with the results, tap the **Apply** button.

Pretty convincing, right? It seems almost impossible that this level of graphic editing can be done on a thin hand-held device with just the the tip of my finger. We are modern day wizards, thanks to technology.

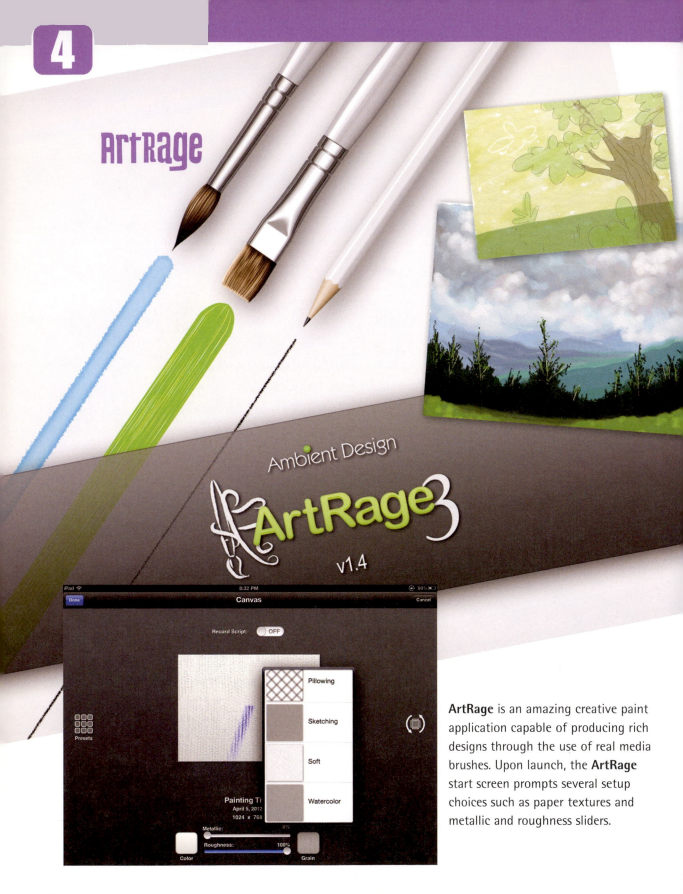

ArtRage is an amazing creative paint application capable of producing rich designs through the use of real media brushes. Upon launch, the **ArtRage** start screen prompts several setup choices such as paper textures and metallic and roughness sliders.

The range of colors, brushes and textures that can be created with **ArtRage** is seemingly endless. Tap a brush from the tool box on the left and customize it by tapping the **Brush Settings** button in the lower left corner. The color mixer is located in the lower right corner. Both the brush tools and color mixer can be minimised during the creative process if desired.

Each brush can be customized by clicking the icon with the two gears on it in the lower left corner underneath the current brush icon. For this background I selected the **Watercolor Brush** with the settings shown on the left.

This background was drawn entirely using the **Watercolor Brush** and the **Felt Pen** tool across several layers. Tap the folder icon to save the image to the **ArtRage** gallery. The idea here is to bring the background into **Adobe Photoshop Touch** as an image to apply some **Adjustments** and **Effects**.

Return to the **ArtRage** gallery and then tap the **Export** icon. **ArtRage** supports exporting to the **iPad Photos** application, while other options include: **Send to iTunes** as a **PNG** or **JPG**, **Email**, **Store Online**, or **Send to an AirPrint printer**. If you select **Store Online** you will have the option to upload the image to **DeviantArt**, **Facebook** or **Dropbox**. For further editing in **Adobe Photoshop Touch**, I saved the image to the **Photos** app on my **iPad**.

Launch **Photoshop Touch** and open the image created with **ArtRage** that was saved to your **Photo Gallery**. Tap the **Adjustment** icon and then tap **Levels**.

The **Levels** filter allows you to adjust the **RGB** color values globally or independently using sliders. Tap the icon on the left to activate the color value of your choice and then drag the relative slider to adjust that color value throughout the image. Tap **Apply** when done.

Tap the **fx** icon to launch the **Effects** menu and then tap the **Scratches** thumbnail. **Scratches** is one of my favorite effects for making an image look distressed and a little bit worn.

Scratches has an amazing number of adjustment tools allowing a myriad of ways to customize the effect. Tap the **Scratch Color** button to launch a color mixer that allows you to mix and choose a custom color for the scratches themselves. You can choose between **HSB** and **RGB** as well as the visual style of the mixer. You can select the angle of the scratches, the type (**Metal**, **Floor**, **Concrete** or **Crumpled**), the **Intensity**, **Smoothness** and **Scale**. Tap **Apply** when finished.

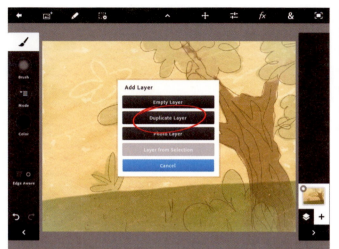

Duplicate the layer by tapping the '+' icon in the **Layers** panel and then tapping **Duplicate Layer** from the popup menu. I could leave this image as it is in its current state but I often prefer to push the envelope a little and see how much I can get out of the software.

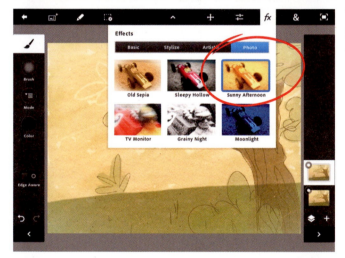

Tap the **fx** icon again and then tap the **Sunny Afternoon** thumbnail in the **Photo** tab.

Drag the **Intensity** slider until the image looks relatively washed out and over-exposed. Tap **Apply**.

Tap the **Layers** icon in the **Layers** panel
and set the **Opacity** to around **33%**. From
the **Blend Mode** drop-down menu choose
Overlay. The result is a color blend of
this layer with the original copy of the
background below it, giving the scene a
bit more luminance. To adjust the amount
of blending between the layers, drag the
Opacity slider.

I'm still not done with the pursuit of per-
fection. Duplicate the original layer again
and then tap the **fx** icon again and this
time choose **Gaussian Blur**.

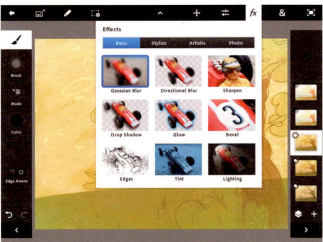

Drag the **Gaussian Blur** slider until the
value is approximately **20** or until the
image is blurred to the extent where the
objects are barely recognizable. Tap **Apply**.

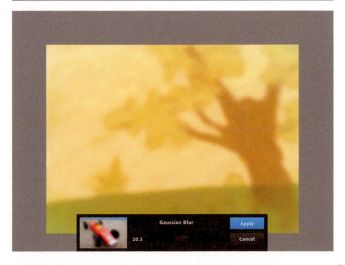

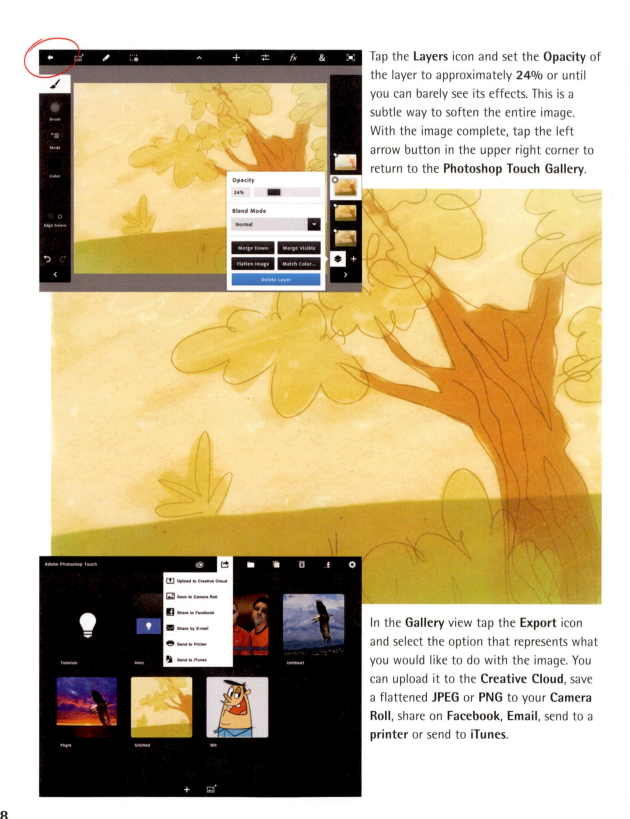

Tap the **Layers** icon and set the **Opacity** of the layer to approximately **24%** or until you can barely see its effects. This is a subtle way to soften the entire image. With the image complete, tap the left arrow button in the upper right corner to return to the **Photoshop Touch Gallery**.

In the **Gallery** view tap the **Export** icon and select the option that represents what you would like to do with the image. You can upload it to the **Creative Cloud**, save a flattened **JPEG** or **PNG** to your **Camera Roll**, share on **Facebook**, **Email**, send to a **printer** or send to **iTunes**.

Adobe ideas

Adobe Ideas is another great tool in the suite of **Adobe Touch Apps**. The core strength of **Ideas** is its vector format. The toolset is simple: a **Brush**, **Eraser**, **Undo**, **Redo** and a **Layers** panel.

Whether you draw with your finger or a stylus, **Adobe Ideas** is perfect for conceptualizing your design or creating finished work. You can import an image from the **Creative Cloud**, your **Photo Library**, take a photo using the built-in **Camera**, or browse **Google** or **Flickr** for inspiration. Adjust the **opacity** of the **photo layer** and then trace over it on a **drawing layer** with the vector **Brush**. Pinch and zoom in as much as you need to draw the fine details and then zoom back out for the broader strokes.

Upload the image to the **Adobe Creative Cloud** and with the use of a plugin, continue editing your work in **Adobe Illustrator**.

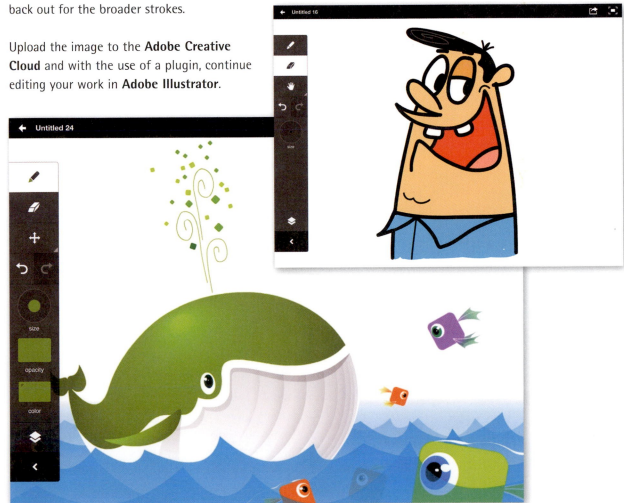

wacom inkling

The **Inkling** is a device that captures your analog drawings on paper and digitally transfers them to your computer for further editing in Adobe Photoshop, Adobe Illustrator, Autodesk SketchBook Pro and beyond. While drawing, your strokes are recorded electronically. When finished, you can connect the Inkling to your computer and import your drawing as raster or vector artwork. What distinguishes this from using an ordinary scanner is that the Inkling supports layers.

The Inkling is extremely well designed and each component comes self-contained in the solid plastic housing. The Inkling comes with the pen, receiver, a mini-USB cable and four extra ink cartridges. The case feels high in quality and snaps closed magnetically. The Inkling case is very portable and easily fits in my laptop bag without worry of anything inside being damaged.

The Inkling receiver is approximately 2¾ inches wide, 1¼ inches deep and ½ inch in height. Don't let its size give you the wrong impression when it comes to how much data it can store. I have used the Inkling to record numerous drawings over a period of days before connecting it to my laptop. Once the receiver was connected, all my sketches were transferred without a problem. It seems possible to me the receiver could record more strokes than I could ever draw.

The pen has an ergonomic design and weighting that feels good in the hand. The tip of the pen has an integrated transmitter that sends the information for each stroke to the receiver. During the drawing process the transmitter must have a direct line of sight to the receiver which means being mindful of your finger positioning on the pen.

With a single click of a button you can record actual layers. The recorded layers are Photoshop, Illustrator and SketchBook Pro supported.

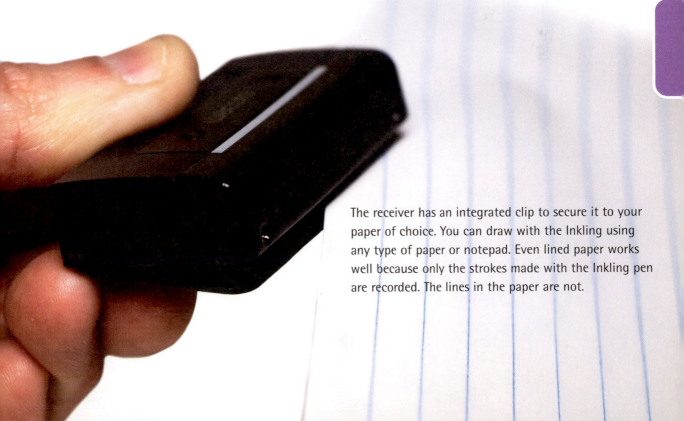

The receiver has an integrated clip to secure it to your paper of choice. You can draw with the Inkling using any type of paper or notepad. Even lined paper works well because only the strokes made with the Inkling pen are recorded. The lines in the paper are not.

The Inkling pen is easy and comfortable to draw with. I've always enjoyed drawing with ballpoint pens so this is not unfamiliar territory for me. To ensure each stroke is recorded, keep the area between the pen and the receiver clear of any objects, including your free hand.

The Inkling pen supports 1024 levels of pressure sensitivity that will be recorded and represented in your digital image.

Press the layer button on top of the receiver to record a new layer. All subsequent strokes will be recorded to the new layer. There's no documentation that speaks of a limit to the number of layers the Inkling supports. Personally I have yet to reach the limit, if it does in fact exist. Until that happens I will continue drawing with the Inkling with reckless layer-creating abandon.

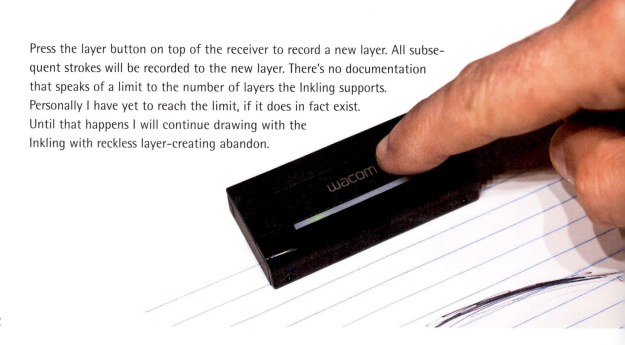

The one thing to remember about the Inkling is that it is meant for recording your concept drawings and sketches. It is not designed to capture finished work. If you expect your lines to be captured and recorded exactly as they were drawn, you may be disappointed. The Inkling does an amazing job capturing strokes accurately, but in some cases where drawings may involve complex line work, the receiver may miss a stroke or two.

Use the included mini-USB cable to connect the receiver to your computer. This is what justifies the Inkling as a worthwhile drawing tool over using a scanner for traditional sketches. Without the Inkling you have to wait until you get home to the scanner, connect to your computer, launch the scanner software, save each scan as a file and then launch your graphics program of choice and import the scanned images into it. The process isn't difficult, it's just time consuming. With the Inkling you can capture your drawings digitally while on the road.

The first time you connect the Inkling to your computer, you will be prompted to install the **Sketch Manager** software. With the Sketch Manager software launched, all recorded Inkling sketches will appear as thumbnails.

Select a thumbnail and then click either the Photoshop, Illustrator or SketchBook Pro thumbnails at the top of the Sketch Manger to open the selected file in the program of choice.

Double-click a thumbnail image to manage the contents of the file. In this view you can show and hide individual layers (if any), as well as merge, split and delete layers.

Select a layer in the **Layers** panel and use the timeline handles below the preview window to select a segment of your recorded drawing. Click the **Split** button located at the bottom of the **Layers** column to split the selection to a new layer. Splitting sections of your drawing can be useful if you decide you need parts of your drawing and didn't create layers during the capture process.

244

Click the **Player** button below the pre-view window to access playback controls. You can play, fast forward and rewind your drawing as it was recorded by the receiver. You can adjust the size of the preview window as well as the playback speed using the respective sliders located on either side of the playback controls.

The **Sketch Manager** provides the option to save the drawing as a flattened image. Right-click over the thumbnail of the drawing and select **Save as Different Format**. Choose between **PNG**, **JPEG**, **PDF**, **SVG**, **BMP** or **TIFF** file formats. I saved my sketch as a **JPEG** file and imported it into **Adobe Flash** so I could trace it using **Flash**'s vector drawing tools.

DoInk Animation

DoInk (pronounced 'do-ink'), is developed by **DK Pictures, Inc** and may just be the coolest drawing and animation app currently available. Its strength is its simplicity. The drawing engine is vector and offers a **Brush** and bézier curve editing capabilities. The animation interface is based on a flipbook style, pose-to-pose technique. Share your creations on the web directly from the **DoInk** interface and join the **DoInk** community.

The **Brush** tool creates vector lines similar to the way **Adobe Flash** does. Select from four different drawing modes as well.

You can mix colors using the **DoInk Color Mixer** panel. Just tap the color swatch in the menu bar to access it.

Set the **Brush** mode to **Inside** to paint inside a fill with a different color. **Inside** mode is great for adding shading to your drawings.

Tap the '**+**' icon in the lower right corner to create a new keyframe. **Onion Skin** is automatically turned on to help you animate.

You can add as many keyframes and drawings as you like.

In the **Projects** panel you can add a title, description and tags for your animation. Click the **Export** button to upload your work to **DoInk.com**, **Preview the clip** or **Export to Saved Photos**.

Export to DoInk.com

Preview this Clip

Export to Saved Photos

Karen Miller is the brains and passion behind **DoInk**. I have not met anyone with as much affection for the application and the die-hard community that supports it as Karen has. If you browse the **DoInk** forum you'll quickly find that Karen not only reads users' posts but responds to them as well. From hobbyists to professionals, the **DoInk** animation community is a passionate and approachable lot. Join the fun by going to **doink.com**.

Paper

Paper is a drawing app from **FiftyThree** that is great for sketching and writing your ideas with really cool tools. The **Fountain Pen** draws lines from thick to thin based on your movement. The **Pencil** tool creates lines that blend from light to dark like a real lead pencil. The **Marker** draws thick bold lines while the **Pen** is perfect for writing notes, messages and ideas. Then there's the **Watercolor Brush** that blends colors based on movement. The combination of these tools can produce really cool drawings. My favorite tool combination is sketching with the **Fountain Pen** and then painting over it with the **Watercolor Brush**.

Pinch anywhere in the image to return to the cleverly designed main menu. Here you can create, delete and select various sketch books. With a sketch book selected and open, you can swipe to browse through its pages.

Click the Share button to upload your creations to **Tumblr**, **Facebook**, **Twitter**, **Camera Roll** to **Email** as an attachment. Learn more about **Paper** by going to **fiftythree.com**.

PoseBook

Have you ever suffered from artist's block? Stephen Silver has provided us with the cure: PoseBook. Choose between the Male or Female version (or get both) and you'll have your own personal gesture model in the palm of your hand. Each Posebook app offers 2000 hi-definition images of a fully posed character, silhouettes, facial expressions and hands. One of the smartest features is the ability to 'Flip' each image horizontally.

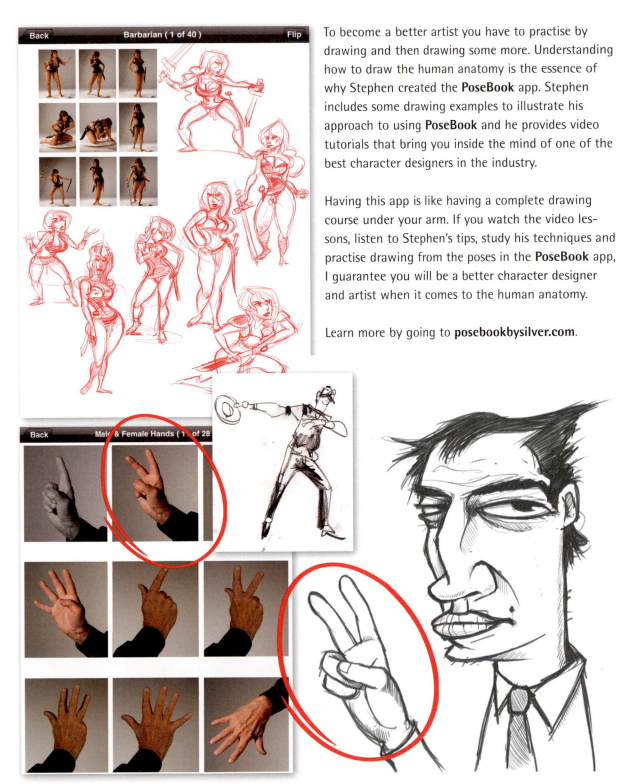

To become a better artist you have to practise by drawing and then drawing some more. Understanding how to draw the human anatomy is the essence of why Stephen created the **PoseBook** app. Stephen includes some drawing examples to illustrate his approach to using **PoseBook** and he provides video tutorials that bring you inside the mind of one of the best character designers in the industry.

Having this app is like having a complete drawing course under your arm. If you watch the video lessons, listen to Stephen's tips, study his techniques and practise drawing from the poses in the **PoseBook** app, I guarantee you will be a better character designer and artist when it comes to the human anatomy.

Learn more by going to **posebookbysilver.com**.

Animation HD

Animation HD is filled with so many features, it rivals many desktop animation programs. On the surface, the interface is quite clean and sparse which allows you to focus on what is important, the animation. You can draw directly in **Animation HD** or import an image. You can animate on different **layers** and the **Brush** tool supports several stroke types. Other drawing features include a **Pencil**, **Spray Can**, **Eraser**, **Line** and **Rectangle** and if you make a mistake, there are unlimited levels of **Undo**! **Animation HD** supports cutting and pasting of objects and importing of images from your **Photo Library**.

You can record sound directly within **Animation HD** by tapping the **Audio** icon and then tapping **Record**. Upload your animation to **YouTube**, share on **Twitter**, export to your **Photo Library** in **video** format, export as sequential **frames** to your **Photo Library**, **email** as video or email the animation as a **project** file so it can be shared with other **Animation HD** users. I use **Animation HD** for short conceptual animation tests and to practise the art of **frame-by-frame animation**.

Animation Desk

What's unique about **Animation Desk** is its realistic integration of setting and interface. You really feel like you are sitting at an animator's desk with all of your favorite tools within arm's reach. **Animation Desk** allows you to create hand-drawn animation with an intuitive workflow. Choose between three different **Brush** types, a **Bucket** fill tool, **Pencil** and **Crayon**. You can add background music and sound effects to enhance your animation.

My favorite **Animation Desk** feature is the cloth in the lower right corner. Drag this cloth over the tools to prevent your hand from interacting with them while animating. Cool, huh?

Export your animation to **Facebook** and **YouTube** in video format and as frames to your **Photo Library** and as a **PDF** document. You can also share the project between **iDevices**. Learn more at **atkdanmobile.com/en/animation-desk**.

SketchBook Pro

SketchBook Ink has been one of my favorite desktop drawing programs, so when **Autodesk** developed the **iPad** version I immediately installed it. The third generation **iPad** app supports 18 layers with a canvas size of **2048 x 1536**. Over 60 **Brush** presets with up to 90 available for purchase will keep you drawing for hours. You can even save custom **Brush** presets that you like to use most often. **SketchBook Pro** supports the integration with **Adobe Photoshop** by importing and exporting layered **PSD** files. **SketchBook Pro** is a powerful drawing program for the hobbyist and professional alike.

SketchBook Ink

SketchBook Ink is another drawing app from **Autodesk** that features a vector-based drawing engine allowing you to export your work to a massive **4096 x 3072** resolution. Select from a variety of **Ink Styles** from the toolbar on the left and **Color Swatches** from the toolbar on the right. There's also a **Color Well** that provides the ability to pick colors from the screen. Tap and hold a color swatch to launch the **Color Mixer** panel so you can mix your own custom colors.

Import a background image from your **Photo Library** that could be an actual photo you've taken or perhaps an image you created in a different drawing app such as **SketchBook Pro**. Continue the creative process using the power of vectors in **SketchBook Ink**. **SketchBook Ink** was developed for the casual artist and professional designer. I love **SketchBook Ink** for client work as much as my kids love doodling with it for fun.

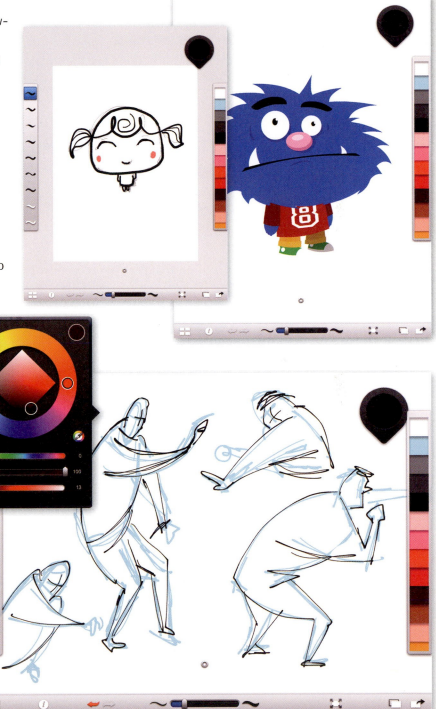

Procreate

Procreate uses the **OpenGL®** **Silica** engine for its 64-bit painting engine. This means **Procreate** paints fast enough to keep up with your finger or stylus. I've tested the painting engine by moving my finger back and forth as quickly as I can and **Procreate** had no trouble keeping up with me without any noticeable lag.

Procreate has over 45 tools ranging from various pencils to paint brushes to abstract brushes. Canvas size is a massive **1408 x 1920** pixels and supports up to 16 layers. Export your artwork as a **JPEG** or **PNG with Alpha** to **Photos**, **iTunes**, **Twitter** or send via **Email**. The **Export to iTunes** feature supports layered **PSD** support.

I love **Procreate** for everything from quick sketches to creating high quality backgrounds for animations and beyond.

ZenBrush

Are you looking for an app with a realistic ink brush? Then **ZenBrush** is the app for you. ZenBrush has only one drawing tool, the Ink Brush, and it draws so nicely it's all you need to create really cool line work. There are no layers and only one Undo level, so drawing with ZenBrush feels a little like drawing without a safety net. One too many mistakes and you may have to start over or use the eraser to repair things. You can choose from a long list of custom background textures

Bamboo Paper

Wacom, known for their industry standard graphics tablets, enter the mobile ring with **Bamboo Paper**. The core strength of **Bamboo Paper** is communicating your ideas through notes, doodles and sketches. Combined with the **Bamboo Stylus,** the **Bamboo Paper** app turns your **iPad** into a virtual notebook for expressing ideas.

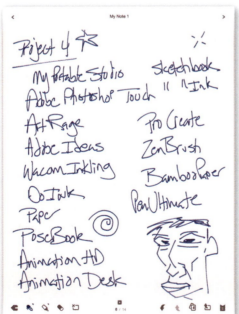

Dedication

Adobe Flash, it's just a software program, right?

It was February and my family was spending school vacation in Florida without me. I stayed home to isolate myself with the goal of getting a massive amount of writing done for this book. It was a trying time for me as I was burning the candle at both ends between my full-time job and writing. Eighteen-hour work days were normal and began to take their toll on me mentally and physically. I was feeling overwhelmed by the workload and the never-ending deadlines.

I needed inspiration.

During that week at home, I received a letter in the mail. An actual two-page letter, printed on real paper, folded by hand and placed in an envelope that was addressed to me. In addition to the letter, the envelope contained a disc with animations on it and an original piece of fine art. I can't remember the last time I received an actual letter from another human being. As I opened the letter and discovered its contents I knew I was in receipt of something very personal.

The letter was from a woman named Sally, an independent designer living in Wyoming. Sally and I have never officially met except through my books and subsequently Facebook. While taking a Flash course, Sally found one of my video tutorials online that explained how to design and animate a character in Flash. Sally explained in her letter how that particular video '*rocked her world*' and provided her with a clear understanding of how to use Flash to create animation. It was through this online tutorial that Sally landed her first job as a web designer and became a fan of the *How to Cheat in Adobe Flash* series.

In the letter Sally explained to me how she'd had to overcome some major personal obstacles in her life including the death of her father and brother-in-law, divorce from her husband after 26 years, and her only daughter leaving home to attend college. Sally also suffered a stroke that affected her vision and as a result she became desperately sick. She lost the ability to maintain her balance and coordination and speaking became a challenge as well. Even typing was difficult as she couldn't coordinate her fingers to use a keyboard.

Sally was then diagnosed with multiple sclerosis and had to quit her job to focus on recovery. The following year was extremely difficult. The combination of events in her life was devastating to her health and well being. But Sally fought through it and began to recover.

Sally found rehabilitation through Flash.

Eventually Sally became well enough to start her own design business and began getting client work. Her first job was to animate a horse for the community college she attended. Sally turned to Flash and was able to deliver a fully animated college mascot character. It was a milestone in Sally's life and career as she proved to herself she had gained her life back.

Sally began seeing a new neurologist and through a series of tests it was concluded that she had been misdiagnosed with multiple sclerosis. Her condition was re-diagnosed as an advanced stroke disorder which is much more treatable. With proper medication, Sally is on her way to making a full recovery and planning to create a new animation to celebrate her new lease on life.

Sally's story is why Flash isn't just a software program. It's deeper than ones and zeros. Flash can be personal, emotional, even life-changing.

I had found my inspiration to finish this book and I dedicate every page of it to Sally.

Painting by Sally

index